Economic Impact of the Arts

A Sourcebook

Hm789
66

National Conference of State Legislatures
William T. Pound, Executive Director

1560 Broadway, Suite 700
Denver, Colorado 80202

444 North Capitol Street, N.W., Suite 500
Washington, D.C. 20001

Second Printing, November 1990

Table of Contents

Foreword

The very act of launching this project suggests that its sponsors believe that government has a legitimate role in connection with the arts. According to opinion surveys and the informal soundings that successful politicians take, most ordinary people, as well as advocates for the arts, agree. This view is by no means a universal one in this country today. For example, the most recent in the series of Twentieth Century Fund books on public policy and the arts, Edward C. Banfield's *The Democratic Muse*, argues that public spending in support of the arts is wholly illegitimate. One need not enter into this debate here, however, for the subject is not the arts *qua* arts but the economic impact of the arts.

State governments (and the local political units that the states have created) do have a lively concern for their economies. Some might argue that this concern, too, is beyond the proper role of the states in the ideal American republic, but it is far too late to wipe the slate clean and ignore the more than 350 years during which colonial and state legislatures have been intimately concerned with the economic development of their jurisdictions. The web of taxes, subsidies, regulation, and public investment that affects the economies of the states—sometimes only inadvertently as a by-product of actions for other reasons but often quite deliberately—is so elaborate that the states cannot back away now. One can advocate minimal state promotion of the arts, but if the economic impact of the arts is, or is suspected to be, consequential, then the states must be concerned.

If the arts were viewed as noxious, the only question would be whether the stamping out of this noxious activity would have high economic costs. But, of course, the arts are not seen in this light; even those who think that government should not spend tax money to foster the arts see them as a good thing. So, one has a happy coincidence: The arts, that good thing (perhaps not a justifiable object of state expenditure by themselves) also may be good for states' economies, and states cannot be indifferent to *that* consideration.

The chapters in this book are concerned with this question: How can the good that the arts do for state and local economies be converted into claims on private and public patronage of the arts? Subordinate questions are addressed in the individual chapters. In what ways are the arts good economically? How can this impact be measured? What have previous attempts to measure the impact—or impacts—shown? What is wrong with the usual approaches? Are there alternative approaches? And how can pub-

lic policymakers and arts advocates use the results of studies of the economic impact of the arts?

In the first chapter, Harry Hillman-Chartrand establishes the broad context for considering the economic impact of the arts. He examines the changing social perception of the arts over time—as economic activity, wealth, or symbol—and how economics itself has changed over time. He also points out a variety of subtle, but pervasive, effects of the arts on the macroeconomy that are usually neglected but, once mentioned, obvious—such as the roles of good design in the postindustrial world and the arts in fostering the spirit of innovation. In addition, Hillman-Chartrand describes the interaction among the sectors of the arts—the nonprofit arts that are the usual object of public support; the commercial arts that are part of the ordinary profit-making, taxpaying private sector; and the domestic or amateur arts that are part of education and leisure activities.

Bruce A. Seaman offers a devastating critique of the validity of the economic impact study. He points to typical errors in measuring the amount of primary spending associated with arts activity in a state or city and explains that the multiplier effects are likely to be small in most small places where primary spending might be large. Seaman questions whether the theory that underlies this type of study is correct (whether the export base really is the determinant of regional development), and he identifies a number of other flaws. Yet, Seaman does see the arts as having an important role in local economic development by improving the social infrastructure of communities and by enhancing the quality of human capital within a region, which—like education—raises productivity within communities and helps them attract business.

Seaman's approach is similar to that of R. Leo Penne and James L. Shanahan, who see much merit today in the postindustrial society. In the late 1950s, city planner Hans Blumenfeld and economists Edgar M. Hoover and Raymond Vernon independently noted that over the years in any given city, state, or region, the principal export industries come and go. What remains is the human capital and social infrastructure; if they are in good shape, then the city finds new export industries to replace the old ones. Thus, the arts as amenities that attract and retain talented people, foster the spirit of innovation and adventure, and convey the image that the city is indeed a head's-up place are real contributors to local economic development.

Seaman's chapter makes clear that studies of the economic impact of the arts have little merit as intellectual exercises (assistant professors should not gain tenure by making such studies). The real purpose of the studies, however, is "to increase the effec-

tiveness of arguments for the arts before representatives of the public and private sectors," as Anthony J. Radich and Sonja K. Foss put it. Their chapter explores the ways in which five illustrative economic impact studies were tools of effective advocacy for the arts by achieving some degree of communion between arts advocates and representatives of business and government, who traditionally operate in separate worlds with distinct values, vocabularies, and modes of thought.

Anyone who has been tuned into the discourse of the last decade about public and private patronage of the arts (and has examined the data on increases in state and local government and corporate support) must admit that the barriers between the two worlds have disappeared considerably in many places; economic impact studies have made important contributions to this outcome. The incremental value of further economic impact studies in these places may be doubtful. In other places, however, the economic impact perspective may be useful as the primary focus for arts advocacy. As Radich and Foss rightly conclude, there is a time and place for the economic impact perspective in arts advocacy; it is hardly an eternal verity.

David Cwi's review of economic impact studies in 16 states discusses the terms of reference and content of those studies. Whatever the virtues of the studies as generalized advocacy instruments that build communion with influential outsiders—in the terms discussed by Radich and Foss—Cwi faults the typical study as doing less to assist its sponsors, the state arts councils in most cases, in arts policymaking than such studies could. As he suggests, the thinking seems to be that the business of the state arts council is not to generate economic benefits but to choose among grant recipients; if the arts council commissioned an economic impact study that did more than enhance the dialogue with potential supporters, then the council might be pressed to consider, for example, the differential impact of the various institutions and disciplines in grant making. That is something that most councils would resist, and they would be right in that resistance.

I interpret Cwi's recommendations, however, in a way that is less threatening: If economic impact studies are to be made for advocacy purposes, then no good reason exists why they cannot be designed to generate, as a by-product, information on arts activities and institutions per se that state councils do not have and that can be useful (in a way that cannot be called Philistine) in making grants policy choices.

William S. Hendon's chapter explores an alternative type of economic analysis, benefit-cost analysis. The virtues of this approach are that it is cheaper than the conventional economic im-

pact analysis, more suitable for analysis of the small-scale arts initiative, and far more appropriate as a means of appraising specific arts policy decisions. Moreover, most of the time, policymakers are engaged in unarticulated and unquantified comparisons of benefits and costs before they act. What Hendon explains is that arts policymakers should try explicit and quantified benefit-cost analyses (as are often done in other areas of public policy); he also shows how to go about doing so.

What does all this mean for state legislators, for city officials, and for people in the arts? First, there is more than one way to examine the positive economic effects of arts activities in a community or state; the conventional economic impact study is not the only approach. Second, that conventional approach does have serious flaws in the usual applications. In the world of public policy, however, the flaws may not be fatal ones.

Policy is made with a variety of motivations, including concern about relatively short-term effects (due to the shortness of life, it is best not to be too sniffy about the short term) in particular places and for particular groups. A given stimulus—say, the creation of a summer arts festival in a smallish place—very well may have more impact in the short run than in the long run. It may help only some local enterprises and residents, not all of them. In addition, it may entail diversion of income and jobs from other places. But policymakers may identify the place as especially hard hit financially and thus deserving of help; the job and income gainers may be thought especially deserving (perhaps because of past and present misfortune); and the arts festival may be the quickest, or even the only nonharmful, way to help those deserving souls. Therefore, it is not totally useless to identify for policymakers the immediate economic consequences of subsidizing the festival.

This, of course, does not justify grotesque exaggeration of the positive effects, ignoring negative effects where these are likely to be consequential or assuring policymakers that the festival is the yellow-brick road to sustained economic growth and prosperity. Nor does it justify inattention to other ways in which support of the arts can do good and do so in ways that have economic relevance.

Whatever their attitude toward economic impact studies as such, a common thread in these chapters is that the arts not only are a good thing in themselves and for themselves but also have pervasive, if hard to trace, positive effects on local economies. The state economic development game often has been called a zero-sum one, with one place winning only at the expense of others. But if the instrument of interstate competition is support of the

arts, the game is transformed into a positive-sum game. If states compete for economic growth by fostering the arts, they won't hurt themselves and they probably will help everyone.

Dick Netzer
New York University
New York, New York
May 1987

Acknowledgments

The National Conference of State Legislatures acknowledges the following people for their assistance with this project:

Chapter Reviewers
William S. Hendon
Dick Netzer
Barbara Hancock

Project Advisors
Senator Stanley Aronoff (Ohio)
James Backus
Lewis Bolan
Norman Cournoyer
David Cwi
Stephen Dennis
Greg Geissler
William S. Hendon
Jonathan Katz
Representative Patricia Kelly (N.D.)
Senator Tarky Lombardi (N.Y.)
Sandra Lorentzen
Robert Lynch
Paul Minicucci
Senator Carl Moore (Tenn.)
Susan Moorehead
Kevin Mulcahy
R. Leo Penne
William Pound
Malcolm Rivkin
Beth Rowe
Rosemary Scanlon
Ellen Sollod
Kirstin Thompson
Katherine Warwick

Project Monitors
National Endowment for the Arts
Harold Horowitz
Tom Bradshaw

Project Consultant
Sonja K. Foss

Book Design
David Baker

Manuscript Preparation
Mary Shaver
Agnes Zimmermann

This project was sponsored by the Research Division
of the National Endowment for the Arts

Introduction:
The Value
of Economic
Reasoning
and the Arts

by

Harry Hillman-Chartrand

The Canada Council
Ottawa, Canada

Introduction

In this age of change and uncertainty, it is not surprising to find accepted truth eroding before an onslaught of new knowledge. This is certainly the case regarding the relationship between art and the economy. Until recently, the economic impact of the arts was either a contradiction in terms or the ultimate statement of the contemporary Philistine. Today, however, an ever-increasing number of researchers around the world are demonstrating that what was once considered a fiction—the economic impact of the arts—is a fact, a fact with significant implications for the performance of national economies.

Economics generally is considered a science in that it is thought to be objective and its theorems testable in terms of mathematics. In fact, economics is a social science which, like the arts, is concerned with human values and precepts that extend far beyond simple calculation of dollars and cents.[1] This concern with values is most visible in "economic thought" or the sum of opinions and desires involving economic subjects, especially about public policy bearing upon these subjects that, at any given time and place, float in the public mind.[2] Such opinions cannot be subjected to mathematical testing. Nonetheless, economists and business people generally accept them for a time as true because of their intuitive reasonableness. Given the subjective nature of the arts, it should not be surprising, therefore, that many of the most important economic impacts of the arts cannot be quantified.

Keynes best expressed the mix of skills required by an economist, particularly in the study of nontraditional subjects such as the economic impact of the arts:

> The master-economist must possess a rare combination of gifts. He must reach a high standard in several different directions and must combine talents not often found together. He must be mathematician, historian, statesman, philosopher—in some degree. He must understand symbols and speak in words. He must contemplate the particular in terms of the general, and touch abstract and concrete in the same flight of thought. He must study the present in the light of the past for the purposes of the future. No part of man's nature or his institutions must lie entirely outside his regard. He must be purposeful and disinterested in a simultaneous mood; as aloof and incorruptible as an artist, yet sometimes as near the earth as a politician.[3]

In this chapter, the idea of economic impact of the arts with respect to national wealth, capital, technology, and employment, as well as the role of government, will be explored first. The need for economic impact studies by the private, public, and philanthropic sectors then will be outlined. Before doing so, however, it is appropriate to consider the concept of economic impact.

There are three distinct segments of contemporary art: the fine arts, the commercial arts, and the amateur arts. In each, the creative source is the individual artist. The fine arts are a professional activity that serves "art for art's sake" just as "knowledge for knowledge's sake" is the rationale for "pure research" in the sciences.[4] The commercial arts are a profit-making activity that places profit before excellence. The amateur arts are a "recreational" activity that serves to re-create the ability of a worker to do his or her job or a "leisure" activity that serves to "self-actualize" a citizen's creative potential, thereby permitting him or her to appreciate life more fully. Collectively, all three make up the arts industry, which includes advertising, broadcasting, motion pictures, performing and visual arts, publishing, and sound and video recording.

The Idea of Economic Impact

Economics can be defined as either the study of the principles governing the allocation of scarce means among competing ends, or the study of human activities in satisfying wants.[5] One must conclude, therefore, that economics is concerned with the means of attaining human ends. Most people, however, generally accept art as a human end, in and of itself. In any assessment of the economic impact of the arts, this viewpoint must be kept in mind.

Economics usually is divided into microeconomics and macroeconomics. Microeconomics is the study of the economic behavior of consumers and well-defined collectivities such as the firm, the market, and the industry. Macroeconomics is the study of the functioning of the economy as a whole, with special emphasis on national wealth or income, employment, and capital and how they can be manipulated to achieve national economic policy objectives. The economic impact of a given phenomenon, therefore, can be defined as the effect of that phenomenon on such economic factors.

To date, most economic impact studies of the arts have involved microeconomics. Studies have tended to concern the direct, indirect, and induced expenditure and employment generated by artistic enterprise in a given city or town. Subsequent chapters discuss many of the microeconomic impacts of the arts. This chap-

ter considers the macroeconomic impact of the arts on national wealth, capital, technology, employment, and government. The investigation focuses on how the arts affect these critical macroeconomic variables.

National Wealth and the Arts

Since the Renaissance, there has been a progressive expansion of the conceptual sources of national wealth. This expansion has involved a series of crises in confidence concerning previously accepted systems of economic thought.[6] From the 16th century until the end of the 18th century, people thought that only physical capital, in the form of gold, silver, and land, was productive of an economic surplus. By reinvesting this surplus in primary industries like farming, fishing and mining, many believed that national wealth would increase. During this so-called "pre-classical" period of economic thought, art was a symbol, not a source of wealth:

> The idea of using art as a form of investment was unknown in the eighteenth century.... One bought paintings for pleasure, for status, for commemoration, or to cover a hole in the ancestral panelling. But one did not buy them in the expectation that they would make one richer.[7]

By the end of the 18th century, division and specialization of labor were accepted as productive of an economic surplus. When reinvested in secondary or manufacturing industries, this surplus would lead to an increase in national wealth or income. During this "classical" period of economic thought, art was an important social activity, to be patronized by church and aristocracy, but not a source of national wealth:

> In fact, [Adam] Smith's usage of the term "wealth" can, with one important qualification, be translated into modern terminology as "national income." The point at which Smith and today's national income accountants in Western countries part company turns on the definition of "productive" activity. In Smith's view, only the outputs of the productive employments of labor should count in calculations of the social product. Virtually all "service" activities were excluded, on the grounds they failed to yield either tangible products or reinvestable surpluses.

This definition also reinforced Smith's general attitude towards a wide range of policy issues. It followed that all activities of governments were unproductive as well as "some both of the gravest and most important, and some of the most frivolous professions: churchmen, lawyers, physicians, men of letters of all kinds; players, buffoons, musicians, opera-singers, opera-dancers, etc."[8]

In the late 19th century, technological change through the medium of perfectly competitive markets was recognized as productive of an economic surplus. When this surplus was reinvested in the tertiary or service industries, especially in financial markets and transportation—e.g., the telegraph and the railroad— economists believed that national wealth would increase. During this "neo-classical" period of economic thought, art sold through the emerging competitive bourgeois art market was a source of national wealth:

> The second half of the nineteenth century was, in market terms, the great age of the living arts. . . . [By this time the purchase price of a work of art] included all reproduction rights to the picture. The ownership of these rights was of vast importance to the Victorian art market. It affected the price of popular pictures in exactly the same way that the market for film and TV rights affects the price of popular novels today. . . . What transformed the popular market for living artists was the steelfaced engraving plate, which made it possible for just about everyone . . . to have a three-shilling print.[9]

The Great Depression of the 1930s convinced most economists and policymakers that the perfectly competitive market was no longer the dominant form of industrial organization. Large-scale industrial enterprise combined with widespread unionization now required government to become actively involved in the economy to maintain full employment and price stability. Therefore, from the mid-1930s until the recessions of the late 1970s and early 1980s, economists and policymakers considered government a source of national wealth resulting from its "fine tuning" of the economy and its countercyclical management of aggregate economic demand.

During this "Keynesian" period of economic thought, art was recognized as a "public good." As in several other areas of social policy, policymakers believed that the benefits of the arts could not be fully captured by private producers on the open market. Therefore, government had a legitimate patronage role to ensure that an appropriate quantity and quality of art was made avail-

5

able to the general public. Art was, then, a form of national wealth, in and of itself:

> The arts are public goods whose benefits demonstrably exceed the receipts one can hope to collect at the box office. It is a long-standing tenet of economics that if the wishes and interests of the public are to be followed in the allocation of the nation's resources, this is the ultimate ground on which governmental expenditures must find their justification. Government must provide funds only where the market has no way to charge for all the benefits offered by an activity. When such a case arises, failure of the government to provide funds may constitute a very false economy.[10]

At present, no single school of economic thought enjoys general public confidence. Various new schools of "post-modern" economic thought have emerged in recent years. They tend to share a common belief that new factors have emerged as sources of economic surplus and, hence, of national wealth. Such emerging factors generally have been recognized by redefining older concepts such as capital and technological change. In the case of capital,

> a strong argument can be made that information capital is as important to the future growth of the American economy as money. Despite this perception, this intellectual capital does not show up in the numbers economists customarily look at or quote about capital formation. . . . In saying that, I am not arguing that money capital will not continue to be very important; it will. But I am suggesting that the amazing accumulation of knowledge capital in the last twenty years is very substantial and growing every day but it is uncounted. We have little or no control over the natural resources within our borders, but we do have control over our educational and cultural environment. . . . If we want better economic forecasting and better policies, clearly some way needs to be found to crank the growth of knowledge into our equations.[11]

Similarly, redefining technological change permits us to recognize two new factors of production: changes in organizational technology and changes in product or aesthetic design.[12] The relationship of these new factors to national wealth is analogous to traditional technological change. Research in the physical sciences results in improved physical technology, which leads to growth in national wealth. Research in the social sciences results in improved

organizational technology, which leads to growth in national wealth. Research in the arts results in improved aesthetic or product design, which leads to growth in national wealth.

The economic impact of improved organizational technology on national wealth has been estimated at 20 to 40 percent of the net national product of the United States.[13] The impact of improved aesthetic design has not yet been quantified. Furthermore, it is fundamentally different from advances in technical or functional design such as building a better automobile engine. Aesthetic design concerns two ill-perceived, but increasingly important dimensions of economic competitiveness: first, improved product design, and second, advertising.

First, if a consumer does not like the way a product looks, he or she may not bother to find out how well it works. In the upwardly mobile "Yuppie" market with its demand for high-quality, sophisticated goods and services, the consumer now searches for "the best looking thing that works."[14] Accordingly, aesthetic design is playing an increasingly important role in helping companies and countries meet their export, sales, and marketing objectives:

> There is, then, another aspect to culture, namely good taste, good design and creative innovation, that should enable smaller industrial economies to compete effectively in the world economy. . . . In this endeavour, higher quality implies an organic relationship between business and engineering, on the one hand, and design and craftsmanship, on the other. . . . High-quality products, technologies, plants, homes, cities and locales require the presence of creative artists of all kinds. To increase the long-run supply of artists . . . governments must support the artists and the arts. The long-term return from investment in artists and the arts is real and substantial.[15]

Second and often forgotten is that within the ecology of capitalist realism, advertising is the lubricant of the market economy. Advertising, to a great extent, applies the literary, media, performing, and visual arts to sell goods and services. Corporations employ actors, dancers, singers, musicians, graphic artists, copy writers, and editors to sell virtually everything. In fact, the art-centered production cost of a one-minute advertisement on national television equals or exceeds that of an hour-long episode of *Dallas*. From where does advertising talent and technique come? From the arts. Thus, in "post-modern" economic thought, the arts are analogous to research and development in the physical sciences and increasingly are recognized as a source of national wealth.

Capital and the Arts

As with all industries, the arts are based upon a complex network of invested capital. In the arts industry, invested capital takes the form of facilities generally located in the cities and towns of a nation, as well as intellectual capital in the form of repertoire and copyrighted properties accumulated over the years. Repertoire is a critical element of artistic capital because it makes design images of the past available to the present and the future. Thus, unlike in the sciences, the new does not necessarily displace the old in the arts. Copyright is a critical element of artistic capital because it forms the legal foundation for industrial organization in the arts.[16]

Facilities in the arts industry include distribution areas, exhibition halls, offices, performing spaces, production studios, storage areas, training centers, libraries, art galleries, audio and video studios, museums, printing plants, artist-run spaces, movie houses, professional schools, and theatres. Unfortunately, no one has conducted research concerning the relative share of the national stock of physical capital made up by artistic facilities and inventories.

There are three ways, however, by which artistic facilities affect the economies of cities. First, such facilities draw large numbers of people from the suburbs as well as tourists whose spending supports local business and land development. An example is Lincoln Center, which was built in 1959 in a depressed neighborhood in New York. Fourteen years later, the center was surrounded by $1 billion in new office buildings, apartments, and restaurants.[17] Another example is found in Dallas, Texas, where property values surrounding the new arts district have risen 733 percent following completion of the art museum there.[18]

The arts thus serve to enhance one of the built-in advantages of the city, that of urbanity. The arts increase the element of excitement and variety that is the key to urbanity. Government and the private sector now recognize the role of artists as dynamic city builders.[19]

Second, the arts revitalize urban centers through "artists' colonies," concentrations of artists living in a given neighborhood. In most cases, the low income of artists, second only to pensioners, forces them to live in the less expensive areas of a community. When concentrated in such areas, however, artists tend to change the ambiance and image of these neighborhoods.

By enhancing the image of the district, an artists' colony can result in "gentrification" by attracting young, middle-class professionals to live in the neighborhood and thereby to share in the

artistic ambiance—e.g., Yorkville in Toronto and Soho in New York City:

> The rezoning of the Soho [and now Noho and TriBeCa] district of Manhattan to permit artists to live and work in industrial zones backfired on the artists themselves. After moving into former manufacturing buildings, and renovating and restoring them with their own money, artists succeeded in making the area a desirable place to live. Landlords then raised the rents and artists were forced to move out. While economic redevelopment of the area has certainly occurred, the artists' needs were met for only a limited period of time. After "fighting the zoning battle, making the area safe, and filling the streets with energy, and the buildings with boutiques . . . [artists] have been left to the forces of the market."[20]

Third, artistic facilities attract new industries to a state, province, or community. Traditional industrial location theory states that companies situate their plants to gain access to markets, raw materials, and energy supplies. During the 1960s, however, many companies, particularly in the service industries, began to locate according to the "amenities" available in a given community—e.g., good weather or easy access to cultural, educational, and recreational facilities.

The tendency to make industrial location decisions based on a community's amenities has been amplified by the shift from traditional "smokestack" manufacturing to high-tech industries. A number of observers have suggested that jobs now follow people in high-technology industries rather than people following jobs. If this is the case, then to attract scarce, highly trained workers, companies and communities must offer an increasingly attractive quality of life that includes the arts.

Construction of cultural facilities in communities across Canada and the United States during the last decade partially reflects this perceived need to increase cultural amenities in order to compete for the industrial location of new companies. Such facilities also have gained importance in economic development plans because many corporations, urban planners, and developers attach value to the physical and social environment of the workplace itself.[21]

The "creative" artist is the wellspring of artistic growth and development.[22] The contemporary creative artist, however, is engaged in a permanent struggle with his or her predecessors. Work of long-dead colleagues has the advantage of being known and having been *shifted* by ongoing comment and criticism. Historical

works, therefore, often have a greater chance of performance because of fame and acclaim. Foreign works hold the same advantage. Furthermore, the costs and risks of producing new works are significantly greater than those associated with a proven work. Thus, unlike the sciences where new displaces old, in the arts, historic and foreign repertoire is a critical element of current capital because it makes design images of the past and other cultures accessible now and in the future.

Accordingly, an existing stock or repertoire of works is bequeathed to the present by the past as well as a flow of new works, some of which will pass the test of time. The value of either the stock or the flow of art works, including novels and poetry, paintings and sculptures, plays, musical scores or choreographic works, at present cannot be estimated.

The capital value of artistic repertoire is embodied in a stream of income inherent in the grant of copyright. Copyright, in economic terms, does not refer to a specific piece of legislation but rather to a category of property rights. To the general public, copyright is a right, granted by the state, as an incentive and reward for creativity. In this tradition, intellectual property legislation is justified as a protection of and incentive to human creativity. In return for this protection, the state expects that creators will make their work available to society as a whole and that a market will evolve in which such work can be bought and sold. Yet, while the state encourages creativity, it does not want to foster harmful market power. Accordingly, the state limits the rights granted to the creator, both in time and space. Rights are granted for a fixed period of time and protect only the *fixation* of human creativity in material form.

Copyright and related neighboring rights such as "moral rights," "rights of following sale," and "performance rights" are the unifying economic principle that tie together the component arts industries. In fact, such rights form the legal foundation of industrial organization in the arts.[23] Each arts industry is based upon the buying, selling, and production of copyrighted works. Each is related to its fellows by the sale, license, or other exercise of copyright. An extreme example illustrates the point. A literary work becomes a play through the exercise, license, or sale of the author's right to adaptation. In turn, the play becomes a film that, in turn, spins off posters, toys, and a sound track. Both film and sound track are broadcast on radio and television. Eventually, a book is made concerning the making of the movie, and a sequel of the movie is then produced. Thus, the value of a literary property can be amplified many times by adapting and licensing copyright in different media.

Even museums and archives are related to copyright in that most of the artifacts and documents they contain are within the public domain—i.e., copyright has lapsed through time. The copyright crossovers, in conjunction with the transferability of many skills and equipment between component arts industries, are so great that one can speak meaningfully of the arts industry as a distinct, recognizable industrial entity.[24]

Extension and development of copyright and neighboring rights are accelerated by conceptualization and introduction of new rights that can evolve inside and outside the constraints of international covenants and conventions—e.g., the Berne Convention and the Universal Copyright Convention. New or reemerging rights, currently being discussed or applied in various parts of the world, include public lending rights, performance rights, and *droit de suite, droit moral,* and celebrity rights. It is within this dynamic process that the arts industry evolves and mutates.

Technology and the Arts

Economists generally consider technological change responsible for 75 percent of the historical growth of the economy in the last century. How such technical invention and innovation comes about and how they result in economic growth, however, are unclear. In fact, some economists find the contribution of technological change to economic growth to be "the measure of our ignorance." Partially, this situation can be attributed to a failure to distinguish between advancement in the physical sciences from advancement in the social sciences, resulting in improved organization technology, from advancement in artistic knowledge, resulting in improved aesthetic design. Today, a series of new communications technologies are radically transforming the nature of the economic process. These new technologies have generated the information economy,[25] which includes the collection, processing, and application of information. In 1981, an estimated 50 percent of the gross national product (GNP) was contributed by the information economy.[26]

While most analysis has focused on information production, equally profound implications exist for consumption of artistic goods and services. News, entertainment, and arts, in fact, represent the largest single component of consumed information, almost all of which is made up of copyrighted materials.

Extension and development of copyright and neighboring rights are a dynamic process that accelerates with technologies that provide new ways to fix the product of human creativity in

material form and that, in turn, create new ways to pirate such products. Communications conglomerates, such as Ted Turner's CNN, have discovered that libraries of older films and television programs represent a capital asset worth millions of dollars in the form of videos, pay television, and syndication on ordinary television stations. Copyright piracy of old and new materials has become a multimillion-dollar crime of international proportions. In addition, the interface between copyright and home taping for personal use is a news item almost daily. In both the United States and Canada, the question of imposing a tax or royalty on blank audio and video recording tape and equipment is before the legislature.[27] If such a charge is imposed, the question arises: Who should benefit—creative artists or communications conglomerates?

Some argue that the traditional arts cannot be adapted to the new technologies. Others argue that the fine arts must adjust, adapt, and evolve with the new technologies if they are to survive as living art forms. Gordon Tullock, in his long-running debate with William Baumol, argues:

> Both of us would agree that a new technology is in the process of replacing an old one. The new technology is not only cheaper, it has technical superiorities; but does not involve "live" performances. I would simply say that, although the advent of television and motion pictures has had a "cataclysmic" effect on live performances, it has massively expanded the amount of "theatre" consumed by the average citizen.[28]

From the revisionist perspective, new technologies that foster and promote media extension of the fine arts are a natural and desirable development. While overt disruption of the live arts should be avoided, the new technologies must be embraced if there is to be a future for the performing arts.

A synthesis is emerging, however, that recognizes that the new technologies can be used to educate and stimulate the general public to consume "live" art. In a sense, media extension represents a new form of touring the fine arts. A single opera broadcast reaches more viewers than the entire live audience who has ever seen it on stage. That such media extension acts as a stimulus to consumption of live art has been evident for many years in classical music, where rising record sales have been matched by increased attendance at live concerts. Furthermore, experimental film, video, and integrated media art—i.e., combinations of new technologies in creative and artistic ways—have demonstrated that, like the printing press and the motion picture, they are new art forms with a distinctive "aesthetic."

Employment and the Arts

In macroeconomic theory, there are three types of unemployment. First, frictional unemployment is of short duration. It results from movement of new entrants and reentrants into the labor force and from the movement of workers between jobs. Second, seasonal unemployment results from variations in economic activity that take place regularly within the period of a single year. Finally, structural unemployment is of long duration. It results from structural change in the demand for labor and, for such unemployment to be reduced, requires some form of transformation of the labor force.

Since the recessions of the late 1970s and the early 1980s, most Western countries have experienced a significant increase in unemployment, most of which is structural in nature. This section explores the impact of the arts on employment, with particular emphasis on structural unemployment. Taken into consideration are total arts-related employment, the arts labor force, the arts industry labor force, artists, and the dollar efficiency of arts-related employment compared with that of manufacturing.

In Canada, arts employment data do not permit a distinction between fine arts and commercial arts employment. Furthermore, arts-related workers cross back and forth. Accordingly, total arts-related employment will be reported. There are two distinct arts-related employment populations. Together they include 414,000 workers or 4 percent of the Canadian labor force in 1981.[29] In fact, arts-related employment in Canada is as large as the agricultural labor force or federal government employment, including crown corporations. Assuming the 1:10 relationship between Canada and the United States, American employment figures would be 10 times higher.

The first group is the arts labor force, made up of workers who use arts-related skills in their day-to-day jobs as artists and arts technicians; they include curators, librarians, and camera operators. There are at least 278 arts-related occupations.[30] Between 1971 and 1981, the arts labor force increased 74 percent, compared with 39 percent for the Canadian labor force as a whole.[31]

The second group is the arts industry labor force, made up of workers employed in arts industries such as advertising, publishing, motion pictures, live staged events, fine arts schools, and libraries. Only 35 percent of the arts labor force are employed in the arts industry.[32] The rest of the arts labor force works in other parts of the economy—e.g., product designers employed in manufacturing industries and window designers employed in the retail trade industries. Thus, the arts labor force is similar to scientific

and technical professions in that arts-related skills are distributed throughout the economy, not just in the arts industry.

Between 1971 and 1981, the arts industry labor force increased 58 percent and grew to 2 percent of the total labor force. Of this total, 52 percent were men and 48 percent were women, compared with 60 percent men and 40 percent women in the total labor force.

In the airline industry, a large number of ground personnel are required to keep an airplane flying. Similarly, in the arts industry, a large number of technical and administrative personnel are needed to keep artists on stage, in front of the camera, in print, or in galleries. In fact, artists made up only 24 percent of the arts industry labor force; other arts-related occupations such as librarians, camera persons and projectionists, 18 percent; arts administrators, 8 percent; and support personnel, 50 percent.

Between 1971 and 1981, the number of Canadian artists increased 102 percent.[33] By contrast, the number of artists in the United States grew only 51 percent between 1970 and 1980.[34] The number of Canadian artists, in fact, rose more than two-and-a-half times faster, in relative terms, than the total Canadian labor force. Artists increased from 0.8 percent in 1971 to 1.1 percent of the labor force in 1981.

In 1981, only 41 percent of artists actually worked in the arts industry. The remainder were employed in other sectors of the economy. Only in the performing arts occupations did the majority of artists (73 percent) work in the arts industry. The majority of fine and commercial artists (81 percent) and writers (56 percent) were employed in other sectors of the economy.[35]

Two distinct groups of artists are found working in Canada. The first is self-employed artists. The second is artists who are employees. According to Revenue Canada, the number of self-employed artists increased 70 percent to 16,600 between 1974 and 1982, or at an average annual rate of 6.2 percent. Average income of self-employed artists, measured in constant 1971 dollars, fell, however, from $4,835 in 1974 to $4,041 in 1982. Artists were second only to pensioners as the lowest paid occupation recognized by Revenue Canada.[36]

Approximately 108,000 fine and commercial artists worked as employees. The artist as employee was, however, as financially distressed as the self-employed artist. On average, no artistic profession such as dancer, musician, or actor enjoyed a working season of sufficient length or with sufficient salary to support a family of four above the poverty line.[37]

The fine arts are an extremely "employment-efficient" sector of the economy. A 1982 comparison between all manufacturing industries and the performing arts reveals that of every revenue dollar earned by manufacturing companies only 20 cents was

spent on salaries and wages. In the performing arts, on the other hand, 66 cents of every revenue dollar was spent on salaries and wages.[38] Given that average wages in the arts are less than half those in manufacturing, the employment advantage of the arts is at least *six to one.*

There are three other significant characteristics of artistic employment. First, artistic jobs provide "meaningful employment" in that workers receive a high degree of job satisfaction. Artistic workers also exhibit strong career commitment despite an average income second only to pensioners as the lowest paid occupational category.

Second, employment in other sectors of the economy depends on depreciating physical capital. Employment in the arts, on the other hand, depends on the "appreciation" of human capital and the increasing excellence of Canadian artistic production. Appreciation of cultural capital is reflected in the international success of Canadian artistic enterprises such as the Stratford Festival, the Royal Winnipeg Ballet, and the Montreal Symphony. Such enterprises take as many as 10 years to mature to "world-class" status but can collapse in a single season.[39] Similarly, the "maturation" of creative or interpretative artists such as Alex Colville, Maureen Forrester, and Karen Kain generally takes decades of practice for them to reach world-class status.

Third, professional artists are highly educated. They are an important part of a country's stock of highly qualified person-power and contribute to the evolution of a cultural heritage to be shared by generations to come. Highly qualified personnel combined with employment intensity suggests that support to the fine arts can be a cost-effective employment strategy complementary to a high-technology industrial strategy that, by its very nature, leads to declining employment in traditional sectors of the economy.

Government and the Arts

Excluding monetary policy, government uses tax revenues and deficit borrowings to secure: (a) adjustment in the allocation or provision of resources, goods, and services; (b) adjustment in the distribution of income and wealth; and (c) attainment of economic objectives such as growth, stabilization, and employment.[40]

The arts have an economic impact on government's macroeconomic policies in many ways. First, the fine arts generate positive social externalities, and, therefore, public support represents a re-

allocation of resources toward a meritorious activity. Next, artists are second only to pensioners as the lowest paid occupational group, and, thus, government support represents redistribution of income towards an economically deprived group. Third, the arts contribute to advances in aesthetic design, and, hence, public support contributes to economic growth. Fourth, the arts industry is relatively recession proof, and, therefore, public support contributes to stabilization. Fifth, the arts are an employment-efficient sector, and, thus, government support increases employment.

In pursuing its macroeconomic objectives, the state can play four alternative roles in support to the arts—facilitator, patron, architect, and engineer.[41] Furthermore, the state can have two different objectives—to support the process of creativity[42] or to support production of specific types of art such as socialist realism.[43] Roles and objectives are not mutually exclusive; a single government may play more than one role and may seek to achieve more than one objective.

For purposes of demonstration, the next part examines the four roles as pure types with respect to the mechanism of funding, policy objectives, standards, and dynamics as well as the economic status of artists and artistic enterprises.

The *facilitator state* funds the fine arts by tax expenditures made on behalf of individual and corporate donors; i.e., donations are tax deductible. The policy objective of the facilitator is to promote diversity of activity in the nonprofit amateur and fine arts. The facilitator supports the process of creativity rather than specific types or styles of art. Furthermore, the facilitator does not support specific standards of art but rather relies on the preferences and tastes of corporate, foundation, and individual donors. The policy dynamics of the facilitator state are random in that changes in support to the fine arts reflect the changing tastes of private donors. The economic status of the fine artist and the artistic enterprise depends on box office appeal and the tastes and financial condition of private patrons.

The strength of the facilitator lies in the diversity of funding sources it creates. Individuals, corporations, and foundations choose which art, artists, and arts organizations to support. The facilitator role also has weaknesses. First, standards of excellence are not necessarily supported, and the state has no ability to target activities of national importance. Second, difficulties occur with respect to the evaluation of private donations in kind—e.g., paintings donated to a museum or art gallery. Third, public support of some arts activities may be of questionable benefit to the particular state and its people; it has been suggested, for example, that reconstruction of Versailles was funded through tax-exempt contributions of American taxpayers.

16

The *patron state* funds the fine arts through arm's-length arts agencies. The government determines how much aggregate support to provide, but not which organizations or artists should receive support. The council is composed of a board of trustees appointed by the government. Having been appointed by the government of the day, trustees are expected to fulfill their grant-giving duties independently of the day-to-day interests of the party in power, much like the trustees of a blind trust. The agency generally makes granting decisions on the advice of professional artists working through a system of peer evaluation.

The arts agency supports the process of creativity, but with the objective of promoting standards of professional artistic excellence. The policy dynamic of the patron state tends to be evolutionary and responds to changing forms and styles of art as expressed by the artistic community. The economic status of the artist and the artistic enterprise depends on a combination of box office appeal, the taste and preferences of private donors, as well as grants received from arm's-length arts agencies.

The very strength of the arm's-length arts agency may be its principal weakness. Fostering artistic excellence often is perceived as promoting elitism, both with respect to type of art work produced and audience served. Support of artistic excellence, thus, may result in art that is not accessible to, or appreciated by, the general public or by their democratically elected representatives. In most patron states, there are recurring controversies in which politicians, reflecting popular opinion, express anger and outrage at support given to activities that are, for example, perceived as politically unacceptable, pornographic, or appealing only to a wealthy minority. With an arm's-length format, however, politicians can claim neither credit for artistic success nor responsibility for failure.

The *architect state* funds the fine arts through a ministry or department of culture. Granting decisions concerning artists and arts organizations are made by bureaucrats. The architect tends to support the arts as part of its social welfare objectives. It also tends to support art that meets community rather than professional standards of artistic excellence. The policy dynamic of the architect is usually revolutionary. Inertia results from the entrenchment of community standards developed at a particular point, leading to stagnation of contemporary creativity, as recently observed in France.[44]

The economic status of artists in the architect state often is determined by membership in official artists' unions. Once an artist gains membership in such a union, he or she becomes, in effect, a civil servant and enjoys some form of income security.

The economic status of artistic enterprise is determined almost exclusively by direct government funding. The box office and private donations play a negligible role in determining artists' financial status. Artistic enterprise generally remains autonomous of government, however, with respect to artistic choice.

The strength of the architect role lies in the fact that artists and arts organizations are relieved from dependency on popular success at the box office and experience an "affluence" gap.[45] The status of the artist is explicitly recognized as well in social assistance policies.[46] The weakness of the architect is that long-term, guaranteed direct funding can result in creative stagnation.

The *engineer state* owns all the means of artistic production. The engineer supports only art that meets political standards of excellence; it does not support the process of creativity. Funding decisions are made by political commissars and are intended to further political education, not artistic excellence. The policy dynamic of the engineer state tends to be revisionary; artistic decisions must be revised to reflect the changing official party line. The economic status of the artists is determined by membership in official party-approved artists' unions. Anyone who does not belong to such a union is, by definition, not an artist. All artistic enterprises are state owned and operated; i.e., all artistic means of production belong to the state.

The engineer role is attractive to a "totalist" regime because it focuses the creative energies of artists toward attaining official political goals. Many Western governments, however, also find the engineer role attractive in constructing a commercially viable arts industry in which the profit motive, or "capitalist realism," plays an ideological role analogous to "socialist realism." In the West, this role can be summed up as "if it does not pay, kill it."

There are several weaknesses with the engineer role. First, art is subservient to political or commercial objectives. Second, the creative energy of artists cannot be completely channelled. Repressed artistic ambition results in an "underground" subversive of party aesthetics or capitalist values—e.g., the "counterculture."[47] Often, counterintuitive results are associated with the engineer role. With respect to the Soviet Union, for example, the works of the czarist period receive critical acclaim in the West, not the works of socialist realism. With respect to Western art, the popular cultural products, e.g., Hollywood movies and rock music, are eagerly sought after within socialist and communist countries, not the works of socialist realism.

While roles are mutually exclusive in theory, in practice most nations combine some or all of them. A few examples will demonstrate. In the United States, the National Endowment for the Arts (the facilitator) complements tax expenditures with grants to arts

organizations, thus playing a patron role. In Great Britain, the Office of Arts and Libraries complements the patron role of the Arts Council of Great Britain by providing direct grants to selected arts and cultural facilities. In France, the architect role of the state is complemented by tax expenditures in support to charitable donations to the arts; i.e., the state plays a facilitator role.

Impact Studies: Who Needs Them?

The arts, then, are present throughout the economy. The impact of the arts, therefore, ought to be of considerable interest to private sector, philanthropic, and public decision makers, both in determining the direct economic effects of the arts and in managing those effects, in so far as desirable, to expand and extend benefits from the arts.

Private Sector

The private sector needs to determine the economic impact of the arts for at least four reasons. First, the cultural consumer represents the fastest growing, richest market of the postmodern economy. Second, the commercial arts depend on the fine arts for their research and development—new scripts, scores, talent, and technique. Third, the private sector relies upon advertising to market and sell its products. In fact, advertising can be considered the application of the literary, media, performing, and visual arts to sell goods and services. Fourth, all consumer goods industries have an increasing need for improved product design in order to compete in the emerging "narrowcast" marketplace.

Consumption in macroeconomics refers to the use by consumers of goods and services in the satisfaction of human wants. This section considers the role of the arts in consumption measured by personal expenditures on cultural goods and services, the size and nature of the arts audience, the participation of citizens in arts-related leisure activities, and the role of the arts in marketing and product design.

In 1983, Canadians spent $6.4 billion, out of pocket, on arts-related activities, including movies and other commercial cultural activities; museums; art galleries; live dance; music; theatre; opera; and private tuition for painting, music, dance, and other classes.[48] Personal cultural expenditures accounted for 1.6 percent of the gross national expenditure, or $220 per capita. Personal expenditures, by definition, exclude more than $2 billion in gov-

ernment and corporate grants and donations to cultural activities. Assuming the traditional 1:10 relationship between economic activity in Canada and the United States, Americans spend at least $64 billion a year on arts-related activities.

Studies conducted around the world demonstrate that the fine arts audience has high levels of education and, hence, high average incomes.[49] A proxy for the size of the arts audience is the number of adult Canadians 15 years and over who have at least some post-secondary education. Between 1961 and 1985, the fine arts audience grew from 12 percent to 31 percent of all adult Canadians. Between 1985 and the year 2000, the fine arts audience will grow to 38 percent of the adult population. Growth in the arts audience among the labor force—taxpayers—is forecasted to grow even faster. Between 1977 and the year 2000, the fine arts audience will double in absolute numbers from 3,355,000 or 32 percent to 6,657,000 or 45 percent of the Canadian labor force.[50]

Next to education, sex is the most important indicator of arts participation. Overall, women make up 60 percent of the audience in Canada and the United States, compared with 50 percent in Europe. In dance, women make up as much as 85 percent of the audience. Furthermore, in the arts industry, women play a leading role in the creation of arts institutions, unlike other sectors of the economy.[51]

According to the 1981 Canadian census, women represented 40 percent of the total labor force, but 48 percent of the arts industry labor force. Furthermore, only 48 percent of all women in the labor force had some postsecondary education, compared with 65 percent of women employed in the arts industry. Similarly, only 1 percent of females in the labor force had master's degrees, but 11 percent of all women with master's degrees were employed in arts-related occupations.

After education and sex, age is the next most important indicator of participation in arts-related activities. Assuming that mandatory retirement is rescinded, then the financial status of senior citizens will increase as will their ability to participate in the arts. Thus, impact of the arts on consumption extends beyond young, highly educated or female consumers to the mental and physical health needs and costs of an aging population:

> Another important—and tragic—example of our economy's failure to provide adequate stimulation to the unskilled consumer is the problem of the aged. When people retire they are suddenly deprived of the stimulus satisfaction their work has given them, and, naturally, they try to fall back on the other sources of stimulation accessible to them. If they are unskilled consumers, they soon find

their sources of stimulation inadequate; the result is the heartrending spectacle of elderly people trying desperately to keep themselves busy and amused but not knowing how to do so. Boredom seems inescapable, and boredom is a great killer. That may well be part of the explanation of the male's relatively low life expectancy. Women are better off in this regard, for they have housework and cooking to keep them occupied and alive.

The remedy is culture. We must acquire the consumption skills that will give us access to society's accumulated stock of past novelty and so enable us to supplement at will and almost without limit the currently available flow of novelty. . . . Music, painting, literature, and history are the obvious examples.[52]

Furthermore, if the work week continues to decline over the next decade, there also will be increasing leisure for the labor force as a whole. A comparative indication of the growing economic impact of the arts on consumption is participation rates in alternative leisure-time activities. Between 1977 and 1985, the adult population grew at an average annual rate of 1.6 percent. Participation in arts-related activities rose significantly faster than other leisure activities. Attendance at museums and art galleries grew at an average annual rate of 2.6 percent, use of libraries at 2.4 percent, and attendance at live theatre at an average annual rate of 2.1 percent. Attendance at sports events increased at an average annual rate of 1.3 percent and television viewing at 1.4 percent.[53]

Compared with manufacturing industries, the arts industry in Canada is the largest employer, the sixth largest with respect to salaries and wages, and the ninth largest with respect to revenue.[54] Within the industry, the commercial arts increasingly rely on the nonprofit fine arts for research and development of talent, technique, and copyright properties. This contention is supported by the fact that of 16 major industries only entertainment has no reported research and development expenditure as percent of income.[55] For example, it is from the nonprofit regional theatre that the commercial Broadway and West End London theatre is deriving more and more of its new product. The process goes something like this: A new nonprofit production receives critical and audience acclaim in the regions and then moves to Broadway, where if the production again attains acclaim, it then moves to Hollywood to be produced as a motion picture.

A similar pattern has developed in the music industry, where large multinational communications conglomerates dominate the

distribution system but rely on small, entrepreneurial firms to discover and develop talent:

> The deliberate creation of a group with a sound and performing style dictated by market research data (such as the Monkees, a television-based American derivative of the Beatles back in the 1960s) has never been more than partly successful. Rock music can be messy to manage.

> Holding the artist's hand is often best done by a small company: performers generally want access to the top man. For this reason, the conglomerates tend to devolve record production to subsidiary "labels" or to small independents for which they supply marketing, distribution and often finance.[56]

The commercial arts rely on the nonprofit fine arts not only for copyright properties such as scripts, but also on artistic talent and technique developed in all the fine arts. In the case of Great Britain, this interrelationship increasingly is being recognized:

> The reason why so many BBC and ITV drama series have sold well abroad is because British television directors have so much expertise, derived from the [nonprofit] theatre, on which they can draw. Indeed the health of our future export trade in television films largely depends on the buoyancy of our theatre.[57]

It generally is forgotten that the most visible and pervasive application of the arts in the economy is advertising, particularly advertising of consumer goods. In some cases, advertising and marketing expenditures of major corporations such as Procter and Gamble account for one-third of total costs of undifferentiated consumer products such as soap and shampoo. Actors, dancers, singers, musicians, graphic artists, copy writers, and editors are employed by all major corporations and their advertising agencies.

In this regard, a recent survey by the Institute of Donations and Public Affairs Research indicated that in 1984 the total donations budgets for a sample of 296 corporations was $19 million, but the advertising budget for the same corporations was more than $280 million.[58] How many artists and arts-related professionals were employed because of corporate donations versus corporate advertising? At present, this is not known.

The increasing role of the arts in consumer and market research suggests that there is also a significant impact of the arts on the economic behavior of the consumer:

In its brief history, the study of consumer behavior has evolved from an early emphasis on rational choice . . . to a focus on apparently irrational buying needs . . . to the use of logical flow models of bounded rationality. The latter approach has deepened into what is often called the "information processing model." The information processing model regards the consumer as a logical thinker who solves problems to make purchasing decisions.

Recently, however, researchers have begun to question the hegemony of the information processing perspective on the grounds that it may neglect important consumption phenomena. Ignored phenomena include various playful leisure activities, sensory pleasures, day dreams, esthetic enjoyment and emotional responses. Consumption has begun to be seen as involving a steady flow of fantasies, feelings and fun encompassed by what we call the "experiential view." This experiential perspective is phenomenological in spirit and regards consumption as a primarily subjective state of consciousness with a variety of symbolic meanings, hedonic responses, and esthetic criteria.[59]

Even the marketing motifs and styles adopted by commercial advertisers often originate in the nonprofit fine arts:

The essential values of the public are most clearly evident, and in some instances only, in the arts—in music, the drama and the dance, in architecture and design and in the literature of the times. It is through knowledge of people's values that corporate marketers know what goods and services to provide and how to motivate consumers to buy their products.[60]

The fine arts also play an increasingly direct role in the marketing strategies of corporations. The "upscale" nature of the arts audience—i.e., high levels of education and income—is an attractive market for many corporations. Corporations increasingly sponsor fine arts activities not as charity but as a major marketing technique. In this regard, an Institute of Donations and Public Affairs Research survey of 293 Canadian corporations indicated that 139 corporations sponsored sports events in 1984, while 171 corporations sponsored arts-related activities.[61]

Sponsorship reflects the correspondence of a corporate target market and the arts audience. Sponsorships are made from public relations, not from donations budgets. Problems have been re-

ported. Specifically, the control required by commercial sponsors to ensure that public relations objectives are achieved may clash, from time to time, with the artistic objectives of an arts organization. No dollar figures are available concerning the scale of corporate sponsorship of arts-related events and activities.

Finally, the emergence of the "narrowcast" market as opposed to the "mass market" is one of the most significant marketing developments of the 1970s and 1980s. The growth of numerically small but economically viable markets has resulted from an unprecedented average level of education, an unparalleled division and specialization of labor, an unrivaled degree of urbanization, and a "third wave" of technological change:

> The industrial revolution produced standardization throughout society, the third wave (the emerging era of computers and instant communications) will reverse the process. . . . There is a rising level of diversity, a "de-massification" of the marketplace with more sizes, models and styles, a de-massification of tastes, political views and values.[62]

Implications of these changes were driven home by recent recessions:

> With [their] stranglehold on consumer spending, companies were forced into trying to understand what made the domestic market tick. They soon discovered that demographic and lifestyle changes had delivered a death blow to mass marketing and brand loyalty. A nation that once shared homogeneous buying tastes had splintered into many different consumer groups—each with special needs and interests.[63]

The arts are the historical leitmotif for this general market trend toward differentiation in consumer taste. Examples of highly differentiated taste in the fine arts are reflected in styles of painting such as impressionist versus realist versus abstract versus conceptual versus minimalist. Producers can and are learning from the experience of the fine arts in dealing with highly differentiated and educated consumer tastes.

In First World economies, the emergence of this narrowcast economy is popularly identified with the "Yuppies"—young, upwardly mobile professionals. This group of consumers is attracting the attention of both producers and politicians.[64] In essence, the Yuppie is a consumer with a high level of education and income who demands high-quality, sophisticated goods and services.

A proxy for the upscale Yuppie market is the number of citizens with some postsecondary education. In 1977, 32 percent of the Canadian labor force had some postsecondary education. By 1985, this segment of the labor force grew to 38 percent. By the year 2000, 45 percent of the labor force will have at least some postsecondary education.[65]

In both the United States and Canada, higher quality consumer products tend to come from abroad, particularly from Europe. Why? Given that capital plants and equipment in North America are as good as those in Europe, the answer is not superior European production technology. In fact, it results from a feedback between skilled consumption and production. The North American

> buyer of European imports benefits from the high standards which careful European shoppers' finicky demand imposes on their producers; he does not have to be a careful shopper himself. In other words, he can be what is known as a free rider, enjoying the benefits of other people's careful shopping without paying his share of the cost, in terms of time and effort, that careful and aggressive shopping involves. That explains why producers find it unprofitable to cater to his demand by trying to out-compete high-quality imports, despite the often exorbitant price they fetch. Consumers seem willing to pay a high price, in terms of money, for the *reputation* of European imports; that is we pay cash to obtain high quality without having to pay for it in terms of careful shopping.[66]

When the design advantage of European producers (and increasingly that of Japanese producers of consumer electronics) is combined with the wage advantage of offshore or Third World producers, then the North American producer is left with a narrowing mid-range market. This combination of design and wage disadvantages may explain the apparent "de-industrialization" of North America. Improved productivity through robotics and other new technologies may lower costs of production, but only improved design will secure for North American producers part of the growing domestic and world Yuppie market.

There are now indications that a major change toward enhanced design is underway by major North American corporations such as SCM, Teledyne, Black & Decker, and J. C. Penney. This change relects a "bottom-line" awareness that

> if a consumer doesn't like the way a product looks, he or she may never get close enough to find out how well it performs, and there's no chance at all for a sale. Marketers'

growing awareness of that basic principle is resulting in increased recognition of the importance of industrial design and the role it plays in helping companies meet sales and marketing goals. Thus, more and more marketers are enlisting the aid of design consulting companies and are even setting up their own in-house design departments.[67]

Design skills and techniques evolve from the arts. If the economic impact of the arts is not studied and understood, then North American manufacturers will suffer in the narrowcast marketplace, as they have since the end of the 1960s.

Philanthropic Sector

Economists have underestimated severely the importance of the philanthropic, voluntary, or not-for-profit sector. Partially, this results from economists' tendency to assign production of collective goods to government, which has the power to compel payment and thereby overcome the free-rider problem and correct private market allocative inefficiency. It also reflects the progressive displacement of traditional philanthropic activity by the welfare state:

> One problem with this perspective on collective goods is that it views the economy as having only two sectors. All goods, collective and private, are seen implicitly as being provided either in a private for-profit sector or in a public sector. From this perspective it follows that if the private for-profit market fails to allocate resources efficiently to collective goods, then there is only one potential collective agent, government.
>
> Such a view is seriously incomplete. First, the ability of governmental institutions to correct private market failures is limited. Lack of information about consumer demands confronts governmental as well as private decisionmakers. Moreover, incentives facing government decisionmakers rarely coincide with what is required to correct the private markets' failures. . . .
>
> A second inadequacy of the prevailing economic theoretic reliance on government is the lack of recognition of a third sector, the nongovernmental, not-for-profit sector—which we term "voluntary nonprofit". . . . There are, in short, more possibilities for collective-goods provision than in the for-profit or the governmental sectors. In addition, when it is recognized that a collective good is collective for only

some people—in the sense that the good enters positively the utility function of only those persons—the potential for organizing collective-good activity outside of government, in voluntary nonprofit organizations, appears more likely.[68]

This section examines the reasons why the economic impact of the arts should be of concern to the academic, business, education, and health segments of the philanthropic sector. The examination will be suggestive rather than definitive. The arts also affect many other segments of the philanthropic sector. Empirical research, however, will be required to estimate the value, in human and dollar terms, of the impact of the arts on the philanthropic sector.

Economic impact studies of the arts are required in the academic community for two reasons. First, the universities and colleges are a major focus for both the training of arts-related professionals and the production of arts activities.[69] The number and value of arts facilities on campus represent a significant national capital asset, but no comprehensive studies have been conducted to estimate the economic importance, both costs and benefits, of arts activities in the academic community.

Second, within the academic community, particularly within departments of economics, there is a need for comprehensive economic impact assessment of the arts. Such studies must embrace both microeconomic and macroeconomic impact in order to demonstrate the intellectual legitimacy and significance of cultural economics. Such studies are essential if cultural economists are to compete effectively with other areas of economic research for resources including money, talents, and time.

At present, no formal recognition of cultural economics exists within the university community. Most universities deal with arts research either from the perspective of leisure studies in the context of recreology or from the perspective of urban studies in the context of amenities theories. No department of economics offers a program of study concerning cultural economics as a subdiscipline.

This partially reflects the effect of certain traditional economic assumptions that have limited intellectual interest in the arts. Specifically, traditional economics has treated the consumer as a psychological "black box." The consumer is assumed to be rational in that he or she consciously tries to make the best out of a given situation. Advertising is assumed to have no manipulative power, only information value. Consumer taste is assumed to be a given. No allowance is made for "acquired tastes":

The emphasis on learning is perhaps the crucial difference between mechanistic economics and cultural economics. Mechanistic economics tends to take preferences and even skills and techniques for granted, as the data or ultimate determinants of the economic process. Cultural economics must look upon both preferences, skills, and techniques as essentially learned in the great process of cultural transmission.[70]

The private sector plays an important role in philanthropy. According to the Institute for Public Donations and Research, corporate cultural donations increased from $3.2 million in 1972 to $8.8 million in 1983, or 11 percent of total corporate donations to all charitable activities.[71] This is roughly the same share of corporate philanthropy as in the United States.[72] In constant 1971 dollars, however, corporate support to the arts in Canada was $3 million in 1972 and only $2.5 million in 1983. This decline in the real level of corporate support to the arts in Canada is not apparent in the United States, possibly because of the longer, more firmly established tradition of corporate giving.

The unstable nature of corporate patronage in Canada reflects, among other factors, "money illusion," an illusion that also plagues support from the public sector. Real support, measured in constant dollars, declines, while the nominal current dollar value of patronage may increase.[73]

Corporate patrons also suffer from the "St. Matthew Syndrome"— i.e., to those who have shall be given.[74] Corporate patrons, at least in Canada, tend to be cautious and conservative. They tend not to support controversial productions or innovative art forms. This is reflected by private patronage of Canadian theatre, a highly visible, articulate, and sometimes controversial art form. In 1982, private patronage represented only 10 percent of total theatre company expenditure, compared with 14 percent in dance, 17 percent in opera, and 18 percent in music.[75]

Beyond traditional arguments concerning the intrinsic value of the arts, the arts have an impact on education in at least two related ways. First, education in the arts affects industrial invention, innovation, and diffusion of new technologies by reinforcing the creative process of managers and workers, thereby encouraging an innovative institutional climate. Many observers have recognized that psychology of the creative process is an area of commonality between the arts and sciences.[76] In both, creativity occurs when an individual steps beyond traditional ways of knowing and doing and making:

We have come to recognize the processes which bring about creative advances in science, the new paradigms

as processes of human design, comparable to artistic creation rather than logical induction or deduction which work so well within a valid paradigm. . . . The norms of artistic design [are] "inherent in the specific psychic process, by which a work of art is represented" and thus in the creative act, not in the created object—in the process not the structure.[77]

The origins of creativity in the sciences and the fine arts have an empirical basis in neurophysiology. Recent research in brain physiology suggests that the creative process is rooted in the lateralization of brain function:

Whereas the left hemisphere is primarily responsible for traditional cognitive activities relying on verbal information, symbolic representation, sequential analysis, and on the ability to be conscious and report what is going on, the right brain—without the individual being able to report verbally about it—is more concerned with pictoral, geometric, timeless and nonverbal information.[78]

Such research suggests that it is in the right lobe that those flashes of insight and intuition that lead to what is commonly known as invention take place. The arts, the most developed right-lobe function of contemporary society, serve to balance what to many observers is the overdevelopment of left-lobe functions within Western society:

I welcome the recent findings of brain science to support the common experience that we have two "styles of cognition," the one sensitive to causal, the other to contextual significance. I have no doubt that the cultural phase—which is now closing—restricted our concept of human reason by identifying it with the rational, and ignoring the intuitive function, and thus failing to develop an epistemology which we badly need, and which is within our reach—if we can overcome our cultural inhibitions.[79]

The arts, therefore, play a crucial role in the emergence of what Marshall McLuhan called the "electronic man":

In terms of our education, the entire establishment has been built on the assumptions of the left hemisphere and of visual space. This establishment does little to help in the transition to the electronic phase of simul-

taneous or acoustic man. Our education procedures are still oriented towards preparing people to cope with specific industrial products and distribution of same. Electronic man, on the other hand, is in need of training in ESP and empathy and intuition. Logic is replaced by analogy, and communications are being superseded by pattern recognition.[80]

Second, since the introduction of universal education in the last century, training in production skills has progressively crowded out education in the arts and humanities, the traditional source of what can be called "consumption skills." This crowding out partially reflects the Puritan and republican traditions of North America in contrast to the Catholic and aristocratic traditions of Europe.[81] It also reflects an initial need, in the 19th to mid-20th centuries, to develop repetitive industrial skills among a relatively uneducated, rural work force. In the late 20th century, this is no longer the case. The new production skills of the emerging postmodern economy tend to be nonrepetitive, adaptive, and judgmental, characteristic of traditional consumption skills developed through training in the arts and humanities. No studies have been undertaken yet to determine the economic impact of training in the arts with respect to improved production skills in the postmodern economy.

In summary, education through the arts fosters and promotes a psychological and social climate in which industrial invention, innovation, and diffusion of new technologies can occur more readily. The arts sensitize entrepreneurs, managers, and employees to the context of change and enhance their ability to respond to change in a positive and constructive manner. The need to increase the innovative capacity of the economy has been recognized as critical to future economic growth and development:[82]

With respect to the health care system, the relationship between the arts and medicine is very ancient indeed:

> Asklepios, the Greek god of health, was worshiped in temples, to which patients repaired to be cured. In the medical wards of these temples, beautiful votive reliefs are found, thanks offerings for received cures. In this connection, attention must be drawn to a series of frescoes made by Domenico de Bartolo in the 15th century in the hospital of Santa Maria della Scala in Siena, or to the paintings of Mathias Grenwald in the former monastery of Isenheim, where the painter also worked as male nurse.

These examples of famous works of art illustrate the close relations among religion, art, and medicine. The most famous physician of all times, Hippocrates, said "Life is short, and art is long." Today, religion is not all-important as it was formerly, but the link between art and medicine is still important.[83]

Within the last half-century, the use of the arts for medical and rehabilitative purposes has been formalized in virtually every artistic discipline, including dance, music, theatre, and the visual arts. Academic programs, certification procedures, professional organizations, and international associations of art therapists have evolved;[84] and national and international systems for the classification of occupations identify arts therapy as a distinct profession.[85]

The role of the arts in health care involves both healing in the sense of facilitating recovery from illness and rehabilitation in the sense of improving physical function:

> The term "healing" implies illness as well as the implication that something can be "cured." In many human service settings, this is not often the case, for example, among terminally ill cancer patients, inmates of prisons, the physically handicapped, and those who are economically or socially disadvantaged or isolated. However . . . such people are in "crisis," are "troubled," and are suffering psychologically and emotionally by virtue of their circumstances. For such people, "healing" is synonymous with "improvement," with the overcoming of psychological and emotional barriers within the individual and with others. . . . The art therapist goes still a step further to sharply "focus" the energies of the arts to help "dissolve" the barriers to improved function.[86]

Within the health care system, the arts play a formal therapeutic role that has significant economic implications, particularly in light of rapidly escalating health care costs. No one, however, has investigated empirically the impact of art therapy in reducing health care costs and the cost-effectiveness of such therapy compared with alternative treatment techniques. In view of the aging demographic profile of the population, as well as associated increases in future health care costs, the therapeutic use of the arts probably will rise dramatically in the next few decades.

Public Sector

It can be demonstrated that the arts have an economic effect on four levels of public sector activity—international, national, regional, and local. At the international and national levels, the impact is mainly macroeconomic and influences international relations, trade, and competitiveness. At the regional and local levels, the impact tends to be microeconomic and influences regional and local development policies. Subsequent chapters discuss the microeconomic impact of the arts at the regional and local levels. This section explores why the economic impact of the arts should be of concern to public sector decision makers at international and national levels.

The arts increasingly influence international affairs in three ways. First, the arts are recognized as part of "alternative diplomacy," a preferred instrument of geopolitical competition.[87] Such forms of competition are not covered by the terms of the General Agreement of Tariffs and Trade (GATT). Many nations, including the United States through the U.S. Information Agency, actively use the arts in international affairs. At least among First World countries, where once soldiers fought and died, now a nation's actors, dancers, designers, film makers, musicians, sculptors, writers, and business representatives practice their art and compete for rights, manufacturing privileges, and international acclaim:

> Upon this ever-shrinking globe all societies and all cultures are involved in an inevitable struggle for pre-eminence and survival. Those who shape tomorrow's world will be those who can project their image in order to exercise a dominating influence and long-range control. If we wish our values and style to triumph, we are forced to compete with other cultures and other centres of power.[88]

Second, the role of the arts in international relations is taking on a new dimension with the rapid spread of the new communications technologies and emerging issue of transborder data flows (TBDF) created by technologies such as direct broadcast satellites.[89] As a noted Canadian artist has said:

> TBDF is not a new concept. Every time a book or a newspaper or a telegram is sent from Canada to the U.S., or vice versa, that's Canadian-American TBDF. Phone calls, radio and television programming, exchange of video and audio cassettes, high speed digital communications—all terrestrial or satellite communications between nations

32

make up the data exchange described as TBDF. As you might imagine, being that Canada is a relatively small country with a very sophisticated communications system, we import far more data than we export.[90]

Media extension of the traditional fine arts as well as the experimental media arts such as computer art[91] play an ever-increasing role in TBDF. New videotext technologies, for example, could make traditional exports of books and periodicals obsolete and open domestic markets to an electronic flood of foreign works.[92] To compete with other nations for "name" recognition in world markets, the public sector must subsidize fine arts TBDF, particularly given the growing importance of the home entertainment center.

Third, as can be shown through the histories of Poland and Ireland, the arts and culture are increasingly recognized as an effective defense against military aggression:

> Alexandre Zinoviev . . . has issued a useful warning to nations fascinated by the marvels of Orwellian organization. He believes that the best weapon against invasion is the specific culture of each country; even if a nation's army were destroyed, its cohesive force would remain. Furthermore, the general trend is towards disintegration . . . rather than integration (the absorption of one country by another). The specific cultural development of the "small sisters" is hence the only effective check against the hegemony of the "big brothers."[93]

At the national level, the arts affect three major national policies—trade, research and development, and employment. First, the fine arts serve to define national standards of excellence in world markets and to project these standards abroad.[94] Projection of national standards through the fine arts improves the image and competitive position of other domestically produced goods and services—i.e., trade follows the arts and not the gunboat in a postindustrial society. This role for cultural diplomacy has been explicitly recognized by France, West Germany, Japan, Canada, and Australia.[95] In the case of Canada:

> In the past three years the Montreal Symphony Orchestra, under its conductor Charles Dutoit, has won almost every award worth winning for its recordings, the Toronto Symphony toured Europe to rave reviews, John Gray's *Billy Bishop Goes to War* was a smash hit

at the Edinburgh Festival, and Les Grands Ballet Canadiens triumphed in Latin America.

As a result, business is impressed with the arts. Businessmen on sales missions abroad are aware that our major cultural bodies have, in a sense, paved the way for them. Also, when foreign executives arrive in Toronto, Vancouver, Winnipeg or Montreal, they find facilities and entertainment the equal of those anywhere else in the world.[96]

In a sense, the nonprofit fine arts are a loss leader—a product sold at a loss to encourage the sale of other, more profitable goods and services. Domestically, the arts attract international visitors who purchase accommodations, meals, souvenirs, and other goods and services during their visits. To the extent that these expenditures are directly associated with the fine arts, they can be considered "joint goods"; in order to consume the arts, it is necessary that these other goods and services be purchased. While no empirical studies have been conducted yet, it is probable that cultural tourists spend significantly more per visitor than do other types of tourists such as campers.

In an enlightened community, manufacturers and producers who sell these associated goods and services would compensate the arts. This "cross-subsidization"[97] would equal what other industries would be willing to pay rather than do without the extra business and profits generated by the fine arts. Similarly, artists and arts organizations, when they tour abroad, often facilitate increased export sales because of the good "image" created. Accordingly, exporters, in an enlightened community, also would pay in order to ensure that these additional export sales occur. In practical terms, however, it is virtually impossible for other domestic producers to identify by how much sales have increased due to the activities of the fine arts.

Accordingly, the public sector is called upon to cross-subsidize the fine arts in their role as trade ambassador. No cost/benefit estimate is currently available concerning public sector grants to festivals and the touring of national fine arts abroad. It is possible that national governments recuperate more through taxes from increased foreign sales than they pay out in grants to the fine arts. Empirical research, however, is required to prove or disprove what can be called the enhancement-of-trade argument for public support to the arts at the national level.

The recent exhibition of British treasures in Washington has been described as cultural diplomacy at its most effective:

It induces American tourists—who spent £1 billion in Britain last year—to extend their trip to view the treasures hidden in the British countryside, [and] it will be worth millions of pounds in advertising and public relations. Nor is commerce the only return: "It does the NATO alliance no bad thing" said one of the exhibition's backers, "to be reminded occasionally of the civilization more directly at risk to Russia's SS-20s."[98]

Second, the fine arts are a research and development sector, not just for the arts industry but for the national economy as a whole. In a critical review of arguments favoring government support to the arts and culture, only the research and development argument withstood the test of neo-classical analysis.[99] Four research and development arguments were found to provide theoretical justification for public support to the fine arts:

- First, given that the fine arts provide training and professional development for the commercial arts, but private sector firms cannot be made to pay for such benefits, then the public sector is justified in providing support to the fine arts.
- Second, given that experimental works in the arts, even when they fail, provide valuable knowledge for future creative efforts—i.e., the "right to fail" argument—and given that the positive externalities of such experimental work cannot be effectively captured by private firms, then the public sector is justified in providing support to the fine arts.
- Third, given that the social returns from major artistic innovations, e.g., Art Nouveau or Art Deco, exceed the returns that can be captured by private firms, then public sector support to the fine arts is justified.
- Finally, given that the nonprofit fine arts cannot raise money in capital markets in order to diversify and spread risk, then it is appropriate for government to exercise its risk-pooling capacity through support to the fine arts.

A recent Royal Commission on Canada's economic future reached similar conclusions:

High quality products, technologies, plants, homes, cities and locales require the presence of creative artists of all kinds. To increase the long-run supply of artists in all areas of our national life, as well as their artistic and

35

cultural expression, governments must support the artists and the arts. The long-term return to an investment in artists and the arts is real and substantial. In the absence of strong public support of this sector, Canada will not reap these benefits. Governments at all levels should increase their contribution to their respective arts councils.[100]

Daniel Bell has put the research and development argument even more forcefully when he said:

Today culture has clearly become supreme; what is played out in the imagination of the artist foreshadows, however dimly, the social reality of tomorrow.

Culture has become supreme for two complementary reasons. First, culture has become the most dynamic component of our civilization, outreaching the dynamism of technology itself. There is now in art—as there has increasingly been for the past 100 years—a dominant impulse toward the new and original, a self-conscious search for the future forms and sensations, so that the idea of change and novelty overshadows the dimensions of actual change. And, second, there has come about, in the last 50 years or so, a legitimation of this cultural impulse. Society now accepts this role for the imagination, rather than seeing culture, as in the past, as setting a norm and affirming a moral-philosophic tradition against which the new could be measured and (more often than not) censured. Indeed, society has done more than passively accept innovation, it has provided a market which eagerly gobbles up the new, because it believes it to be superior in value to all older forms. Thus our culture has an unprecedented mission: it is an official, ceaseless search for a new sensibility.[101]

Third, it is recognized by national governments around the world that at a given level of economic output there exists a trade-off between increased productivity and the level of employment. Thus, when government encourages the high-tech sector because of its export potential and high productivity, the actual number of jobs required to produce the same level of output declines:

Something like 20,000 extra jobs have to be found every day for 18 months in the six big western countries if unemployment is to return to its level before the 1979-81 recession. Only America is on course for achieving that,

though not by cloning Silicon Valleys across the country. It created 20m more jobs in the boom-bust 1970s and has added another 2m since. High Tech accounts for fewer than 3% of them. They have come instead from fast food, entertainment, education, and a zillion other ways of giving people what they want.[102]

As has been demonstrated, the arts are an employment-efficient sector. They can absorb some workers displaced from traditional smokestack industries as well as provide employment for many young people entering the labor force for the first time. Such employment is meaningful, long term, and at a low average annual income. The arts represent an employment-efficient policy complement to governmental support of the capital-intensive, low-employment, high-tech industry.

Conclusions

This chapter has demonstrated that the perception of the relationship between the economy and the arts is in the process of fundamental change and revision. The arts are no longer just a symbol of wealth for the elite but also a source of national wealth for all citizens. Through advancement in product design and advertising techniques, the arts have an economic impact on the competitiveness of all industries. The capital investment in arts, including facilities, repertoire, and copyrighted properties, represents a significant part of total national capital. The arts are a significant, efficient, and rapidly growing source of employment, particularly in First World nations experiencing "de-industrialization."

Given that the economy is a means toward human ends and that the arts are an end, in and of themselves, one would be wrong to argue that the arts should be supported by the private, public, and philanthropic sectors simply because of their significant economic impact. This argument would amount to saying that "the means justifies the end." Such a conclusion also would irritate many artists and humanists who know and accept the arts as an inherent part of being human. On the other hand, the arts have an economic impact so great and all pervasive that they must be recognized as a key and critical sector of economic growth and development.

Notes

1. Harry Hillman-Chartrand, *The Canadian Cultural Industries,* Arts Research Monograph E3 (Ottawa, Canada: Futures Socio-Economic Planning Consultants, 1979).

2. Joseph A. Schumpeter, *History of Economic Analysis* (1954; reprint, New York, N.Y.: Oxford University Press, 1968).

3. John Maynard Keynes, *Essays in Biography* (1933; reprint, New York, N.Y.: Norton & Company, 1963), pp. 140–141.

4. Harry Hillman-Chartrand, *Social Sciences & Humanities Research Impact Indicators* (Ottawa, Canada: Futures Socio-Economic Planning Consultants, 1980).

5. Erwin E. Nemmers, *Dictionary of Economics and Business* (Totowa, N.J.: Littlefield, Adams & Company, 1976), p. 142.

6. G. L. S. Shackle, "To the 'QJE' from Chapter 12 of The 'General Theory': Keynes's Ultimate Meaning," in *The Years of High Theory: Invention and Tradition in Economic Thought 1926-1939* (Cambridge: Cambridge University Press, 1967), pp. 130–132.

7. Robert Hughes, "Art and Money: Part I," *New Art Examiner* (October 1984): 25.

8. William J. Barber, *A History of Economic Thought* (Harmondsworth, Great Britain: Penguin Books, 1967).

9. Hughes, "Art and Money," p. 27.

10. William J. Baumol and William G. Bowen, *Performing Arts—The Economic Dilemma* (New York, N.Y.: Twentieth Century Fund, 1966).

11. Walter B. Wriston, "Gnomons, Words, and Politics" (Chicago, Ill.: The Executive Club, 1985).

12. Edward Shapiro, *Macroeconomic Analysis* (New York, N.Y.: Harcourt, Brace & World, 1970), p. 495.

13. H. Liebenstein, "Microeconomics and X-Efficiency Theory: If There Is No Crisis There Ought To Be One," in *Crisis in Economic Theory,* ed. D. Bell and I. Kristol (New York, N.Y.: Basic Books, 1981).

14. David Cwi. The phrase was suggested in conversation with the author, November 1985.

15. Royal Commission on the Economic Union and Development Prospect for Canada, *Report: Volume II* (Ottawa, Canada: Minister of Supply and Services, 1985), pp. 115–116.

16. John R. Commons, *The Legal Foundations of Capitalism* (Madison, Wis.: University of Wisconsin Press, 1957).

17. S. Backerman, *Arts Means Business* (Vancouver, Canada: Social Planning Department, City of Vancouver, 1983).

18. Peat, Marwick, Mitchell & Company, *Report on the Economic Impact of the Arts in Texas: Executive Summary* (Houston, Tex.: Texas Commission on the Arts, 1984), p. 3.

19. Harvey S. Perloff, *The Arts in the Economic Life of the City* (New York, N.Y.: American Council for the Arts, 1979).

20. Joan Jeffri, "Making Money: Real Estate Strategies for the Arts," *Journal of Arts Management and Law* 12, no. 3 (Fall 1982): 32–50.

21. James L. Shanahan, "The Arts and Urban Development," in *The Arts & Urban Development: Critical Comment and Discussion,* ed. William S. Hendon (Akron, Ohio: Center for Urban Studies, University of Akron, 1980), p. 8.

22. I. Bruce, *Patronage of the Creative Artist* (London: Artists Now, 1975).

23. John R. Commons, *The Legal Foundations of Capitalism.*
24. W. M. Blaisdell, "Size of the Copyright Industries," in *Studies on Copyright* (1959; reprint, New York, N.Y.: Bobbs-Merrill Co., 1983).
25. M. U. Porat, *The Information Economy* (Washington, D.C.: U.S. Department of Commerce, 1977).
26. K. Valaskakis, *Social Change and the Future: The Need for New Paradigms* (Montreal, Canada: GAMMA, 1981).
27. G. Fontaine, *A Charter of Rights for Creators,* Report of the Sub-Committee on the Revision of Copyright (Ottawa, Canada: House of Commons, 1985).
28. Gordon Tullock, "Comment: The Economics of Theatre in Renaissance London," *Scandinavian Journal of Economics* 78 (1976): 115.
29. Canada Council, *A Canadian Dictionary and Selected Statistical Profile of Arts Employment 1981* (Ottawa, Canada: Canada Council, 1984).
30. Ibid., pp. 205–330.
31. Ibid., p. 37.
32. Ibid., p. 54.
33. Ibid., p. 37.
34. Thomas Bradshaw, *An Examination of the Comparability of 1970 and 1980 Census Statistics of Artists* (Akron, Ohio: Third International Conference on Cultural Economics, University of Akron, 1984).
35. Canada Council, *A Canadian Dictionary,* p. 54.
36. Canada Council, *Selected Arts Research Statistics* (Ottawa, Canada: Canada Council, 1985), pp. 69–71.
37. Ibid., p. 72.
38. Ibid., pp. 5–13.
39. V. Bladen, *The Financing of the Performing Arts in Canada* (Ottawa, Canada: Canada Council, 1971).
40. Richard A. Musgrave, *The Theory of Public Finance* (New York, N.Y.: McGraw-Hill, 1959).
41. Harry Hillman-Chartrand and C. McCaughey, *The Arm's Length Principle and the Arts: An International Perspective, Past, Present and Future* (Ottawa, Canada: Canada Council, 1985).
42. D. Cheatwood, "The Private Muse in the Public World," in *Public Policy and the Arts,* ed. K. Mulcahy and C. R. Swaim (Boulder, Colo.: Westview Press, 1983).
43. W. D. Kay, "Toward a Theory of Cultural Policy in Non-Market, Ideological Societies," *Journal of Cultural Economics* 7, no. 2 (December 1983): 1–24.
44. "French Arts in the Doldrums: Bonjour Tristesse," *The Economist* 296 (August 3, 1985): 77–84.
45. Bladen, *The Financing of the Performing Arts.*
46. Harry Hillman-Chartrand, *An Economic Impact Assessment of the Canadian Fine Arts* (Akron, Ohio: Third International Conference on Cultural Economics and Planning, University of Akron, 1984).
47. Bernice Martin, *A Sociology of Contemporary Cultural Change* (Oxford, England: Basil Blackwell, 1981).
48. Canada Council, *Selected Arts Research Statistics,* p. 1.
49. C. McCaughey, *A Survey of Arts Audience Studies: 1967 to 1984* (Ottawa, Canada: Canada Council, 1984).
50. Canada Council, *Selected Arts Research Statistics,* p. 2.
51. C. McCaughey, *A Survey of Arts Audience Studies.*
52. Tibor Scitovsky, *The Joyless Economy* (London: Oxford University Press, 1976), p. 235.
53. Canada Council, *Selected Arts Research Statistics,* p. 3.

54. Ibid., pp. 5–13.

55. "Industry Outlook Scoreboard," *Business Week,* March 21, 1984, pp. 236–286.

56. "The Notes That Come in Wads," *The Economist* 275 (June 7, 1980): 100–101.

57. C. Freud, *The Arts, Artists and the Community: The Liberal Manifesto for the Arts* (London: United Kingdom, 1982), p. 29.

58. Canada Council, *The Arts: Corporations and Foundations* (Ottawa, Canada: Canada Council, 1985), p. 134.

59. Morris B. Holbrook and Elizabeth C. Hirschman, "The Experiential Aspects of Consumption: Consumer Fantasies, Feeling and Fun," *Journal of Consumer Research* 9 (September 1982): 132–140.

60. J. B. Sellner, "The Arts and Business: Partners in the Economy," in *Issues in Supporting the Arts,* ed. C. Violette and R. Taqqu (Ithaca, N.Y.: Graduate School of Business and Public Administration, Cornell University, 1982), p. 17.

61. R. A. Hopkinson, "Corporate Donations and Sponsorship of the Arts," in *The Arts: Corporations and Foundations,* ed. Canada Council (Ottawa, Canada: Canada Council, 1985), p. 61.

62. Alvin Toffler, "Toffler Sees Industrial Breakup," *Globe & Mail,* May 3, 1979, p. B–2.

63. "Marketing: The New Priority—A Splintered Mass Market Forces Companies to Target Their Products," *Business Week,* November 21, 1983, pp. 96–106.

64. "Baby Boomers Push for Power: And They're Getting It—in Business, in Politics, and in the Marketplace," *Business Week,* July 2, 1984.

65. Canada Council, *Selected Arts Research Statistics,* 6th Edition (Ottawa, Canada: Canada Council, 1986), p. 2, Table 2.

66. Scitovsky, *The Joyless Economy,* p. 178.

67. Richard Skolnik, "The Rise and Rise of Product Design," *Sales and Marketing Management,* October 7, 1985, p. 46.

68. Burton Weisbrod, *The Voluntary Nonprofit Sector* (Toronto, Canada: Lexington Books, 1977), pp. 1–2.

69. Alvin Toffler, *The Cultural Consumer: A Study of Art and Affluence in America* (New York, N.Y.: St. Martin's Press, 1964).

70. Kenneth E. Boulding, "Toward the Development of a Cultural Economics," *Social Science Quarterly* 53 (September 1972): 273.

71. Canada Council, *Selected Arts Research Statistics.*

72. J. M. D. Schuster, "The Non-Fundibility of Arts Funding: Perspectives on Corporate and Foundation Support," in *The Arts: Corporations and Foundations,* Arts Research Seminar No. 4, ed. Canada Council (Ottawa, Canada: Canada Council, 1985).

73. Hilda Baumol and William Baumol, "On Finances of the Performing Arts During Stagflation: Some Recent Data," *Journal of Cultural Economics* 4, no. 1 (December 1980): 1–14.

74. G. Vichert, Saskatchewan Ministry of Youth & Culture, Seminar at the First Grantors' Conference, Toronto, Canada, November 2, 1981.

75. Canada Council, *Selected Arts Research Statistics.*

76. R. R. Mayer, *Social Science and Institutional Change* (Chapel Hill, N.C.: University of North Carolina, 1978).

77. Erich Jantsch, *Design for Evolution* (New York, N.Y.: Braziller, 1975), p. 81.

78. Fleming Hansen, "Hemispheral Lateralization: Implications for Understanding Consumer Behaviour," *Journal of Consumer Research* 8 (June 1981): 23–36.

79. Geoffrey Vickers, "The Weakness of Western Culture," *Futures* 9, no. 6 (December 1977): 457–473.

80. Marshall McLuhan, "The Eye and the Ear and the Hemispheres of the Brain," *Futures Canada* 2, no. 4 (1978): 2.

81. Scitovsky, *The Joyless Economy.*

82. Economic Council of Canada, *The Bottom Line* (Ottawa, Canada: Economic Council of Canada, 1983).

83. D. Granaat, "The Plastic Arts in Hospitals," in *The Healing Role of the Arts: A European Perspective,* ed. M. J. Spencer (New York, N.Y.: Rockefeller Foundation, 1983), p. 105.

84. M. J. Spencer, *The Healing Role of the Arts: A European Perspective* (New York, N.Y.: Rockefeller Foundation, 1983), p. 2.

85. Canada Council, *A Canadian Dictionary.*

86. Spencer, *The Healing Role,* pp. 3–4.

87. "Cultural Diplomacy: Britain's Washington Coup," *The Economist* 297 (November 2, 1985): 51.

88. N. Garnham, "Towards a Political Economy of Culture" *New Universities Quarterly* 31 (Summer 1977): 341–357.

89. V. Sears, "Task Force on Information Has Zip To Say," *Toronto Star,* November 10, 1983.

90. A. Czeszak [pen name for T. Sherman], "TBDF: Transborder Data Flow," *Impulse* 10, no. 1 (1982): 25–27.

91. C. Richards, "Computer Culture," *Agenda* 5 (Spring 1982): 17–21.

92. S. Crean, "Video Trouble," *Books in Canada* 11 (August/September 1982): 11–13.

93. M. C. Vettraino-Soulard, "Media in the World of 1984," in *Understanding 1984,* ed. Canadian Cultural Centre (Paris: Canadian Cultural Centre, 1983).

94. N. Garnham, "Towards a Political Economy of Culture."

95. "Cultural Diplomacy: Britain's Washington Coup."

96. A. Edinborough. "Curtain Up on Some World Class Performances," *Financial Post,* Winter 1983-1984.

97. Alan Peacock, "Public Patronage and Music: An Economist's View," *Three Banks Review* 77 (March 1968): 18–36.

98. "Cultural Diplomacy: Britain's Washington Coup."

99. Steven Globerman, *Cultural Regulation in Canada* (Montreal, Canada: Institute for Research on Public Policy, 1983), pp. 46–48.

100. Royal Commission on the Economic Union and Development Prospect for Canada, *Report,* p. 116.

101. Daniel Bell, *The Cultural Contradictions of Capitalism* (New York, N.Y.: Basic Books, 1976), pp. 33–35.

102. "Fast Fries or High Tech?" *The Economist,* June 16, 1984, p. 12.

Arts Impact
Studies:
A Fashionable
Excess

by

Bruce A. Seaman

**Georgia State University
Atlanta, Georgia**

\mathbf{A}rts impact studies have become something of a growth industry. People may grumble about their inadequacies. But there is a great reluctance to simply say "enough!" If one were dealing with clothing instead of research agendas, there might be hope. Just when everyone has purchased a new collection of madras shirts, they are certain to be out of style. Unfortunately, the popularity of a particular research product does not as reliably foretell its doom.

A personal anecdote can exhibit this observation. As a discussant at a session on impact studies at the Third International Conference on Cultural Economics and Planning in Akron, I had just finished raising some fairly standard suspicions about the legitimacy of the conclusions drawn by the Port Authority of New York/New Jersey study (mentioned later). I was approached in the hall by a few arts administrators who good naturedly noted that my questions had never really been satisfactorily answered—an apparent source of concern. It soon became obvious, however, that, despite their doubts, they could hardly wait to return home to initiate their own similar studies.

As advocates for the arts, their enthusiasm for yet another weapon is certainly understandable. As an economist, however, I fear that impact studies are focusing on the wrong issues, using an inappropriate tool, and perhaps reaching false conclusions. At best, one might reach the correct conclusions for the wrong reasons. It is time to make the case that, despite the generation of some useful information from the studies to date, the social value of one more arts impact study is nearly zero. In a costless world, a few more could be justified. In this world, one cannot afford to divert more resources from other, more valuable research projects in the arts.

The Argument in Brief

There are three basic justifications for the kind of arts impact study under discussion: (1) to clarify industry and sectoral interactions in local economies to improve predictions about income and output changes; (2) to serve as a particular case study to help resolve the various weaknesses in regional development models such as input/output analysis and economic base multipliers; and (3) to improve public policymaking regarding the allocation of an economy's scarce resources, or the achievement of "noneconomic" goals such as fairness or enlightenment. These justifications ad-

dress forecasting, scientific, and policy goals. Arts impact studies have been useful in achieving the first goal, are largely irrelevant to the second, and are deceptive and misleading as applied to the third. Even their success in clarifying intersectoral relationships and documenting the distributional effects of arts expenditures has been marred by technical flaws in the analysis. While the economists involved in these studies are aware of the problems and try to provide sufficient caveats, the warnings often go unheeded and the limitations unresolved. And, as usual, the proliferation of these studies leads to more abuse than the professionals claimed there would be.

The studies usually are interpreted as adding some economic evidence to the usual array of noneconomic considerations relevant to cultural policymaking. Properly and cautiously used to supplement other economic analysis, such studies do provide information relevant to the forecasting function. Interpreted, as they too often are by arts administrators and perhaps policymakers, as sufficient or even necessary evidence for additional public financial support, they are an abuse of economic analysis. In fact, ironically, some of the most important concepts in economics such as opportunity cost, marginal versus total measurements, allocation of scarce resources versus distribution of income, marginally relevant externality versus intramarginal externality, and real versus pecuniary effects generally are obscured or ignored in deriving and interpreting the results. In essence, the studies try to add some cost/benefit analysis to the discussion of rational arts policy without being particularly true to the principles of that methodology. And the derivation of the benefits that *are* emphasized—namely, the impact of arts spending on regional income and employment—fails to incorporate fully critical macroeconomic lessons for accurately estimating the important multiplier effects.

Attempting to link the arts to economic development and a healthy local economy, some have only tenuously connected the arts to the research economists have done on regional development. As David Cwi has noted, "By ignoring the export base issues and concentrating solely on multiplier effects, earlier studies have almost completely ignored the questions raised by the regional economist."[1] Even the more economically sophisticated studies, including the Cwi and Lyall prototype National Endowment study of Baltimore and the very recent Port Authority study of New York and New Jersey, do not address the export issue adequately. Ironically, even if it could be shown that the arts *were* an essential basic industry (an unlikely result), there would be no presumption at all that such an industry would remain basic, that basic industries should be subsidized, or that differential growth in regions could be linked closely to differing demands for exportable prod-

ucts.[2] And ironically, by focusing on the multiplier effects of arts spending, the studies' pitfall is that the very cities for which the arts might legitimately have a large export component will likely be cities for which "leakages" of such spending injections from the local region are relatively extensive, thus reducing the value of the multiplier. For example, considerable evidence exists that the nonbasic-to-basic ration (a way of measuring the magnitude of the multiplied spending effects) is, on the average, larger for bigger cities than for smaller ones.[3] Yet, except for the atypical case of New York, cities in which the arts are apt to provide a net positive injection of spending into the community as an export product are probably very small—Jiri Zuzanek's examples were Stratford and Niagara-on-the-Lake.[4] Thus, a careful study probably would find that where the arts are a legitimate export product, the local leakages are due largely to the necessity of a small city obtaining many of its products and services from other regions; hence, the multiplier effect is small. And the multiple effect of truly exogenous additions to total spending is large for those self-sufficient cities for which the arts are less apt to be exports and more likely to represent a diversion of spending from other products and activities.

In essence, impact studies have diverted attention from the kinds of research most appropriate to building a legitimate case for further public support for the arts. By focusing on the similarity of the arts to any other human endeavor—the "we have an economic impact, too" syndrome—they almost have overshadowed the research being done by Throsby, West, and others in designing experiments to estimate the degree to which there really *is* a market failure in providing arts services.[5] Their efforts to measure the magnitude of citizens' willingness to pay for more arts services—i.e., the degree to which there may be a "marginally relevant externality" beyond the direct benefits to attenders of arts events—is more directly germane to improved policymaking.[6] These studies stress the unique difficulties involved in allocating the "optimal" amount of resources to the arts.

It generally has been recognized that impact studies have not been useful in investigating the types of arts effects that could generate marginally relevant external benefits.[7] Effects on a city's image, revitalization of certain neighborhoods, and even increasing worker productivity and emotional health are factors not captured in aggregate spending effects. Yet, these effects would tend to make the arts more like other popularly subsidized activities, such as education, having relevant, unaccounted-for external benefits. Efforts to analyze and measure these effects would be much more useful than yet another spending impact study. Furthermore, the success that economists have had in dealing with these

more intrinsic, difficult-to-measure benefits can go far in diffusing a more radical critique—that the arts are so different from other economic goods that economic analysis is simply inapplicable.[8] In fact, legitimate methodological problems exist with even well-designed, willingness-to-pay, cost/benefit studies. Such arguments, however, may not be needed to defend the arts if it can be shown that even the "flawed" cost/benefit approach can justify expanded public support.

In short, it is time to halt the proliferation of arts impact studies that focus on multiplied spending effects on local regions. The only justifiable expansion of this research might be to elaborate further and update actual input/output tables for both the New York/New Jersey region and, for comparison's sake, selected other regions. But this research should be done strictly as an exercise in input/output analysis with the focus on improved short-run forecasting. As a tool in the debate over public arts policy, resources should be diverted to other more relevant projects. The following sections more thoroughly defend these assertions.

I Have Impact: You Have Impact

No one wants to blunder through life without being noticed, without making waves. A casual reading of the popular press suggests that "economic impact" has become the latest version of ego-enforcing psychotherapy. In the last six months in Atlanta alone, (1) the miserable Atlanta Falcons had between a $37 million and a $59 million (depending on the particular study) effect on the city's economy in 1984;[9] (2) the *commercial* music industry of Georgia contributes $200 million to the state's economy annually;[10] and (3) Georgia State University boosted Atlanta's income by a whopping $227 million last year. The implications of such calculations, which are similar to scores of others produced regularly in other parts of the country, are profound.

Limiting oneself to just Georgia State, Georgia Tech, Emory, and the Atlanta University complex, the university sector apparently could have generated as much as $908 million in income yearly. Assuming about half of the commercial music industry's impact was in Atlanta would create another $100 million. Taking the average estimate for the Falcons ($48 million) and multiplying that by the three professional sports teams in the city would yield $144 million in income from the professional sports industry (higher estimates have been given for the Braves alone). Even if one is conservative and cuts the university figure in half (to get

$454 million), the average industry impact for this small sample of three is $232.67 million annually. A reasonable estimate of the total personal income for the Atlanta metropolitan area, as reported by the Georgia State University Economic Forecasting Center, is $32 billion for 1984. By dividing this $32 billion by the estimated industry average impact of $232.67 million, one finds that Atlanta can have no more than 138 separate industries without totally exhausting its annual income.[11]

Industry definition is a matter of careful analysis and can vary depending on the problem at hand. But relying upon the often-used U.S. Government standard industrial classification (SIC) system allows for the identification of 1,002 separate "4-digit" industries. So Atlanta, with a well-admired diversified economy, must have no more than about 14 percent of all the 4-digit industries represented within its borders for this average industry impact to be plausible. Of course, one might argue that this obviously limited sample is unrepresentative, perhaps because those three industries are uniquely powerful—an assertion returned to later. It is this kind of extrapolation, however, that has made economists uneasy about the accuracy of the claims made in impact studies.

It is doubtful that too many newspaper readers are diligently cross checking the various claims for logical consistency. So it is certainly no surprise that the noncommercial performing arts industry would feel terribly hurt if it had no economic impact as confirmed by a similar highly publicized report. Thus, with almost endearing innocence, the publicists for most arts impact studies proudly proclaim that, at least in this respect, they are just like everyone else. To some extent, such a finding is a bit like proclaiming the existence of oxygen on the planet earth. A truly noteworthy discovery would have been that spending by the arts industry did not have widespread effects on other product supplies and incomes in those related sectors. After all, a dollar spent by an artist at the local grocery store should have the same effect on check-out-counter jobs as one spent by a steelworker. Only the traditional unfamiliarity of many talented people in the arts with the notion of themselves as economic agents could account for the perceived novelty of this insight.

The Actual Measurement
of the Economic Impact

Challenging the value of the finding that the arts have a measurable impact on economic aggregates does not imply that nothing has been learned from the dozens of impact studies completed to date. Extremism in opposition to misconception may be no vice, but moderation in pursuit of accuracy is certainly a virtue. For example, the Port Authority study concluded that the arts in the New York/ New Jersey metropolitan area are a larger industry than advertising, hotel and motel operations, management consulting, and computer and data processing services. The particular industries benefiting indirectly from arts spending, in order of importance, are real estate, business and professional services, wholesale and retail trade, eating and drinking establishments, hotel and personal services, utilities, transportation, medical and educational services, finance and insurance.[12] Even though some of these indirect effects were documented as early as the *Report of the Mayor's Committee on Cultural Policy* in 1974, the relative rankings were clarified and updated. Both the Port Authority and the National Endowment studies were especially useful in demonstrating differences among the various types of arts organizations and art forms. And both made an effort, although not fully successful, to identify export components of total spending. As Wassily Leontief, father of modern input/output analysis, said recently, "A major problem in economics is to be able to describe an entire forest in terms of individual trees and their interrelationships—to perceive the totality, while preserving all the minutiae in clear detail."[13] Impact studies are capable of adding to the stock of knowledge about the minutiae of these interrelationships.

It is critical, however, that the actual dollar estimates of these impacts be consistent with economic principles. The list of technical complaints economists have raised is lengthy and treated in detail elsewhere in this book. Economists, who from their earliest collegiate declarations as economics majors, have been fighting a losing battle with their families and the general public about just what it is that an economist does—"oh, you're studying economics; what's GNP going to be next year?"—have been defensively determined to avoid any taint from number-crunching, double-counting, causally confused, and conceptually implausible financial impact estimates. Most economists involved in conducting these studies have done credible jobs in trying to keep the record straight and at least pay lip service to the practical difficulties in avoiding conceptual errors. Inevitably, however, this approach becomes reminiscent of the per-

son who always precedes some questionable behavior by announcing, "I know I shouldn't do this, but. . . ."

It is important to recognize that the impact calculations consist essentially of two component parts of a simple equation: Full impact = (multiplier) × (net additions to total spending). Estimating the multiplier requires the researcher to trace the degree to which any spending "circulates" around the local economy and has indirect effects on spending by other people and industries. The primary determinant of the size of that term in the equation is the magnitude of "leakages" from the local economy as the additional spending goes to firms and individuals outside the local economy. The greater the leakages, the smaller the magnified multiplier effect. Studies using input/output tables (such as the Port Authority study) are particularly good at tracing these indirect spending flows so that the so-called "marginal propensity to consume locally" is correctly identified. But the other part of the equation, "net additions to total spending," is an even more treacherous problem that no study has adequately confronted.

To explain this point, one can refer briefly to the macroeconomic origins of these regional multipliers. In "Keynesian" terms, the net additions to total spending, the so-called "injections," consist of consumption, investment, government spending, and net exports (exports—imports). If the marginal propensity to consume is, say, .75, it is common for introductory textbooks to conclude that a $100 increase in "exogenous" consumption demand will create a total change in national income of $400. The multiplier is 4. Using monetary aggregates to make a similar point, it is clear that there is some "money multiplier" in evidence when gross national product is some multiple of the existing money supply. So the existence of multiplier effects from any of the types of net additional spending is a commonplace result.

Students who have never gone beyond the simplest versions of this multiplier analysis, however, are perfect examples of those for whom "a little learning is a dangerous thing." In response to both conceptual enigmas and empirical failings of the standard Keynesian analysis, extensive research has been done to improve understanding of these processes. Much of this work has focused on improving the microeconomic basis for some of the macroeconomic conclusions. In general, the modifications have greatly reduced the magnitudes of the multiplier effects.

Sticking to macroeconomics, for a moment, the multiplier reductions have been due largely to a more accurate treatment of the net additions to total spending part of our simple equation. For example, it is well known that the standard textbook increase in government deficit spending (i.e., government spends more without raising taxes) may have only a muted effect on expanding

the economy due to effects of reducing the *other* components of aggregate spending. Thus, if the additional government spending raises interest rates, investment demand likely will decline, and consumption also may fall due to a combination of interest rate effects and the recognition that the government bonds used to finance the deficits may not really constitute an increase in net wealth.[14] "Supply-side" production constraint problems can complicate this even further. Suffice it to say that when inquiring as to the source of these quasi-mysterious "exogenous" increases in overall spending, one often discovers that they may not constitute net increases, but merely changes in the composition of spending demand. Government might increase at the expense of investment and consumption.

This problem also has plagued the consumption component of aggregate demand. Students for decades have asked, "Just what is an exogenous increase in consumption demand? Where does it come from?" Silly students—always asking uninformed, brilliant questions. Being at a point in their lives where the term "budget constraint" is not just a test question, they do not easily see how they, or the economy for that matter, can just decide to "dissave" and increase consumption. Of course, when savings are positive for the economy as a whole, savings can be reduced, or a change in the distribution of income from savers to spenders could have the same effect. But the students are clearly on to something. To avoid having to confuse them further with more abstract explanation, the savvy instructor gives export demand as the fool-proof example. Since most American students are notoriously poorly informed about the external world beyond U.S. shores, this truly exogenous increase in spending coming from "out there" causes few problems as an example of a legitimate injection into the U.S. economy.

This conceptual difficulty with an increase in consumption spending clearly extends to regional applications of multiplier analysis. While no problem occurs with identifying even more sources of export demand (there is more "out there" when studying an individual city), the same issue is raised when the increase in overall spending is alleged to occur fully within the city. Again, the possibility exists of consumption rising while investment and/or government spending falls so that there is not net increase in demand. Obviously, the potential for a diversion of spending from one type to the next is many times greater when one further disaggregates and considers not just total consumption or total investment, but consumption spending for a particular product, like the arts. Now one does not even have to ask whether other types of nonconsumption spending are adversely affected. It is problematic enough that just a different *type* of consumption spending is affected adversely.

This problem is clearly recognized, but not adequately corrected, by the economists conducting impact studies. Among the many caveats provided by Cwi and Lyall in their prototype Baltimore study is a section entitled "Negative Effects on Business Volume." The key observation in this section is "to the extent that the institutions operate enterprises or provide services in competition with local businesses, their receipts from these activities should be recognized as a substitution for other private business earnings in the community."[15] They then attempt to justify their decision to consider most arts-related spending as a "net addition to total business volume, perhaps competing with activities outside the area but not reducing sales within the region."[16] To the extent that they can identify "import substitutes" of this kind, they are on safe ground in considering such spending net additions to local demand. But it is clear that their examples of such import substitution are too limited and cannot account for the primary volume of direct expenditure within the arts sector. They cite gallery sales in museums as "items that were largely unobtainable elsewhere." Furthermore, "museums stimulate other private sector purchases through heightened interest in the purchase of art."

Even if they are correct that someone wanting to purchase a copy of an oil painting exhibited in the museum could not have gone to a competing local gallery and obtained such a print, the question must still be asked: how is the person financing that purchase? If it is from savings at a local bank, the secondary effect would be a reduction in the available pool of loanable funds for, perhaps, local investment or consumption projects far removed from the arts. If it is from a reduction in restaurant visits, the secondary effect will be a reduction in income generated in the restaurant industry. If it is from fewer clothing purchases, that sector declines. This applies far beyond the so-called subsidiary activities of the arts institutions (the gallery shops, theatre souvenir stands, opera cash bars). As admitted by Cwi and Lyall, "No data are available on which to make an evaluation or assumption of the transfers from other recreational, entertainment, or educational areas that may be represented by all or a portion of the ticket and related expenditures associated with attendance at arts events."[17]

Now this is getting serious. When one remembers that the first-round spending effects on all of the impact studies are simply the budgetary outlays of arts organizations—labor expenses, payroll taxes, space rentals, advertising equipment, travel—it becomes clear that this entire amount of spending in fact may be simply a diversion of spending from other products. How can one say this? One has only to take note of the accounting identities involved in an arts organization's ledger. Total spending must equal the sum of

(1) ticket revenues; (2) contributed income; (3) government grants and subsidies; (4) subsidiary activity revenues; and (5) net borrowed income from banks and other sources. Cwi and Lyall admit there is a potential problem with (1) and (4) being diversions of spending rather than net additions, and they did not even consider spending being diverted from the *non*entertainment/educational sector. But the problem extends to all five revenue sources. Admittedly, contributions can be made from outside the community, and some of the ticket revenues clearly come from visitors, a category that most studies attempt to measure. Government funding is partly federal or state and, in fact, might be a net increase to the local community after subtracting local tax contributions to those higher level treasuries. Local government support might come partially from bonds sold to nonlocal financial institutions. The point is that this problem of confirming that even the first-round, direct-spending components of the economic impacts are net additions to community income is much wider than even Cwi and Lyall allow.

It is revealing to note how the Atlanta sports, university, and commercial music studies handled this problem, as well as to check how other arts studies have fared in isolating real exports and import substitutes. One can see immediately that one reason for the likely inconsistency of the Atlanta results is the failure to consider local spending substitutions. And, even the best of the arts studies, the Port Authority study, does not adequately avoid this error.

For example, the reported Atlanta Falcons impact is the sum of two columns of spending nicely portrayed in an easy-to-read graphic. In one column is a list of the spending in thousands of dollars by local fans and in the other the same categories of spending by out-of-town fans. Local fans spent $6,513,000 in 1984 on tickets, concessions, parking, and food, while out-of-towners spent $5,225,000. This total of $11.7 million, when multiplied by an unexplained multiplier of 3.16, yields the $37 million impact (a New Orleans study credited the Falcons with a $59 million effect on Atlanta and the Saints with a $78 million effect on New Orleans). At least, in this case, no one denies that the Falcons are partly a legitimate export product. While no attempt was made to estimate the additional costs of having these visitors to the city, one can assume that the result would still be a net positive one, although less than half as potent as that in the headlines. Similar problems plague the Georgia State estimate. Knowing quite a few of these students myself, I can attest that much of their tuition and ancillary spending is coming from painful reductions in what they sometimes view as higher priority consumer goods. And while GSU attracts students from other parts of the

state, country, and world, a majority are Atlanta-area residents, not "export products."

As for the Port Authority study, no one can fault the attempted conservatism of the approach. In determining how to define the initial base of direct expenditures, the all-important first-round effects, the authors correctly note that "direct expenditures made by arts institutions outside the 17-county area exert no regional impact; they are leakages and must be subtracted from direct expenditures before impact analysis can begin."[18] And the category of spending called "expenditures of arts motivated visitors" is carefully analyzed. Such ancillary spending is counted only "when a person from outside comes into the region, or alternatively, extends a trip to the region made for another purpose, primarily because of the arts."[19]

Confusion still exists, however, between net increases in total spending in the region and transfers of spending from one sector to another while holding total spending constant. Consider, for example, the specific examples cited to help the reader visualize these complicated impacts.

> A museum orders a catalogue to be printed by a New Jersey firm. The amount billed to the museum indirectly pays for some of the printer's rent, new machinery, and expansion. Thus, the museum expenditures support the commercial real estate, printing and machinery sectors of the economy.

> A motion picture production company employs a local film crew for a location shoot. Members of the crew use their paychecks for rent, food, and other household expenditures. The movie company's expenditures for labor, therefore, induce support for residential real estate, retail food, and other sectors of the economy affected by the level of personal consumption.

> A family travels from Pennsylvania to attend a Broadway show. Once inside the region, they spend money not only for theatre tickets, but also for tolls, parking, dinner, and a hotel room. Their trip expenditures thus help to support not only the arts but also a number of tourist-related industries.[20]

The study treats all three of these examples as if they were conceptually identical. They are not. The museum is able to order its catalogue because it has revenues from one of the sources identified in the accounting identity earlier. A large part of this

revenue may have come from a diversion of local spending from other sectors of the local economy. The fact that this purchase has improved the economic status of the real estate and printing sectors of the economy is primarily a distributional effect, not an aggregate output and income effect. Someone is better off and someone else is apt to be worse off. The pie is sliced differently; it is not a bigger pie.

The family traveling from Pennsylvania is going to have aggregate income and output effects as well as distributional effects on the local economy. The fact that it travels to attend a Broadway show rather than a Mets game will mean that its impact will be channeled to the economy via actors' incomes, theatre expenditures, and perhaps midtown restaurant receipts rather than through beer vendors' incomes and hot-dog-stand receipts. And depending on the particular marginal propensities to consume from this additional income, the indirect effects may be of a different magnitude. But either way, there has been a net injection of new spending into the region.

The motion picture example has elements of both of the above, depending on the export versus purely local spending nature of this particular set of transactions. The point is simply that even a very carefully conducted study typically does not adequately distinguish purely distributional effects from aggregate income effects. Identifying distributional effects is an important enterprise. Based on the three examples, I would guess that the already heavily subsidized real estate industry would welcome an expansion of the arts sector. And simply documenting the relative size of arts spending versus nonarts spending is a useful exercise in data gathering. But these effects should be distinguished carefully from claims related to the overall growth and health of the local economy.[21]

Impact Studies and Regional Development

The attempt to establish a uniquely important role for the arts by focusing on its size relative to other industries and the extent of its widespread financial consequences is understandable given the woeful quality of popular discourse on economic affairs. Everyone has been a victim of nightly news economics correspondents who blithely identify the fate of a particular industry, nay, often a particular firm, with the ultimate destiny of the entire economy. To this entertaining crew of mythmakers, the U.S. econ-

omy is synonymous with the auto industry or the steel industry, the textile industry or the agricultural sector, depending on which set of current crises provides the most vivid visualization of the amorphous notion of an "economy." Thank goodness, there were few feature stories about the American slide-rule industry. There would have been mass panic.

It is no wonder that when a secretary of defense wants to justify the continued existence of even the most superfluous and militarily unproductive army base, he stresses the financial impact on the local community rather than the intrinsic value of that particular facility to the taxpayer "consumers." It is much easier to visualize a reduction in beer sales on the periphery of the base than to determine if the marginal social value of one more base exceeds its marginal social cost. And make no mistake: For many small communities for which such bases are *the* primary industry and the source of unambiguous net additions to spending from outside the community, the demise of those bases may have more than just short-term "adjustment effects." But the economy as a whole doubtless would be better off reallocating scarce resources to more productive uses, and the local community itself may be able to develop other basic industries better designed to meet consumer and taxpayer demands. As hard as this lesson may be, the history of this and other economies is that there are no truly essential industries. In fact, societies that try to treat particular industries as essential often suffer the consequences of slower growth and stymied development. The so-called "British disease" is only the most popular example because of its familiarity to Western observers.

True as this may be, those responsible for local and regional policy and those living in a particular geographical area are legitimately more interested in what will improve their own individual situations. Abstract arguments about overall efficiency in the economy and the inevitability of change can be recognized without necessarily being compelling. It must be asked whether arts impact studies can help policymakers who necessarily have less global perspectives, and to what extent these studies can contribute to an improved understanding of the process of regional development.

In this regard, there are four conclusions: (1) Arts impact studies have established little evidence that the arts are a basic industry, defined as an export industry, an import substitute industry, or an industry providing services critical to an export industry; (2) even if the arts had been established to be a basic industry, their importance for regional growth would not necessarily be proven due to the recognized weaknesses of economic base models of development; (3) the role of the arts as an important part of a city's or region's infrastructure may have "induced" ef-

fects on firm and household interregional location decisions, but little evidence exists that the interregional mobility of firms has been an important factor in differential growth rates, nor have impact studies been useful in establishing interregional location effects of either firms *or* households; and (4) the most important role of the arts in local development probably is related to intraregional location decisions, the distribution of intraregional economic activity, and the enhancement of the quality of the "human capital" within the region, thereby having real productivity effects similar to education. This last effect, as well as the consumption externalities discussed in the following section, are not, however, the domain of the traditional arts impact study. Therefore, arts impact studies are of little use to policymakers interested in development issues. And arts impact studies have not been designed to advance the "science" of development studies and are of little interest to the development specialist.

In the previous section, the distinction between net additions to spending and substitutions among different categories of spending was emphasized in order to put the findings of impact studies into better perspective. When someone reports that the Chicago Symphony Orchestra has added, say, $150 million to the Chicago economy in a particular year, one should realize that the disappearance of the institution, tragic as that would be for other reasons, would be unlikely to reduce total personal income in Chicago by $150 million. It certainly would affect individual suppliers of inputs to the orchestra and all of the subsidiary results that an input/output table could trace. But unless aggregate spending in the area were reduced rather than simply transferred, the effects again would be largely distributional. This is why taste changes among a sometimes fickle public usually are viewed with more bemusement than terror (unless one is producing the now out-of-fashion product). Someone's tragedy becomes another's opportunity. In this context, exports become a useful example of net additions to local spending.

It would be a misconception, however, to infer that the economic growth of a city or region depends solely on its ability to increase the demand for its exports. One can imagine a small town producing brooms, for example, and selling them elsewhere in the county. Then the county, having many textile mills, exports to other people in the state. And the state produces products partly for sale to the rest of the country, and the country sells products to other countries elsewhere in the world. The obvious problem is that at this point one has run out of likely candidates for further export markets. Planet earth cannot yet export products to other planets. Obviously, the degree to which one is dealing with an "open" economy or a "closed" economy depends on the level of aggregation one uses. Even

at the level of a city, it is possible to imagine a very large, entirely closed city with no access to the outside world. Could this city grow? Could it provide an ever-increasing quality of life for its residents? Of course. Although it almost certainly will be poorer than if it availed itself of the opportunities for mutually advantageous trade with other cities.

The overemphasis on spending flows that characterizes all impact studies is a logical extension of the Keynesian influence on macroeconomics, from which regional multiplier analysis grew. The "supply-side" revolution in economics is just a return to a more balanced perspective that reminds one of the essential factors responsible for long-term economic growth—the increased specialization and division of labor that is possible among larger populations, increases in the quantity and quality of physical capital, education and training as ways to enhance the quality of "human capital," and technological change. In this context, the arts would not have to be exportable to be important. One might suspect that the role of the arts in this overall development scheme would be easily overwhelmed by that of other enterprises. But, at least arts proponents would not have to worry about whether impact studies have established the arts as a basic industry.

It is difficult to overemphasize the importance of this argument to the entire case being made against arts impact studies. For even if such studies were to succeed beyond the wildest dreams of their proponents, they would be essentially superfluous. That is, even if the arts could be shown to be the major export industry in a city, a true candidate for "basic" industry status, there would not necessarily be a strong reason for local public officials to view that industry as a critical lever with which to influence growth.

The opinion of the experts on this point provides stunning reading. As early as 1973, Benjamin Chinitz lamented the excess emphasis on the demand dimensions of industry interdependence prevalent in basic-nonbasic multiplier models (including the more sophisticated input/output models).[22] In his view, one should refocus attention on the way that the structure of local industry affects wages, production costs, and entrepreneurial behavior. And as noted by James Heilbrun in his *Urban Economics and Public Policy*, the tendency to ascribe changes in local economic activity almost exclusively to changes in exogenously determined final demand is "a limitation, if not a defect, of the methods of economic base analysis."[23] He cites John F. Kain as arguing that

> this way of looking at the local economy inevitably focuses attention on matters over which local authorities have no control—the exogenously determined compo-

nents of final demand—while distracting attention from the very thing they *can* influence—the nature and attractiveness of the local economic environment.[24]

In the short run, fluctuations in outside demand will affect local activity. But internal factors such as labor productivity and the quality of the infrastructure are more important long-term growth determinants.

According to Heilbrun, the most radical critique of the unwarranted export bias in economic base analysis was offered by Hans Blumenfeld, whose observations in this regard require full quotation:

> The bases [of the amazing stability of great cities in the face of economic change] are the business and consumer services and other industries supplying the local market. They are the permanent and constant element, while the "export" industries are variable, subject to incessant change and replacement. While the existence of a sufficient number of such industries is indispensable for the continued existence of the metropolis, each individual "export" industry is expendable and replaceable.

> In any commonsense use of the term, it is the "service" industries of the metropolis that are "basic" and "primary" while the "export" industries are "secondary" and "ancillary." The economic base of the metropolis consists in the activities by which its inhabitants supply each other.[25]

Part of this theme was echoed in a debate about Atlanta's future economic growth, during which Tony Catanese, city planner and director of Georgia Tech University's Center for Planning and Development, argued that Atlanta's lack of national dominance in any particular industry, specialization, and clearly defined economic base constitute its major strength. He sees Atlanta's diversity as its "dominant industry."[26]

According to Richard Muth, "little systematic empirical evidence" supports the "strong" version of the export-base theory that identifies differential increases in the demand for exports as responsible for different *rates* of city growth.[27] In fact, he provides a sobering reminder of the limitations of even a weaker version of the export-base theory—the theory that the *level* of employment in industries providing goods sold locally depends upon the level of employment in the export sector of a local area. His example is a good lesson in careful economic reasoning. He asks us to consider the effects of an increase in employment at a Boeing plant in Seattle due to an increase in sales of Boeing 747s. It

initially would seem obvious that this activity would have to increase employment of grocery clerks, retail sales clerks, doctors, and all of the other providers of services to those workers. But depending on local labor market conditions, Boeing might have been forced to pay higher wages to hire those workers partly to attract them to move to the region and partly to move from other jobs—such as being a grocery clerk—already in the region. As wage rates rise in those other local sectors, influenced by Boeing's increased demand for labor, product prices rise "both absolutely and relative to the prices of imported commodities, and fewer workers would be hired by producers of domestic commodities."[28] One would see a shift in the composition of jobs, not necessarily an increase in the total number of jobs.

Muth goes on to identify "differential shifts in labor supply" among cities, not in response to a demand change for locally produced products, but due to some unexplained factors influencing labor mobility, as a legitimate, more plausible source of differences in the growth rates across cities. Here the earlier references to the importance of a city's infrastructure and the nature and attractiveness of the local economic environment provide a real potential role for the arts as a vehicle of regional growth and development.

This role for the arts stems from its potential to influence location decisions of either firms or households. The arts, perceived as an urban amenity, can be one of the factors responsible for labor's being willing to accept a lower real wage in one region versus another.[29] And, in turn, firms might be more willing to relocate due to both the lower real wages and the possibility of being able to draw from a more educated work force.

Regarding business-firm-location decisions across regions, there are, however, two problems with this optimistic assessment: (1) all of the evidence suggests that the arts per se are only a very minor factor in relocation decisions;[30] and (2) it does not matter that their influence is minimal because regional growth and decline have been found, contrary to popular opinion, to be almost totally unrelated to such interregional firm mobility. In fact, arts impact studies have been of little or no help in addressing these issues. They have generated no real evidence about firm relocation. And regarding household "induced" decisions, the impact studies have been limited to the analysis of tourist decisions to visit temporarily, not relocate permanently.

Requiring brief documentation is the claim that even if the arts *could* be linked to firm relocation, it would be irrelevant to regional development. In a 1981 article, Birch reports the findings of a study by the M.I.T. Program on Neighborhood and Regional Change.[31] The most important finding was that virtually none of the employment change in an area is due to firms moving from one region to another.

Firms often move short distances, and it is here that the arts may have an effect *within* a city. But it is the very rarity of major-firm relocations that leads people to imagine that firms abandoning an area is the primary cause of economic woe and another region's economic salvation. Another result reinforces our earlier emphasis on the absence of any "essential" industries and the ubiquity of economic change. The study found that every area in the country loses jobs at about the same rate, regardless of the rate of change in the net job pool in the area. That is, almost all of the differences in the net changes in jobs across regions are due to differences in the rates of job gains, not losses. Birch concludes, "The reality is that our most successful areas are those with the highest rates of innovation and failure, not the lowest."[32] This discovery is fully consistent with the research of Miller, who has argued vehemently that the recently diminished Sunbelt/Snowbelt growth differentials have had almost nothing to do with firm relocations. He concludes, "Plant relocations do not appear to be a major factor in either national or regional manufacturing growth or decline." Furthermore, "plant closings, starts and stationary operations clearly had more influence than relocation on regional manufacturing employment during the [1969-1975] period."[33]

In summary, arts impact studies have failed to establish the arts as a basic export industry that would have the effect of increasing exogenous final demand into a region. Ironically, such a failing is not particularly relevant to the longer term issue of the determinants of local economic development. The failure of such studies to do what their methodology emphasizes they should do—i.e., establish the connection between *net* increases in spending and multiplier effects on income—pales in importance when a careful examination of that methodology uncovers widespread discontent among scholars as to the very validity of such spending multiplier effects in determining interregional growth differences.

The next section investigates more legitimate lines of inquiry that *can* help policymakers improve public decisions regarding the arts and their communities.

A Coherent Policy Framework: A Real Role for Economics in Arts Policy

Perhaps the greatest tragedy of the popularity of arts and other impact studies has been the widespread confusion they have created regarding optimal public policy. Conducted largely for public relations, they contain an implicit premise that the identifi-

cation of multiplier income effects is somehow germane to the debate regarding public support for the arts. Regardless of the disclaimers of those economists involved in these studies, the motive of the arts community is clearly to establish the relationship between the size of the industry and the legitimacy of its claims upon the public purse. This premise may or may not be good politics. It is certainly bad economics. Ironically, it also may be exceedingly detrimental to the cause of the arts in seeking additional resources.

Economics provides a powerful set of guidelines for policymakers considering controversial social problems. This perspective, however, may not allow for the exact calculation of the "optimal solution." The following section briefly surveys some conceptual problems with standard welfare economics. But when faced with the complexities of claims and counterclaims of competing constituent groups, an elected official can be greatly assisted by the clarity of systematic economic logic.

Physicians are admonished to, at least, "do no harm." Economists admonish governments to "do nothing inefficient." It is the economists' cross to bear that this admonition is simultaneously as pure as motherhood and as unappreciated as mothers. This is largely the fault of economists themselves, whose preference for talking to themselves rather than outsiders is legendary. As Shelling has characteristically observed:

> The word "efficiency" sounds more like engineering than human satisfaction, and if I tell you that it is not "efficient" to put the best runway lights at the poorer airport you are likely to think you know exactly what I mean and not like it, perhaps also not liking me. If I tell you that "not efficient" merely means that I can think of something better—something potentially better from the points of view of all parties concerned—you can at least be excused for wondering why I use "efficient" in such an unaccustomed way.[34]

In practical terms, when economists say they have discovered a more efficient way of doing something, they mean that they believe the additional benefits of a particular action exceed the additional costs. When this is true, it is at least possible for everyone to be better off since the sum total of net benefits in the world has increased. The way in which such additional net benefits actually are distributed to individuals can vary greatly. Some people, in fact, may benefit only after a considerable delay or never at all. For this reason, *actual* mutual benefits and not just *potential* mutual benefits must be a legitimate concern. But it is

hoped that if the television networks *had* devoted more time to the demise of the slide-rule industry, they would have stressed that the disruption in the lives of slide-rule manufacturers was not a sufficient reason to forestall the rise of advanced electronics.

Arts impact studies usually are portrayed as a way to introduce quantification into the abstract debate about the arts. They are heralded as a way to bring an economic sensibility to deliberations— a way to take advantage of the economists' penchant for cost/benefit analysis. There will be no more endless debates about the value of arts to a society. One is going to prove that the arts are important: "The Chicago Symphony Orchestra added $150 million to the city's economy." Alas, the costs are ignored, the benefits are misstated, and the implications of the results for government policy are misconstrued. It is a parody of economic analysis.

For most products consumed every day, the benefits, as evidenced by what one is willing to pay, clearly exceed the costs, as evidenced by what the seller is willing to accept. No reader of this book needs to be reminded that the dilemma of the arts stems from their difficulty in meeting this particular benefit/cost test. Anyone who has ever perused an economics textbook knows, however, that such a test is not foolproof. A product having "external costs" not fully captured as "private costs" may be overproduced compared with its "optimal" quantity. And another product having "external benefits" not fully reflected in "private benefits" may be woefully underproduced. But a correct application of this important insight requires reading past the introduction.

A rose may be a rose, but an externality is not just an externality. There are distinctions. The two most important for our purposes are the differences between a "pecuniary" and a "real" externality and the difference between a "marginally relevant" and a "marginally irrelevant" externality. Only passing references to these terms have been made earlier. Pecuniary externalities are everywhere, and they are inevitable. The attempt of arts impact studies to broaden the measurement of arts benefits beyond the ticket revenues paid by direct consumers is an exercise in measuring pecuniary externalities. By and large, they are irrelevant for public policy because they represent no failure of the market system to reflect properly peoples' demands for products and society's cost in meeting those demands. If the hoola-hoop craze were suddenly to return, the increased demand would require resources to move from other goods to the newly emergent hoola-hoop industry. Prices of plastic might increase, relative wage rates may change, temporarily high profits might be made by the first entrepreneurs to spot the trend, hamburger joints located near the hoola-hoop plants will have increased revenues, retail outlets selling the hoops will offer sales clerks more overtime, ad infinitum until one

runs out of patience in tracing these effects. The input/output models would save some time in doing this, but when all was completed, one would have merely succeeded in documenting the beauty of a market economy in action. This is not a "market failure." This is a market success. When all was documented, we would have established the "importance" of hoola hoops to the economy and added to the stock of economic statistics to be used by future graduate students in the "empirical results" section of their dissertations. Any attempt to avoid such externalities, such as keeping plastics prices from rising, would have prevented the market from sending the correct signal—in this case, the signal to produce more plastic and substitute consumption away from other plastic products.

Arts proponents should ask themselves why the case for public support for education is rarely tied to this array of pecuniary externalities. Certainly, university impact studies in the mold of the arts impact studies have been done.[35] But I have never seen such a study done for elementary or secondary schools. In that there is a message. All such educational institutions have pecuniary externalities, as do all other economic agents in any economy. But only certain products provide real externalities that are marginally relevant.

A "real" externality is one that does, in fact, have the potential for creating a market failure. A real external effect occurs when prices do not fully reflect the marginal benefits of goods consumed or the marginal costs of goods produced. As opposed to pecuniary externalities, which reflect necessary market signals for the movement of resources, real externalities occur when the signals are confused. They are, in some sense, avoidable to the extent that prices can be corrected to better reflect benefits and costs. While all industries generate pecuniary externalities, not all industries generate real externalities.

One can consider first the example of education. Few people doubt that basic skills such as literacy and arithmetical competence provide benefits to society beyond those that are captured by the individuals developing those skills. The widespread absence of such skills would greatly inhibit the necessary communication and day-to-day transactions that typify civilized life and the tangible economic benefits from mutually advantageous trade among people. Some also would cite the exposure of individuals to cultural norms and a common heritage as important external benefits of a basic education. If individuals could not capture all these benefits fully in the form of, perhaps, private income, they *might* choose systematically to remain undereducated as they compare only the private benefits of additional education with the price they must pay to obtain it. It, therefore, would be efficient—that is, beneficial to all

parties concerned—to transfer some of these benefits back to the individual as, say, education subsidies to help pay the tuition. If these transfers are not forthcoming through private contributions, the government may tax other individuals who, in this case, might "volunteer to be coerced" into making such payments in their own best interest. The fact that an individual would make the "incorrect" decision about the number of years of schooling to obtain, based purely on private benefits and costs, means that this externality is not only "real," but "marginally relevant." For this reason, economic impact studies for elementary and even secondary schools are rare. It is unnecessary to document the obvious pecuniary externalities that they generate when the more important real externalities are both substantial and marginally relevant. The case can be made for public support (even if the particular vehicle for such support is controversial) because of its real, not just pecuniary, impact on the economy.

The prevalence of pecuniary impact studies at the university level is, perhaps, a fascinating admission that the case for their public support is not as compelling. When one cannot measure what should be measured, one quantifies what is available. And what is available is the fact that university students eat X amount of food in downtown cafes and spend Y amount on public transportation. Students at this level are well beyond basic literacy, and some even have essential mathematical skills. The latest census report indicates that the private benefits from a college education, compared with that of a high school education, are still substantial and growing. In 1979, the average gap between incomes of high school and college graduates was 21 percent; as of 1984, it had grown to 39 percent to 74 percent, depending on stage of career. Therefore, even if one argues that real external benefits exist from a college education, it is unclear that they are marginally relevant. The *total* benefits from a college education might exceed the total purely private benefits. But the additional marginal private benefits of one more year (say, the final year) to most individuals *may* be close enough to the marginal social benefits of one more year so that, even at unsubsidized tuition rates, students choose the "correct" number of years for which marginal social benefits equal marginal social costs. Even in this case, some of the external benefits might be in the form of "distributional equity" stemming from certain minorities having easier access to higher education or the general public obtaining benefits from the knowledge that U.S. universities are widely respected around the world. Thus, some forms of subsidy still could be justified. Rational public policy, however, should incorporate these distinctions among the types of externalities.

Arts proponents, therefore, are involved in a dangerous game when they resort to impact studies. In a sense, they are choosing to play one of their weakest cards, while holding back their aces. The resort to impact studies that simply document the kinds of pecuniary effects common to all industries unnecessarily obscures their uniqueness as a potential source of real, marginally relevant externalities. They simply cannot win in the fight about who has the biggest impact or who is most critical to economic development. And some of the results of the studies can be detrimental to their cause. What is the socially responsible reader to think after being informed that the arts in New York are a larger industry than advertising or management consulting? Now there is an industry worthy of public support? What about the distributional implications of the fact that among the most heavily indirectly enriched industries are real estate, utilities, and finance and insurance—industries surely on everyone's Christmas list? While it is certainly no surprise, the Port Authority's finding that one-third of the audience visiting arts events had incomes over $50,000 and another third had incomes between $25,000 and $50,000 has ambiguous implications at best. If there is going to be an influx of visitors making additional demands on local public services, they may as well be rich. No one denies that these visitors, as a legitimate source of "export" earnings to the local community, are apt to be more welcome guests than an international conference of hobos. Does this observation, however, justify the jump in logic to the next step—that tax money should be used to make their consumption of the arts less costly or the income of arts organizations more substantial? By this reasoning, one should really become socially responsible and hurry to subsidize the yacht industry in hopes of luring a convention of Greek boating enthusiasts. To the extent that the purely local population of arts consumers has similar incomes, the question can again be raised—why can't the arts pay for themselves?

Years of economic analysis suggest reasons why the arts, even given these demographics, might not be able to pay for themselves. Arts impact studies, however, are a poor vehicle to make the case that people perceive more value in the arts than the arts have been able to capture in tangible revenues. Even if such studies were better able to make the case that the arts are critical for economic development, the policy implications would hardly be clear. As Globerman, among others, has argued:

> Affirmation of the valid claim for cultural subsidies even as an investment requires more than a demonstration that the arts provide benefits of an urban development variety. It must also be demonstrated that the optimal rate of

cultural "investment" would not be realized in the absence of government subsidies. Also, it must be established that subsidies to the arts promise a higher rate of return than government subsidies to other activities.[36]

Already noted is the relative unimportance of the migration of firms from one region to another as a source of regional growth differences. Such a finding makes it particularly distressing to notice the cannibalizing efforts of individual regions to bid for new industries. No one denies that the acquisition of new firms is one way (although historically not the most important way) to generate local jobs. This, however, is clearly a zero-sum game for the nation as a whole. Industries are subsidized at the expense of taxpayers, with the only effects being that one region gains and another loses.

Yet other forms of regional competition need not be zero-sum games. As Heilbrun has argued, interregional competition in the form of industrial location subsidies is harmful in the aggregate, but "competition that takes the form of creating more attractive environments can hardly fail to be generally beneficial."[37]

This point shifts the focus again to the arts as having important intraregional effects as opposed to interregional effects. The results in this regard, however, are incomplete and ambiguous. Efforts to link the arts to improvements in the environment of particular parts of a city have had mixed results. As noted by Raymond and Sesnowitz, "The use of cultural subsidies to 'save' the central cities may actually be counterproductive."[38] The jobs directly created by the arts either require considerable skills or are largely part-time and pay a relatively low wage (sometimes both). The plight of inner-city residents, of course, might improve somewhat due to the indirect effects traced by impact studies. The absence of such effects in impact studies is noticeable relative to the improvement in the condition of the already flourishing sectors cited earlier. Of course, wages would not be so low if the arts could obtain more funding. But, as Raymond and Sesnowitz observe, "The case for subsidies might better be made on the basis of the alleged external benefits generated by the arts."[39]

Fortunately, economists have not been content to leave such benefits in a state of mere "allegation." It is here that the use of economics provides genuine hope for the arts community. If the previous arguments have suggested to arts proponents that economics can never be a useful tool in the arts' defense, it is time to correct that impression.

Improvements in a city's "social infrastructure" such as parks, playgrounds, pleasant walking areas, recreational facilities, educational opportunities, and cultural variety are certainly the

kinds of investments that would enhance the urban environment in a generally beneficial way. To the extent that these things lift human spirits and generate local pride, they may have more directly measurable benefits such as higher productivity and reduced crime and social tension. Anyone who has ever been in a city swept by the enthusiasm generated by a winning baseball team knows how tangible such benefits can be—people actually talk to each other on the subway. And anyone in a city suffering through the ignominy of yet another disappointing season almost can reach out and touch the gloom. Sports are often a widespread source of local pride. That also can be generated by an orchestra's successful tour of Europe, a shiny new subway system, and the comfort of knowing that when out-of-town guests arrive, there are places of interest to take them.

The important point about these investments is that they are not a zero-sum game for society. One city's gain is not really another's loss, except to the extent that envy regarding one's *relative* position overwhelms the absolute improvements that are realized. The kind of competition for supremacy between Edinburgh and Glasgow, including the intense debate about whose opera house is best, hardly can fail to improve the overall environment in both cities and the pride of all Scotland.[40]

Of course, the relevant question to an economist is not whether things such as social infrastructure and community pride are good in themselves, but whether there is too much or too little social infrastructure. The optimal quantity is the one that counts in a world of scarcity. The very popularity of arts impact studies is partially a result of arts proponents despairing of their ability to advance their view that such public goods in fact are undersupplied at present.

Efforts to confirm the public benefits from the arts have taken two basic forms: statistical estimation and willingness-to-pay surveys. Although the statistical estimation results provided some support for the notion that the arts have public good dimensions, they were methodologically flawed and did not speak directly to the issue of whether the arts were—or are underprovided.[41] It is in recent willingness-to-pay studies for both Australia and Canada that real success has been achieved in measuring public benefits from the arts and their degree of underprovision.

A public good is one that is both "nonexcludable" and "nonrival in consumption." Nonexcludability means that the benefits of the good cannot be kept from someone who does not pay—the benefits cannot be limited to those who pay for the good's production. Nonrivalry is present when one person's consumption of the benefits of a good does not reduce the benefits accruing to someone

else. An apple fails to meet either criterion. National defense is the textbook example of a product meeting both.

The concept of a public good is quite distinct from that of a "merit good," something that provides only limited private benefits and/or public benefits and thus is produced in relatively small quantities or not at all. Yet, it is suspected, at least by a few people, that the good "should" be produced in greater quantities. Public goods may not be provided in adequate quantities because of the technical inability of their producers to capture the revenues that citizens would be willing to pay *rather than do without* the good. Merit goods may not be provided because citizens have an insufficient willingness to pay for them at all.

Most goods can be justified in society as purely private goods. Others failing to meet that test can be justified as public goods or as "mixed goods." Only out of desperation would one argue that a good is intrinsically "meritorious" even though it has no apparent *economic* value as measured by willingness to pay. Too often, arts proponents have stressed the merit-goods argument rather than the public-goods argument, due no doubt to the difficulty of documenting either. New evidence, however, provides tangible support for the arts as a public good.

In a technique first suggested by Bohm, a sample of people are asked questions designed to elicit both over- and understatements of their willingness to pay for various goods suspected of providing public benefits.[42] In this way, the classic difficulty of having people correctly reveal their willingness to pay for a product essentially nonexcludable can be partially resolved. The basic "trick" is to ask them what they are willing to pay for more of a product, first when they are expected to be actually held liable for that amount, and second, when they are told they will have no personal liability. By first obtaining an expected understatement of willingness to pay, and then an expected overstatement of willingness to pay, one can conclude something fairly reliable about their "average" willingness to pay.

Throsby and Withers have conducted these experiments in Australia; West, assisted by Morrison, has conducted them in Canada.[43] Both studies were done carefully to avoid biases in question format that might overestimate public benefits of the arts. Comparisons were sought with other potential sources of similar benefits such as sports, and the distinction between total benefits and marginal benefits was drawn. The following results are among those reported by Throsby and Withers that refer to the level of national public support for the arts in Australia:

> We note that 72 percent of respondents favored an increase in art outlays, which is precisely consistent with those

whose previously expressed accurate willingness-to-pay under no liability exceeded the current actual level of per capita assistance. Of these respondents, 80% preferred reduction in other government outlays, rather than increased taxes. . . . The mean level of support suggested by those favoring an increase, $43 per head, is less than the individual willingness-to-pay results from the earlier tables [in which less information was provided in the questions regarding current support levels relative to other services], but is still substantially greater than current assistance levels. . . . The weighted mean of the nominated levels of assistance across the whole sample assessed from this group of questions is $32.50. [Current per capita support in Australia is about $6.00.][44]

Other answers to more nebulous, less economically interesting questions provide additional evidence that the arts generate sizable nonexcludable benefits to the general population. Fully 94.8 percent of respondents agree or strongly agree that "the success of Australian painters, singers, actors, etc., gives people a sense of pride in Australian achievement." Other substantial majorities agree that "the arts should not be allowed to die out," that "the arts help us to understand our own country better," and that "it is important for school children to learn music, painting, drama, etc., as part of their education."[45] While these answers do not address the question of the optimal level of public arts support, they clearly substantiate the notion that the benefits from the arts are not limited to the direct consumption rewards of arts enthusiasts.

Important in understanding West's study done for the Canada Council is this distinction between the existence of public benefits and the degree to which there are any marginally relevant external benefits yet to be captured by further arts expansion. West asked whether respondents considered the $3.35 paid by each taxpayer in Ontario toward the support of the arts to be "too little," "too much," "just right," or "don't know." After dropping the "don't know" responses, he found that a bit more than 50 percent considered the level of support to be "just right." Over 40 percent, however, did believe that current support was "too little." In further exploring the views of those dissatisfied with public support levels, West discovered that the median preferred amount was between $6 and $9, with the median support of the particular subsample group who thought support was too low being close to $10. This last figure would require a tax increase of about $7 per person.[46] It is important to remember that while a majority did not support *more* funding, a sizable group would have been willing to pay about $7 per person for the arts.

The results also were mixed when a general attitude survey was conducted similar to that of Throsby and Withers cited above. For Canada, fully 40 percent of respondents could cite no specific external benefit from the arts. The highest positive response was that 20 percent cited "anticipated future use" of the arts and 11 percent "welfare of future generations."[47] These results are clearly not as supportive of the arts as major providers of external, public benefits, as are those of the Australian experiment. Nevertheless, this type of research can provide direct evidence to elected officials about the magnitudes of relevant externalities.

Summary

Economic analysis is an important tool for almost any public policy issue and will be until the law of scarcity is repealed.[48] It is helpful due more to the quality of the reasoning it requires than to the quantity of statistics it generates. There is nothing inconsistent about an argument that looks askance at the proliferation of arts impact studies, while at the same time supporting a more thorough analysis of the economics of the arts. It is the art of economics to be able to uncover those impacts that are unique and of value to the people who live in the nation's communities. The impacts uncovered by the multiplier income studies are important for their distributional effects, but not of great relevance to the question: "How many resources should be devoted to cultural enlightenment?" The pecuniary impacts are not especially unique nor especially useful or even favorable to the cause of a healthier arts industry.

Many questions yet are unanswered regarding the actual impact of the arts on the location of economic activity *within* communities, the number of arts institutions necessary to enhance the attractiveness of a city to mobile households (when do diminishing marginal returns occur, and have they already become zero?), the ability of the arts to tap revenues from ticket sales and contributions more creatively, the public's additional willingness to pay for the real external benefits the arts bestow, and the particular role of the arts in the infrastructure of a city at various stages of development.[49] There are indeed many impacts to be analyzed. Continuing studies of the motives of business firms who contribute to the arts might clarify further the degree to which the arts simply provide status to the contributor or actually add to the valuable human capital stock of a community.[50] If arts impact studies were to investigate these issues, there would be

no complaint. The authors of these studies usually do mention how useful such further investigations would be before compiling yet another batch of ever more redundant spending flows. It is time to recognize that there is little more to learn from those traditional impact studies. Their impact has been spent.

Notes

1. David Cwi, "Models of the Role of the Arts in Economic Development," in *Economic Policy for the Arts,* ed. William S. Hendon, Alice J. MacDonald, and James L. Shanahan (Cambridge, Mass.: Abt Books, 1980), p. 311.
2. See, for example, Richard F. Muth, *Urban Economic Problems* (New York, N.Y.: Harper and Row, 1975), p. 41.
3. For further references to this literature, see James Heilbrun, *Urban Economics and Public Policy,* 2nd ed. (New York, N.Y.: St. Martin's Press, 1981), p. 169.
4. Jiri Zuzanek, "Recent Trends in Arts Participation and Cultural Spending," in *Economic Support for the Arts,* ed. James L. Shanahan, William S. Hendon, Izaak H. Hilhurst, and Jaap Van Straalen (Akron, Ohio: Boekman Foundation, 1983), p. 114.
5. See C. D. Throsby, "Social and Economics Benefits from Regional Investment in Arts Facilities: Theory and Application," *Journal of Cultural Economics* 6 (June 1982): 1–14; C. D. Throsby and G. A. Withers, "Measuring the Demand for the Arts as a Public Good," in Shanahan, et al., eds., *Economic Support for the Arts,* pp. 37–52; and E. G. West, *Report to the Canada Council on Canadian Policy Towards the Arts* (Ontario, Canada: Ontario Economic Council, 1985), Chapter 8.
6. A marginally relevant externality is an external effect that is not only applicable to earlier provisions of a product but also extends to additional quantities of the product.
7. In Cwi, "Models of the Role," such issues as changing a city's image and retaining business for the downtown area are discussed in a separate section from that reviewing the results of impact studies. The lengthy list of speculations about the arts and development accumulated by James L. Shanahan, "The Arts and Urban Development," in *Economic Policy for the Arts,* ed. William S. Hendon, Alice J. MacDonald, and James L. Shanahan (Cambridge, Mass.: Abt Books, 1980), pp. 295–304, is provocative largely because these speculations have not been resolved by the mass of impact studies.
8. Economists themselves have been prime contributors to this interesting debate because they are so intimately aware of both the strengths and limitations of the subject. Among the many notable contributions, see the entire section, "Caveats to Cultural Economists," in *Managerial Economics for the Arts,* ed. Virginia Lee Owen and William S. Hendon (Akron, Ohio: Association for Cultural Economics, 1985), pp. 1–22. See also note 48.
9. *Atlanta Journal and Constitution,* July 29, 1985, pp. 1B, 8B.
10. *Atlanta Journal and Constitution,* October 28, 1985, pp. 1B, 18B.
11. *Profile,* brochure (Atlanta, Ga.: Georgia State University, Department of Public Information, October 14, 1985), pp. 1–2, citing a study done by Ellen Posey of GSU's Office of Institutional Research.

12. Port Authority of New York and New Jersey, Cultural Assistance Center, *The Arts as an Industry: Their Economic Importance to the New York-New Jersey Metropolitan Region* (New York, N.Y.: Port Authority of New York and New Jersey, 1983), p. 5.

13. From an interview of Wassily Leontief conducted by *Challenge Magazine,* "Why Economics Needs Input-Output Analysis," *Challenge* (March/April 1985): 32.

14. For a comprehensive and modern presentation of this new orientation, see Robert J. Barron, *Macroeconomics* (New York, N.Y.: John Wiley and Sons, 1984).

15. David Cwi and Katherine Lyall, *Economic Impacts of Arts and Cultural Institutions: A Model for Assessment and A Case Study of Baltimore* (Washington, D.C.: National Endowment for the Arts, 1977), p. 17.

16. Ibid.

17. Ibid.

18. Port Authority of New York and New Jersey, Cultural Assistance Center, *The Arts as an Industry,* p. 66.

19. Ibid, p. 28.

20. Ibid., pp. 20–21.

21. Not all studies exert as much care as that of the Port Authority Study. Harry Hillman-Chartrand, in "An Economic Impact Assessment of the Canadian Fine Arts," in *The Economics of Cultural Industries,* ed. William S. Hendon, Nancy K. Grant, and Douglas V. Shaw (Akron, Ohio: Association for Cultural Economics, 1984), pp. 53–61, cites separate effects, among the many he identifies, for an "income multiplier effect" and the arts' "contribution to external trade." Regardless of the particular merits of that study, the overall conclusion was such a high-dollar impact that when West compared it to the Canadian Gross National Expenditure for 1980, he found that it constituted fully 5 percent of GNE! A similar performance by other industries would have sent Canada beyond any standard of living it has historically accomplished. See West, *Report to the Canada Council,* Chapter 8.

22. Benjamin Chinitz, "Contrasts in Agglomeration: New York and Pittsburgh," in *Urban Economics: Readings and Analysis,* ed. Ronald E. Grieson (Boston, Mass.: Little, Brown, 1973), pp. 26–37.

23. Heilbrun, *Urban Economics,* p. 185.

24. John F. Kain, review of *A Preface to Urban Economics,* by Wilbur R. Thompson, *Journal of the American Institute of Planners,* May 1966, pp. 186–188. For a more comprehensive survey of recent thinking on regional development issues and the weaknesses of simple basic/nonbasic growth models, see Charles L. Levan, "Regional Development Analysis and Policy," *Journal of Regional Science* 25 (1985): 569–592; and Harry W. Richardson, "Input-Output and Economic Base Multipliers: Looking Backward and Forward," *Journal of Regional Science* 25 (1985): 607–661.

25. Hans Blumenfeld, "The Economic Base of the Metropolis," in *The Techniques of Urban Economic Analysis,* ed. R. W. Pfouts (West Trenton, N.J.: Chandler Davis Publishing, 1960), pp. 229–277.

26. *Atlanta Journal and Constitution,* September 3, 1985, p. 12E.

27. Muth, *Urban Economic Problems,* p. 41.

28. Ibid., p. 42.

29. See, for example, Richard J. Cebula and Richard K. Vedder, "A Note on Migration, Economic Opportunity, and the Quality of Life," *Journal of Regional Science* 13 (1975): 205–211.

30. For a brief survey of this evidence, see Bruce A. Seaman, "The Vague World of the Arts and Economic Development," in *The Arts and*

Urban Development: Critical Comment and Discussion, ed. William S. Hendon (Akron, Ohio: University of Akron, 1980), pp. 17–21.

31. David L. Birch, "Who Creates Jobs?" *Public Interest* 65 (Fall 1981): 3–14.

32. Ibid., p. 7.

33. James P. Miller, "Manufacturing Relocations in the United States, 1969-1975," in *Plant Closings: Public or Private Choices,* ed. Richard B. McKenzie (Washington, D.C.: Cato Institute, 1982), p. 22. McKenzie himself has been one of the most outspoken critics of the view that plant relocations are responsible for regional differences in economic performance.

34. Thomas C. Schelling, "Economic Reasoning and the Ethics of Policy," *Public Interest* 61 (Spring 1981): 52.

35. In addition to the Georgia State University study, see, for example, Craig L. Moore and Sidney C. Sufrin, "Syracuse University: The Impact of a Nonprofit Institution on Regional Income," *Growth and Change* 5 (January 1974): 36–39.

36. Steven Globerman, "Problems in Conception of the Arts and Urban Development," in *The Arts and Urban Development,* ed. William S. Hendon, p. 27.

37. Heilbrun, *Urban Economics,* p. 192; and "West German Regions Battle for Business," *Wall Street Journal,* November 19, 1985, p. 34.

38. Richard Raymond and Michael Sesnowitz, "Cultural Policy and Intra-Urban Development," in *The Arts and Urban Development,* ed. William S. Hendon, p. 15.

39. Raymond and Sesnowitz, "Cultural Policy."

40. See "Tales of Two Cities: Edinburgh and Glasgow Vie for Top Billing," *Wall Street Journal,* October 25, 1985, pp. 1, 21.

41. See the discussion in G. A. Withers, "Private Demand for Public Subsidies: An Econometric Study of Cultural Support in Australia," *Journal of Cultural Economics* 3 (June 1979): 532–561; and Bruce A. Seaman, "Economic Theory and the Positive Economics of Arts Financing," *American Economic Review: Papers and Proceedings,* May 1981, pp. 335–340.

42. Peter Bohm, "Estimating Willingness to Pay: Why and How?" *Scandinavian Journal of Economics* 81 (1979): 142–153.

43. See Throsby and Withers, "Measuring the Demand"; and West, *Report to the Canada Council.*

44. Throsby and Withers, "Measuring the Demand," p. 44.

45. Ibid., Table 1, p. 48.

46. Unpublished manuscript version of West, *Report to the Canada Council,* Chapter 8, pp. 17–18.

47. Ibid., Chapter 8, p. 21.

48. In the case of the arts, however, economists have been forced to extend the limits of welfare economics in recognition of the fact that a static approach, assuming tastes are being held constant, may be misleading when analyzing a product whose primary justification might be the enhancement and beneficial change in taste that accompanies its consumption. These fascinating efforts might be viewed as a more rigorous attempt to salvage the concept of "merit goods" from the junk heap of ad hocery. With some of these arguments, even a failure in the efforts to confirm substantial public benefits from the arts as supplements to the apparently too limited private benefits, would not doom the arts to decline. See especially Roger McCanin, "Optimal Subsidies in a Shortsighted World," *Journal of Cultural Economics* 6 (June 1982): 15–31; Roger McCain, "Cultivation of Taste, Catastrophe Theory, and the De-

mand for Works of Art," *American Economic Review: Papers and Proceedings,* May 1981, pp. 332–334, and Dana Stevens, "The Social Efficiency of Arts Addiction," in *Governments and Culture,* ed. C. Richard Waits, William S. Hendon, and Harold Horowitz (Akron, Ohio: Association for Cultural Economics, 1985), pp. 43–53.

49. For further discussion of these issues and some initial research results, see the papers in *The Arts and Urban Development,* ed. William S. Hendon; Bruce A. Seaman, "Price Discrimination in the Arts," *Managerial Economics for the Arts,* ed. Virginia Lee Owen and William S. Hendon (Akron, Ohio: Association for Cultural Economics, 1985), pp. 47–60; and Henry Hansmann, "Nonprofit Enterprises in the Performing Arts," *Bell Journal of Economics* 12 (Autumn 1981): 342–361.

50. For a good survey of these issues, see Virginia Lee Owen, "Business Subsidies to Urban Amenities," in *The Arts and Urban Development,* ed. William S. Hendon; and G. D. Keim, Roger E. Meiners, and Louis W. Frey, "On the Evaluation of Corporate Contributions," *Public Choice* 35 (1980): 129–136, and associated further discussion, same volume, pp. 137–145.

Economic Impact Studies of the Arts as Effective Advocacy

by

Anthony J. Radich
The National Conference
of State Legislatures
Denver, Colorado

and

Sonja K. Foss
Department of Speech
University of Oregon
Eugene, Oregon

Studies of the economic impact of the arts primarily are used for arts advocacy efforts. Those who conduct them and those who use them agree that the principal purpose of such studies is to increase the effectiveness of arguments for the arts before representatives of the public and private sectors. Less familiar, however, is the process that is undertaken in the design and execution of these studies that enables them to be effective as advocacy tools. The studies themselves rarely reveal the decision-making context in which they were conducted that led to the selection of certain strategies of form and content to create the best possible advocacy product. In this chapter, a review of five studies identifies the process by which they work as tools of effective persuasion.

This examination of specific studies as tools of effective advocacy or communication is designed to accomplish two purposes. First, it acquaints those who are planning economic impact studies of the arts with options and alternatives available to them in the design and execution of these studies. By becoming more familiar with choices made in other studies, future sponsors and researchers will be able to plan and execute studies that are as effective as possible in securing support for the arts and avoid common pitfalls.

Second, this examination of specific studies and how they function from a communication perspective should encourage such studies to be seen as valuable and legitimate. Some criticize economic impact studies of the arts because they do not conform to rigorous standards of economic research. The data on which they are based, the methods used to collect the data, and the methods of analysis of the data often are cited as deficient. Admittedly, there are problems in these areas in some studies, but these flaws do not warrant their dismissal. From a communication perspective, these studies are significant and serve very valuable purposes.

Five economic impact studies of the arts were selected for examination in this chapter: (1) a study sponsored by the Metropolitan Arts Congress in Norfolk, Virginia, of the economic impact of the arts in the Tidewater region of Virginia;[1] (2) a study of the economic impact of the arts in the state of Colorado commissioned by the Colorado Council on the Arts and Humanities;[2] (3) the Texas Commission on the Arts' study of the statewide impact of the arts;[3] (4) a study of the economic impact of the arts in Minneapolis conducted by arts groups in that city and sponsored by the Metropolitan Arts Alliance and the National Endowment for the Arts (NEA);[4] and (5) a similar economic impact study of the arts in Columbus, Ohio, sponsored by the NEA and the Greater Columbus Arts Council.[5]

While limitations of time and finances preclude researching more than five studies for this chapter, those selected are roughly representative of economic impact studies of the arts. They were drawn from geographically diverse areas and represent studies in the West, South, East, and Midwest. An effort also was made to obtain a mix of studies dealing with both cities and states; the Texas and Colorado studies are statewide, while the Columbus and Minneapolis studies focus on the economic impact of the arts on specific cities. A metropolitan area was the focus in the Tidewater, Virginia, study, which deals with the economic impact of the arts on an area encompassing five cities. Multistate studies such as the study published by the New England Foundation on the Arts[6] were not included because multistate perspectives on the arts' economic impact are not common. Similarly, the New York metropolitan area study of arts impact,[7] although certainly a significant one, was not included because it reviews a region that is not comparable to any other in this country or perhaps even in the world.

The studies also were selected for their capacity to provide insight into various options in their design and implementation. As will be detailed later, the Minneapolis and Columbus studies were undertaken by arts groups in the cities themselves under an agreement with the National Endowment for the Arts. They were part of a six-city study designed to serve as a demonstration of the possible value of economic impact studies of the arts. In contrast, the Tidewater, Virginia, study was completed by a research center at Old Dominion University and was commissioned by a regional arts organization seeking to build its credibility as an advocacy organization. Still different, the Texas study was commissioned by the Texas Commission on the Arts, conducted by a national accounting firm, and developed in part to create an arts data base. The Colorado study provides yet another element of diversity because it involves a clear connection between the arts and tourism; it examines arts impact in ski-resort towns that use the arts to develop a year-round season as well as in a rural town that benefits from the presence of summer vacation home owners. The diversity of the studies, then, in sponsorship, execution, focus, and geography provides information about a wide range of strategies and options for those undertaking such studies.

The studies examined here were researched through the published reports of the studies themselves as well as through telephone interviews with those who commissioned, conducted, or used the studies. Where such contact was possible, interviews were conducted in person. With few exceptions, the interviews were recorded; thus, the quotes by individuals involved in the studies are from tapes.

In this chapter, the five studies will be summarized and their effectiveness as advocacy tools will be discussed. The remainder of the chapter will detail four strategies of "identification" that emerged from the examination of these studies. Identification is a principal strategy used by study sponsors to form a basis for persuasion.

Overview of the Studies

The Economic Impact of the Arts
in the State of Colorado

The Colorado economic impact study was commissioned by the Colorado Commission on Higher Education through the Colorado Council on the Arts and Humanities. The council's purpose in supporting the study was to create a document that could be used in advocacy efforts with both public officials and private-sector interests. The hope was that the study could be used to leverage additional financial support from these areas.

The study was conducted by the Institute for Urban and Public Policy Research, a part of the University of Colorado at Denver's Graduate School of Public Affairs. It cost $50,000 and was underwritten by a special grant program of the Colorado Commission on Higher Education that encouraged research by institutions of higher education that could be applied to statewide issues. The study was begun in 1982 and was published in 1983.

The work has three distinct segments. The first is an inventory of arts organizations in the state. The inventory was developed through a list of arts organizations the council had created based on grant applications and inquiries. The list was supplemented through "informants" in Colorado counties who identified additional arts organizations not on the council's list. The final accounting identified 505 arts organizations in the state, up from the 290 the council had on its original list.

The second part of the report provides an overview of the arts industry in Colorado and its aggregate economic impact on the state. This information, compiled through questionnaires sent to each arts organization in the state, requested information on the types of programs it sponsored, its expenditures, the number of people it employed, and the like. Twenty-eight percent of the groups surveyed responded to the request for information. Those responding represented the majority of the large organizations;

many of the small groups did not reply. The researchers adjusted for this modest response by creating a weighting scheme that allowed them to estimate the features of the groups that did not respond, particularly their spending patterns.

Once the financial data on the surveys were collected and data for those who did not respond were estimated, the economic impact of the arts was computed. This computation, as reported in the study, included direct expenditures in the state reported by the organizations, as well as in-kind contributions that were treated as direct expenditures. Once this direct, in-state figure was determined, it was adjusted using a multiplier of 2.55. This multiplier, developed by Colorado State University for a study concerned with the revenues generated by sports hunting and fishing activities in the state, was considered suitable because it was recent, derived from a related activity, carefully developed, and statewide in its approach.

The third segment of the report is concerned with case studies of the impact of the arts in five communities—Aspen, Creede, Telluride, Denver, and Colorado Springs. The study details the history of the development of the arts in Aspen and reviews the economic impact of a selected group of major arts organizations in the town. Special attention is paid to the Aspen Music Festival, where the researchers conducted detailed studies of the audience and the spending patterns of the festival's students. In addition, the case study reviews the development of the Wheeler Opera House, a newly renovated performing arts hall in the town.

The second case study reviews the Repertory Theatre in Creede, Colorado, a town of 600 permanent residents. After detailing the development of the theatre in the former mining town, the report lays out the budget for this $200,000 operation that serves an audience of 14,000. It details audience-survey data that were collected to compute economic impact figures and reports that the presence of the performing arts is a major reason cited by many of those surveyed for visiting the area.

The Telluride case study reviews the history of the development of the arts in the small town, which was nearly a ghost town until its revival in the 1970s. The town is especially notable for playing host to a variety of arts festivals, and the study focuses much of its attention on their economic impact. The case study ends with a discussion of the profound impact the arts have on the tourism business of the town and of how the town is working to institutionalize and manage the festivals it sponsors.

The Denver case study is essentially limited to a review of the arts activities that take place in Denver's performing arts complex, the Denver Arts Complex. The audiences of organizations that sponsor activities there were surveyed, and a brief history is

provided for each organization. Special attention is paid to the effect of the performing arts center on businesses in its perimeter, including shops, hotels, and restaurants.

The Colorado study also reviews the impact of the Pikes Peak Center, a performing arts center in Colorado Springs. The center's audiences were surveyed, and surrounding businesses were asked to report receipts so that the impact of the center on these businesses could be measured. In addition to reporting the results of these surveys, the study provides a detailed account of the development of the center and a discussion of the attitudes of citizens toward the further enlivening of the Colorado Springs downtown through cultural development.

The study concludes with a list of recommended actions to be taken to sustain and expand the role of the arts in economic development. These are divided into recommendations to increase the recognition of the role of the arts, to encourage tourism based on the arts, and to use the arts to animate cities. A selected bibliography dealing with the arts and economic impact appears at the end of the study.

Report on the Economic Impact of the Arts in Texas

The Texas Commission on the Arts' economic impact study is one of the most inclusive studies of its kind in that it defines the arts universe as including the commercial as well as the nonprofit arts. Thus, it reviews motion picture and television production activity as well as advertising and service and supply houses that deal with the arts.

The Texas study was initiated by the Texas Commission on the Arts to accomplish two goals: (1) to establish an electronic data base to be used by the commission in its planning process; and (2) to develop a credible document on the role of the arts in the state's economy that could be used for advocacy purposes by the commission and other arts interests in the state. The commission selected the firm of Peat, Marwick, Mitchell & Company to conduct the study; the firm worked on the project in 1983-1984, releasing its report in 1984. The total cash cost of the study was $125,000; however, considerable in-kind services were contributed to the study.

The first segment of the study (not reported in detail in the report) is an inventory of arts activity in the state. The researchers used existing files of the Texas Commission on the Arts to locate an initial list of arts groups. They also talked with members and staff of the commission to determine where they might look for additional arts organizations and businesses. The researchers then used the files of the Texas controller of public accounts to

locate for-profit organizations related to the arts and worked with organizations such as the Texas Film Commission to collect data on more specific elements of arts industries. The research firm also used its regional offices to locate unknown arts groups and discover arts-related industries in the state. A coordinator was appointed in each of the firm's regional offices in the state to review the list of arts-related businesses and arts organizations and add to it if local arts organizations were missing from the list.

Once the arts organizations and arts activities were identified, each was sent a survey crafted to the type of activity in which it was involved. The four surveys prepared and distributed were: a survey of arts and arts-related organizations; a survey of convention and visitors' bureaus, which included estimates of the economic impact of filming on specific areas; a survey of financial data related to film production proper; and a survey of art-education activities in the state. Seventeen percent of those who received the surveys responded to them.

The study's sponsors were committed to identifying arts activity in the rural as well as the urban areas of the state. The researchers thus traveled to east and west Texas and interviewed key individuals there regarding arts activities. They used this information to supplement the data received in the surveys. The contacts made in these areas greatly expanded the list of organizations included in the study.

In addition to the surveys that were used for data collection from arts organizations and industries, the researchers conducted four audience surveys: (1) Houston Museum of Fine Arts during an exhibition from the Shanghai Museum in China; (2) Dallas Museum of Fine Arts during an exhibition, "The Shogun Age"; (3) a performance of *Madame Butterfly* presented by the Texas Opera Theatre in Lufkin; and (4) a performance of *Pump Boys and Dinettes* at the Paramount Theatre in Austin.

In order to arrive at economic impact figures for these organizations and activities, the researchers used Texas Department of Water Resources input/output models as a source for the multiplier. Unlike other studies in Texas, regional multipliers were used rather than a composite multiplier for the entire state. Reflecting this regional focus, arts impact is reported by Standard Metropolitan Statistical Areas, planning regions, and nonurban areas. The result is the clear identification of nine different arts impact situations in the state.

Finally, the study reports on three case studies of newly completed or recently announced art museums and an arts district—the Dallas Arts District, the Laguna Gloria Art Museum in Austin, and the Art Museum of the Pecos in Marfa. The case studies of these museums focus largely on the substantial increase in property

values surrounding these museum projects and their influence on development.

The Arts in Tidewater

In 1977, the Metropolitan Arts Congress, a regional arts service organization, commissioned Roger Richman of the Center for Urban and Regional Research at Old Dominion University to conduct a study of the economic aspects of the arts in the Tidewater region of Virginia. The study was completed in December 1977, and provided an overview of the status of the arts in Tidewater, Virginia, in terms of their economic impact, their offerings and operation, and their financial characteristics. The study was completed at a cash cost of $10,000 with the assistance of numerous volunteers.

The 44 arts-related organizations included in the study were selected as a judgmental sample of organizations involved in the arts in Tidewater. The study was not designed to be comprehensive in nature, and no attempt was made to inventory all arts organizations in the study area. Although the interviews used for data collection focused extensively on arts organizations, also interviewed were representatives of the five cities' governments; members of four city arts commissions; and administrators of performance halls, private galleries, a dinner theatre, and a music school. A mail survey of 30 artists also was conducted.

The first section of the report details the economic impact of the arts in the area. The section begins with a careful explanation of the process of determining economic impact and then details the arts' direct impact, multiplier effects, the spending of arts patrons on ancillary services, and the contribution the arts can make to regional competitiveness in the attraction of businesses.

Section two of the study is a profile of the arts organizations surveyed. One segment details the number and types of performances sponsored by area organizations, while another profiles the governance staff and facilities for these organizations. In addition, the section reports on attitudes held by arts administrators about their present facilities, whether they meet their needs, and what plans they have for the future.

The third section of the report provides a detailed breakdown of the financial structure of the area's nonprofit arts institutions. It compares income to expenditures on an item-by-item basis, details the sources of earned and unearned income, examines expenditure patterns, and reviews earned income in terms of arts discipline. The section also documents the earnings gap experienced by all discipline areas, provides trend data on the earnings gap, and details municipal support for the arts.

An important appendix of the study is a report on an audience survey at the Virginia Beach Art Center's Boardwalk Art Show, an outdoor art exhibition that annually attracts over 100,000 persons. The survey was designed to elicit a profile of the art show's audience and determine its economic impact on the area. Those surveyed were asked where they lived, on what they spent money, whether they came to browse or buy, and a variety of other questions. While this section does not provide an aggregate figure of the economic impact of the show, it represents an initial probe into the character of an outdoor arts festival and the audience spending patterns that accompany it.

Economic Impact of Arts and Cultural Institutions

The six-city study of arts and cultural institutions was facilitated by David Cwi with the sponsorship of the National Endowment for the Arts, but it was conducted independently by organizations in each of the cities. Cwi provided technical assistance to the city-based sponsors and helped them interpret their findings; for this purpose, an economic impact model developed by Isaacs was used that later was adapted by Lyall. For the purpose of this chapter, only two studies in the report—those dealing with Minneapolis/St. Paul, Minnesota, and Columbus, Ohio—were reviewed.

Advisory groups to the project sought cities that were diverse geographically and that demonstrated a potential to use the information generated in the studies effectively. The cities were selected as a result of an announcement seeking cities interested in participating. Organizations in 70 cities expressed an interest in becoming part of the study; after discussions of the effort required for the study (although a majority of the costs for each study were assumed by the research project, participating cities had to provide some staffing for the study), the list of cities was reduced to 20. After extensive review, discussion, and negotiation, an advisory committee composed of representatives of various cities selected six cities to participate. Those selected were Minneapolis/St. Paul, studied under the auspices of the Metropolitan Arts Alliance; and Columbus, Ohio, where the study was sponsored by the Greater Columbus Arts Council. The other cities were St. Louis, Missouri; Salt Lake City, Utah; San Antonio, Texas; and Springfield, Illinois.

Once the cities were selected, coordinators from sponsoring institutions were appointed to serve as the primary on-site directors of the study. These coordinators were taught in workshops at Johns Hopkins University in Baltimore to understand data-collection procedures and the use of the Lyall model. The procedures taught were especially stringent because the goal of the

city-based sponsors and the National Endowment for the Arts was to secure as accurate a measure as possible of the relative importance of various arts institutions in the cities' economies. Such procedures were simplified, in part, through the limitation of the scope of the study to six institutions in Columbus and ten in Minneapolis/St. Paul. Data collected included information on arts institutions' local spending for goods, services, and salaries; spending patterns and demographics; attendance and staffing profiles of arts organizations; the nature of the community in which the institutions were located; and government data such as governmental expenditures and tax rates.

The data collected from the cities were processed through formulae and weightings devised by Lyall for the Baltimore study to arrive at a figure for economic impact. The report for each city breaks down the impact into a number of factors: direct estimated economic effects of the examined institutions; estimated audiences and spending by examined institutions; audience spending by place of residence; audience attendance by institution; and estimated secondary effects. In addition, the study provides a number of background statistics on each city, including a demographic profile, a review of selected arts-related businesses such as bookstores and record stores, and estimated costs and revenues to local government related to the examined institutions. In addition, the study contains a brief historic overview of the development of the arts in each of the cities.

Effectiveness of the Studies

Arts administrators and other arts advocates in the areas in which the five studies were used testified to their belief that the studies enabled them to be more effective in their efforts to secure support for the arts. John Paul Hanbury of the Metropolitan Arts Congress in Tidewater, Virginia, for example, claimed that its study "gave validity to the first regional advocacy effort."[8] The results of the study, explained board member Frances Musick, "woke some people up."[9] "They now see the arts as a modest, but important, part of the area's economy" because the study "helped make the case that the arts are not a giveaway, but an investment."[10]

Arts advocates in Tidewater saw their study as especially useful in presenting the case for the arts to particular audiences. Jerry Haynie, executive director of the Virginia Commission on the Arts, explained that it was a "help in assisting the Virginia Commission . . . in getting additional funding from the legislature,"[11] while Robert

Brown, past president of the Virginia Stage Company, said that a related study was useful in dealing with "the Norfolk Redevelopment and Housing Authority." He believes such studies enabled arts organizations to be more effective with Tidewater's public and private sectors. As Brown related, "We did an economic impact study for a downtown theatre and the mayor and city manager immediately treated us differently—as business-like people." The study also had an impact, he thinks, on a portion of the general public and suggested that it "affected a small, but *critical* public and made them more sympathetic to the arts."[12]

In Texas, the executive director of the Texas Commission on the Arts, Richard Huff, reported similar results from the economic impact study completed in that state. One important effect of the study was that it helped convince state legislators to increase funding for the arts. It "served as one piece of the argument for additional arts support—but a very critical piece" and helped "demonstrate that the state is actually paying a *very* small part of the statewide arts costs." It accomplished these effects not necessarily by changing "the minds of state legislators who were against the arts but [by helping] convince those who were neutral to support the arts." Arts groups also used the study effectively in their fund-raising efforts. As Huff explained, while "the legislature was the prime target for the study, it was designed to help local arts funding efforts and did so."[13]

In Columbus, the former executive director of the Arts Council, Tim Sublett, reported that its study was used successfully to increase "the ammunition arts advocates had to lobby with."[14] Former Columbus City Council President Mari Portman noted that many of the successful results of the advocacy effort involved development of more productive relationships between the private sector and the arts. As Portman explained, the study "helped the private sector realize that it should support the arts out of self-interest," particularly since it helped "answer questions about the relationship of the arts to job creation and return on investment in the arts."[15] Sublett noted that the study specifically "served as the centerpiece of the successful effort to obtain a permanent hotel/motel tax allocation" and "became an excuse to open a dialogue between the arts and tourism interests." Yet another effect of the study was that it generated "a great deal of public relations and good press" for the arts.[16]

Similar effects for the Colorado study were reported by Ellen Sollod, executive director of the Colorado Council on the Arts and Humanities. It was used in the council's advocacy efforts before the legislature, serving "as source material for half the 'pitch' the council made to the legislature's Joint Budget Committee."[17] Equally important, the study was used in a number of cities in

Colorado to lobby for additional city funds for the arts. As Maryo Ewell, program director of community arts programs of the council, explained, the study had some leveraging power: "After a presentation on the project, the Durango City Council voted to set aside $40,000 for a city arts commission." The study was used as well as justification for the Arts Council in Alamosa to ask city government for $6,000 to build a bandshell in the city park; the council argued that it generated that amount in sales tax for the city every year through its summer arts festival. In Aspen, the study was used by the Aspen Arts Council "to lobby for city funds" and to facilitate the development of connections between the arts and business interests, convincing "the resort association there to use the arts in their advertisements."[18]

Testimonials such as these as to the effectiveness of economic impact studies are impressive, and they suggest that an appropriate frame with which to view such studies is one of arts advocacy rather than economic theory and research. Although many of the criticisms leveled at these studies as economic studies are legitimate, they are less relevant when the studies are viewed as tools of effective advocacy. Economic impact studies of the arts are designed, for the most part, not as models of rigorous economic research but as persuasive vehicles by which to argue effectively for the arts.

Studies' Objectives

While the stated objectives of the studies' sponsors varied to some degree, they all centered on presenting the arts in an advantageous way to public officials and business executives for the purposes of stimulating increased funding. For example, Ellen Sollod explained that the purpose of the Colorado council's study was to "demonstrate to the corporate and legislative community that the arts should be given more serious consideration for funding by the state and appear as a major feature when advertising the state."[19] In Texas, Richard Huff explained that the study was initiated there to develop data to help the commission argue for increased appropriations before the legislature."[20] The purpose of the Columbus and Minneapolis/St. Paul studies, according to Cwi, was to "help local arts agencies leverage more dollars."[21] The stated purpose of the National Endowment for the Arts was simply to provide additional information to cities to use however they desired.

Some studies had secondary objectives that were related to the sponsoring agencies' desires to see arts advocacy efforts meet with a more positive reception in the public and private sectors. The Metropolitan Arts Congress in Norfolk, for example, used its

study as a means to increase its credibility as an advocacy organization. As John Paul Hanbury stated, "We wanted to demonstrate our ability to be an effective regional advocate for the arts."[22] The congress also used the study and the publicity surrounding its release to build its name recognition in the area.

A secondary objective of the Colorado study was to secure greater involvement of the state's travel and tourism industry in the arts and to advertise the arts in travel-promotion efforts. This industry, particularly the ski industry, was regarded as an audience that needed to be convinced of the value of the arts to its business; economic concerns were seen as the most effective vehicle for persuasion. As Sollod noted, "We needed a vehicle with which to approach tourism interests. The economic impact study provided such a vehicle."[23]

In Texas, a secondary objective of the economic impact study of the arts was to develop a data base that could be used for planning activities and ongoing advocacy efforts. A central feature of the study was the development of a data base for the arts that would allow the Texas Commission on the Arts to monitor the growth and needs of the arts in the state as well as to develop information for state legislators on the arts in their areas. Huff stated that "there was a need to develop an information system that could be used by the commission in its long-range planning. An important feature of any such information system was that it must be able to be broken down into various regions of the state."[24] Again, while this objective is not directly related to advocacy for increased support for the arts, in the long term, this is an expected outcome. When the growth and needs of the arts in various parts of the state are monitored and legislators are kept informed about them, the groundwork is laid for more effective arguments for the arts in the future. Colorado also developed an arts data base; however, that effort is not automated.

Finally, all the studies held as a secondary objective the generation of publicity for the arts. All arts organizations strive to attract the attention of the press and pursue new attractions and perspectives that accomplish this end. The impact of the arts on the economy, then, was seen as a topic around which new publicity for the arts could be generated—publicity that is expected to pay off in greater support for the arts in the future.

These secondary objectives of economic impact studies can be an important feature of an overall advocacy effort. As Cwi observed, "The economic impact study must be part of an overall program. If it is not, then the study itself is not worth completing as it will serve only a very narrow need."[25] These studies might perform a number of interrelated objectives, then, concerned with short- and long-term advocacy, planning efforts for the arts, re-

source development strategies, and even volunteer development. If they are tied to the broad needs of an organization, the studies have the potential to serve as more than an isolated exercise useful only as a one-shot argument for financial support.

Along with secondary objectives come unintended consequences that may have a negative impact. Although the review of these five studies revealed no specific example of a negative outcome, several of those interviewed cited some of the disadvantages of using an economic approach to the arts. Some mentioned that educating advocates to interpret studies accurately was difficult. This lack of accuracy led some to develop unfulfillable expectations about the potential for the use of the arts in economic development. Another difficulty noted was the inability of many to place the economic impact of the arts in perspective with that of other activities, some of which provide more direct economic benefits to a community. Finally, linking support of the arts to the power to deliver economic benefits can be defeating. Although the arts have an economic dimension, it is not a powerful one. If the arts come to be viewed only in economic terms, their long-term support may be jeopardized.

Advocacy Through Identification

One explanation for the success of these economic impact studies as advocacy tools for the arts is provided by communication theory. The studies, in this view, are effective as persuasive arguments for the arts because they bridge differences or reduce psychological distance between arts advocates and those they must persuade. Persuasion begins with the perception of differences—differences between where one group stands on an issue as opposed to another. Effective advocacy or persuasion results from the bridging of these differences.

Communication theorist Kenneth Burke labels the notion of moving toward an audience psychologically in the hopes it will accept the advocate's position *identification*. Identification is the process of sharing some type of substance with the individual or group that is the target of persuasion. Ideas, values, attitudes, qualities, or possessions all are possible substances on which identification can be based. Burke argues that the only way to persuade is through the creation of identification or the sharing of substance; in fact, he sees the terms *persuasion* and *identification* as synonymous: "You persuade a man only insofar as you can talk his language by speech, gesture, tonality, order, image, attitude, *identifying* your ways with his."[26]

Another communication theorist, Chaim Perelman, uses the term *communion* to describe the process of establishing commonalities or identifying with the audience. An advocate, for example, might establish communion with members of the Veterans of Foreign Wars by introducing a speech with a reference to his own experiences in World War II. Perelman suggests that an advocate who establishes such communion is more likely to be persuasive than a speaker who does not because the starting point of argument is agreement, or the sharing of some frame of reference.[27]

The studies examined here have in common the selection of strategies in their execution and presentation that attempt to bridge differences, create identification, or establish communion between arts advocates and two primary nonarts audiences—public officials and business representatives—groups that are most able to increase financial support for the arts. The studies, then, are oriented to these audiences rather than to the arts advocates themselves. The effectiveness of the studies can be explained as the result of a process in which their designers and sponsors knew the audiences to which they wanted to appeal and selected strategies in the execution and presentation of the studies that created identification between arts advocates and those in the public and business realms. As a result, they were able to persuade these groups more effectively to support the arts.

A number of assumptions lie behind the focus on the audience in these studies. One assumption is that all audiences are unique or, at the very least, that some differences make a difference. In these studies, all audiences are not viewed as alike, nor is the belief held that the same arguments for the arts can be used with all audiences. The studies are based on a second presupposition that what the receivers or audiences need, want, know, and value is of primary importance; the arts advocates have not decided for the audiences what they need and want or should need and want. Thus, the studies are able to present a case for the arts on the basis of the arts' capacity to resolve or reduce the audience's special problems rather than by advocating support for the arts on the basis of their supposed intrinsic merits.[28]

Strategies of Identification

Examination of the five studies revealed four strategies by which they create identification or communion with their targeted audiences: (1) establishment of presence for the economic aspects

of the arts; (2) argumentation based on acceptable premises; (3) use of appealing forms of argumentation; and (4) establishment of credibility.

Establishment of Presence
for Economic Aspects of the Arts

Communication theorist Chaim Perelman, who introduced the concept of communion discussed earlier, suggests that the concept of presence is also important in persuasion. Certain elements in one's perception, depending on the situation, seem more important or special than other elements. Those that are present in one's mind, of course, are the most important, while those that are absent are less important. When a variety of elements of argumentation are available from which to choose, advocates must select certain elements on which to focus attention by endowing them with a "presence." Presence, then, is "the displaying of certain elements on which the speaker wishes to center attention in order that they may occupy the foreground of the hearer's consciousness." To illustrate this concept, Perelman tells a Chinese story in which a "king sees an ox on its way to sacrifice. He is moved to pity for it and orders that a sheep be used in its place. He confesses he did so because he could see the ox, but not the sheep."[29] The concept of presence suggests that persuaders have the ability to make salient to an audience what they consider important to their argument.

But making a particular concept or argument present to an audience is not enough to effect persuasion. What is made present must be something with which the audience identifies. In other words, it must be an element or concept that is important to them, that conforms to their values, and that meets their needs.

In these studies, what is made present is the arts as an economic entity. The arts can be viewed in a number of ways and as having a number of benefits, including the development of visual literacy, their positive impact on the environment, their facilitation of individual creativity, their personal enjoyment value, and their therapeutic worth. But these are downplayed in these economic impact studies. Not one of the studies reviewed here gives more than passing attention to these benefits, and most do not mention them at all. Instead, the arts as economic elements are made present. They are seen as elements that benefit the tax base, help build property values, serve as a source of business attraction, and contribute to an area's economic health.

Not only do these studies make present to politicians and business executives the arts as economic entities, but the releasing of the studies also made the arts themselves more present and

salient for these and wider audiences. Those releasing the studies reported a number of strategies to make the arts more visible in general, with a particular focus on them as economic entities. Through press conferences, press releases, and other media contacts, the project sponsors attempted to obtain the greatest possible press coverage of the results of the projects. For example, in Minneapolis/St. Paul and Columbus, the release of the studies was coordinated with the release of an announcement from a meeting of the National Conference of Mayors in Washington, D.C., to give added prestige and attention to them.

Sponsors of the studies also organized special events around which to release and promote the studies to establish the presence of the arts. In Colorado, for example, then Governor Richard Lamm invited state legislators to a breakfast at the governor's mansion, where he unveiled the report. In Norfolk, the study was released at a luncheon of business and arts leaders. Again, these efforts were intended to create identification between the arts and business and government audiences by making the arts salient as economic entities.

Through various mechanisms, then, these studies make present the economic aspect of the arts. Focus on this perspective on the arts suggests to politicians and business representatives that the arts are a viable contender for resources in an economic world. They make salient the arts as jobs, as urban economic revitalization, as tax-base enhancement, and the like. With this technique, the arts are no longer aesthetic objects for stimulation and enjoyment but rather elements in an economic system.

Argumentation Based on Acceptable Premises

The studies of the economic impact of the arts examined here reveal yet another method of creating identification. They build the case for the arts on general premises that the targeted audiences can accept. A premise is a proposition or "hook" on which to hang an argument, and the purpose of persuasion is to move an audience from agreement about a premise to agreement about some conclusion.[30] Appealing to accepted premises is a major element in successful persuasion because if the premise is one with which an audience identifies, the audience already has started toward the granting of the conclusion as well. An example of this is an advocate who seeks assent for a controversial thesis such as the value of a nuclear freeze; the argument may be built on agreed-upon premises that the audience accepts such as the value of peace.

One major premise on which these studies are based is that economic development is good. This premise is reflected in the core focus of the studies on the arts as economic assets. The assumed

worth of economic development is evident, for example, in the discussion of increased property values surrounding art museums and arts districts in the Texas study. The Norfolk study's concern with the value of the arts to the area's effort to attract new businesses is another example. Similarly, in the Columbus and Minneapolis/St. Paul studies, the focus on spending, tax revenues related to the arts, and the power of arts activities to attract persons from outlying areas who then will spend money in a center city is further adherence to this premise. The Colorado study follows this theme by detailing the development of off-season arts activities as contributions to the summer economic health of ski towns. Each of these foci is based on the premise that economic development is a positive feature—a belief likely to be held by business and government audiences. Nowhere in the studies is the need to limit growth or the value of restricting economic development discussed, nor is there any effort to identify the negative features of economic growth.

A second premise on which the studies rely is one that assumes that activities and organizations should be self-supporting. Although this premise is seldom addressed directly in these reports, a central argument in them is that the arts are not a net drain on a community's resources. The Tidewater, Virginia, study notes, for example, that the arts in the region have experienced an earnings gap—the difference between what the organization earns through its activities and what it spends. This gap, the researchers note, must be closed with the assistance of public subsidy and private philanthropy. The study concludes, "Finding revenue sources to meet this growth in the earnings gap is the major financial challenge facing the region's nonprofit arts organizations."[31] The lack of adequate earned income, then, is perceived as a problem rather than a natural turn of events. The implication is that income that is totally earned is preferable because it would not result in a "major financial challenge." Similarly, in Colorado's study, the research design was crafted with the concept that the arts have a right to exist because they earn their way by providing the state with a number of services. They attract tourists, boost ski-town economies in the off-season summer months, and encourage spending in ancillary businesses such as restaurants and hotels.

In such arguments, arts advocates suggest that public subsidy of the arts is not really subsidy because dollars are returned to the public treasury through economic development and taxes. Therefore, the argument goes, the arts are an activity worthy of subsidy because they actually do pay their own way and subsidy is just a way of catalyzing the process. The implicit starting point for the argument is the premise that organizations and activities should be self-supporting, a premise likely to appeal to representatives of government and business.

The studies also are based on the premise that activities that create jobs are desirable—a premise likely to be held by individuals in business and government. The Texas study, for example, uses an "employment multiplier" to demonstrate the value of arts activities to job creation. Noted in the study is that for every 100 arts jobs in Texas, between 2 and 91 other jobs are developed in the state's economy, depending on the nature of the arts activity and the local economy.[32] Similarly, the Tidewater, Virginia, study reports statistics on both paid and volunteer staff according to arts discipline. Salaries and benefits are noted to total 60 percent of the aggregate arts expenditures in the area, indicating that employment is a primary feature of the economic impact of the arts.[33] The Columbus and Minneapolis/St. Paul studies also focus considerable attention on arts employment. Again, employees' salaries and wages are found to be a major portion of the spending of arts organizations. In addition, the study attributes the creation of a number of full-time jobs to the presence of arts activity.[34]

Other premises are evident in the studies that are likely to appeal to public officials and business representatives. They assume that regions should attempt to attract business and should be in competitively advantageous positions to do so, that balancing economic activity to prevent wide swings—as with winter skiing—is desirable, and that inventorying arts facilities and programs is a sign of managerial maturity and competence. Such premises, then, form a basis for developing argumentation that is understandable and convincing to government and business audiences because it is based on premises with which they can identify.

Use of Appealing Forms of Argumentation

Techniques of presentation or the stylistic aspects of argument also serve as means to create identification in economic studies of the arts. The form as well as the content of an argument can be persuasive. Perelman provides insights into the connection between the content of an argument and the form in which it is presented: "The presentation of data is necessarily connected with problems of language. Choice of terms to express the speaker's thought is rarely without significance in the argumentation." When a person is described as "having a tendency to mislead," for example, the meaning communicated is different than when that same person is described as a "liar";[35] the content is essentially identical, but the form or language in which the content is placed creates a very different argument. In advocacy efforts, then, not only the choice of content but the way in which it is presented are important.

In the five studies, a variety of strategies concerned with the form of presentation of the data are used to establish identification betweeen arts advocates and business and political audiences. Again, the forms selected conform to ones that are used most often by those in business and government and that are valued by them as mechanisms for decision making. Four forms of presentation are particularly effective in these studies in meeting the expectations of business and political audiences: (1) use of business terminology; (2) reliance on "hard" data; (3) use of visual depictions; and (4) specific instances as forms of proof.

Use of Business Terminology. In materials and information addressed and disseminated to arts administrators, educators, and patrons, the vocabulary used often can be described as aesthetic or experiential. Terms used include, for example, *sublime visions, a sense of the visionary, communication of emotion, artistic development, joy in discovery, inner aspects of experience,* and *structural expression.* These terms, of course, have specialized meanings for those involved in the arts and, more important, are not terms that those in business and government are likely to use or necessarily even recognize. They belong to a sphere of activity seemingly foreign to business executives and public officials.

In order to bridge the world of the arts and the world inhabited by those in business and government, arts advocates must present their arguments using terminology familiar to their audiences. As evident in these studies, the required vocabulary is one of business. Despite the fact that these studies are about the arts, the vocabulary developed to talk about the arts and particularly suited to the arts is not used. Rather, the arts are discussed in the vocabulary of management, finance, and economics. Thus, one sees in these studies the predominant use of terms such as *data base, input/output models, real estate spillover effects, employment multiplier,* and *econometrics model.* The arts are discussed, then, using a vocabulary that creates identification with the targeted audiences, and the more natural terminology of the arts simply does not appear in these studies.

Reliance on "Hard" Data. In business and politics, much of the data used in decision-making processes tend to be quantitative data or "hard" data. Historically, business has relied heavily on quantitatively based records in recording items such as net sales, total revenues, net income per share, cash dividends, stockholders' equity, current assets in cash, receivables, accounts payable, expenses, and long-term debt. These quantitative representations increasingly have been accompanied by contextual quantitative expressions of market size, growth, economic conditions, and competition activity. Recently, even more complex statistics and quantitative logic, assisted by the development of computers, have become important in

business; now even elements such as organizational strengths and weaknesses, environmental opportunities and risks, assumptions and guidelines, and development of goals are likely to be expressed in quantitative forms.[36]

Statistical expressions of various values also play an important role in decision making in the political realm. Arithmetic means and percentages are commonly used statistics in government; mathematical models, computer simulations, and complex statistical formulae are becoming increasingly common. Again, as in business, seemingly unquantifiable elements are being translated into quantitative data. Thus, cost/benefit ratios are used to determine things such as the value of water conservation projects, and a definition of the condition of poverty is expressed in terms of the average costs of major items in "typical" stores around the country.

In these studies, the data are presented in accordance with this preference for quantified, statistical forms in the public and private sectors. The Minneapolis/St. Paul and Columbus studies, for example, provide tables of demographic information, percentages, and averages for a variety of information. In addition, in all the studies, reported economic impact figures are derived from complex formulae. Again, the attempt is to create identification with the targeted audiences on the basis of form.

Use of Visual Depictions. Another major form of presentation used in business and politics is that of visual depictions of findings or data. In fact, in some business and governmental presentations, the visual and graphic supporting materials seem to dominate the actual content of the presentation. The rationale for such forms relates to the need to make decisions quickly on the basis of vast quantities of information. A visual depiction or a numerical array enables a trend or phenomenon to be recognized quickly, especially when it captures a large mass of quantitative data that may require a great deal of sophistication to interpret.

The five studies examined here rely heavily on visual depictions of the findings in the reports. The Texas study devotes more than 80 percent of its space to charts, tables, and other graphic material. Cwi's studies include reproduction of a Bureau of the Census map for the study area and nine tables depicting various data. The Colorado study has 79 tables in its 164 pages. The Tidewater study also makes generous use of tables.

Specific Instances as Forms of Proof. In both business and government, specific instances are a common form in which to present data. These are specific cases that demonstrate or illustrate a particular phenomenon in an exceptional or dramatic manner. In business, for example, consideration of claims related to dealing with current problems may be reasoned on the basis of an analogous experience or incident that happened in the com-

pany or to another business. The assumption in this case is that what happened before is about the same as what is currently happening. Based on what is known about that incident, the same or different actions should be undertaken.

Similarly, in politics, a dramatic instance often is as or more persuasive in presenting data than many other forms of evidence. While statistical evidence may suggest, for example, that there is relatively little waste in a governmental program, it may be overlooked if a dramatic instance surfaces of such waste—a welfare recipient who picks up her check wearing a mink coat, for example. Similarly, pointing to an oil spill in Santa Barbara harbor can be a powerful means of presenting data concerning the likelihood of spills in the future and can be used to argue against the granting of offshore oil leases.[37]

Business and government rely on specific instances, then, as an effective form for presenting data. In these studies, this form is used, thereby creating identification between the arts and the targeted audiences. Colorado uses summer arts activities in ski towns as a specific instance, while Tidewater's study presents the Boardwalk Art Show as a specific instance. The Texas study cites property values rising around the Dallas cultural district as such an instance. The six-city study's focus on a selection of arts organizations from an area rather than using all of them is another such case. Further, that entire study was intended to serve in such a "model" capacity.

Establishment of Credibility

A final strategy used in these studies to move toward the audience psychologically is the promotion of an image for the studies with which the targeted audience can identify, resulting in increased credibility for the studies. By emphasizing similarities in background, experience, affiliations, beliefs, and values, a persuader's attractiveness is enhanced. Huey Long, former governor of Louisiana, is said to have launched his successful political career during the Depression by emphasizing similarities between himself and his audience. The film, *All the King's Men,* based on his career, contains a scene in which the main character stands before a group of farmers and says, "You're all a bunch of hicks. That's right. Hicks! You's hicks and I'm a hick and us hicks are gonna run the state legislature."[38]

That these studies emphasize similarities between arts advocates and the targeted business and government audiences is most evident in their use of advisory panels. In all of the studies, some form of an advisory panel was used. The Texas Commission on the Arts served as the advisory panel for the Texas study. A

national advisory panel served this function in the Minneapolis/ St. Paul and Columbus studies. In the others, local advisory panels were formed specifically to work with the researchers on the economic impact studies. They were composed of legislators, business persons, artists, foundation executives, and other community representatives from various regions of the states.

The purpose of the panels ostensibly was to provide advice and input to the designers and researchers of the studies. In the Tidewater, Virginia, study, for example, Research Director Roger Richmond insisted that he meet with a steering committee "to guarantee the study related to the audience and its need."[39] Peggy Cuciti, chief researcher for the Colorado study, consulted with the advisory committee that helped by "identifying case-study cities and providing entré to both researchers and the use of project questionnaires."[40]

While panel members did respond to the form and content of questionnaires developed for the studies and provided input about the likely response of their constituencies to the questionnaires, this was not their primary function. Rather, the panels largely served to establish ties between arts interests and business and government. They served as liaisons or "door openers" to individuals, organizations, and government agencies with which they were affiliated to ensure access to the necessary data and populations and to ensure the smooth collection of data. The directors of Colorado's study used the panel to locate not only case-study locations but persons to interview in those locations.

Advisory panels demonstrated to nonarts interests the commonalities they shared with the arts. As a result, they provided greater credibility for the studies because they were means of identification for various communities and audiences that would be targets of arts advocacy efforts. That this was their main function is evident in the fact that none of the advisory committees had much power over or were consulted frequently about the design and execution of the studies. The researchers interviewed could cite occasional instances where the committees offered useful advice such as identifying how to get arts organizations involved in Minneapolis/St. Paul, but no instances in which they changed major features of the study. As Tim Sublett of the Greater Columbus Arts Council stated, "The advisory committee was there to give feedback, not to get deeply involved in the study's structural development."[41] As vehicles for securing credibility as a result of identification between arts and nonarts spheres, however, their function was a powerful one.

Evidences of similarity are clearly essential, then, in creating credibility, a role performed by the advisory panels to the studies. But in many instances, for persuaders to appear *different* is also

important in order to make them seem more expert, better informed, and more reliable than the target audience. The ideal communicator often is one who seems both similar enough and different enough to appear overall as a "superrepresentative" of the audience.[42] This function was performed in these studies through the selection of the researchers who conducted them. Those selected were respected by the government and business audiences and shared elements in common with them; yet, they were different enough from them so that they were perceived as experts.

In all the studies examined here, the actual execution of the study was by nonarts organizations. Credibility for the studies would not have been secured as easily had they been conducted by the sponsoring arts agencies themselves since these were the very agencies that were perceived as lacking adequate legitimacy and as irrelevant to the primary concerns of the public and private sectors. Thus, the researchers who collected and analyzed the data of the studies were selected on the basis of their connection with institutions other than arts organizations.

Most of the studies were conducted by research departments affiliated with colleges or universities—credible sources for business and government because of their perceived greater expertise. The Colorado study, for example, was undertaken by the Center for Public-Private Sector Cooperation, a research center affiliated with the Graduate School of Public Affairs at the University of Colorado at Denver. The Norfolk study, similarly, was completed at Old Dominion University by the Center for Urban and Regional Research, and the Columbus/Minneapolis, St. Paul studies were completed under the aegis of the Center for Metropolitan Planning and Research at Johns Hopkins University with the support of the National Endowment for the Arts.

Sponsors of all three of these studies explained that a university was selected to enhance the credibility of the endeavor. Cwi noted, for example, that the economic impact approach would have the greatest opportunity for effectiveness if it were sponsored both by the National Endowment for the Arts and "a major university."[43] Sollod of Colorado noted that a university organization was selected to conduct the research because it would "have the credibility the study needed with legislators and others."[44] In Norfolk, the study's sponsors mentioned both credibility and expertise as the reason to contract with a university for the completion of the study.[45]

The Texas study is unique in that it is one of the few in the country completed by a major accounting firm. When searching for a research group to conduct the study, the Texas Commission on the Arts looked for one that would have high credibility with the legislature and would not be viewed as an organization with regional

Texas concerns. The commission issued a request for proposal and determined that a national accounting firm was the most appropriate to direct the research. It shared obvious similarities with business interests; yet, its national focus gave it perceived expertise and credibility with business and government alike.

The studies, then, exemplify the principle that an emphasis on similarities to create identification as well as a focus on differences to establish expertise contribute to a perception of credibility. Advisory panels served the purpose of establishing similarities and commonalities between arts advocates and those involved in business and government, while researchers connected with universities or national accounting firms, suggesting important differences between them, enhanced the credibility of the studies.

Conclusions

The five studies examined here provide support for a view of economic impact studies as tools of effective advocacy. Their success can be explained through their use of several strategies that create identification between arts advocates and representatives of business and government: (1) establishment of presence for the economic aspects of the arts; (2) argumentation based on premises likely to be accepted by business and government interests; (3) use of forms of argumentation—such as business terms and reliance on hard data—that appeal to these interests; and (4) establishment of credibility for the studies through inclusion of nonarts individuals and organizations in various aspects of their design and execution. While the methods used in these studies may not serve as ideal examples of economic research, then, they provide excellent models for effective persuasion.

Effective as these studies are, however, they should not be viewed as isolated features in the arts advocacy process. For any advocacy effort to be successful, arts advocates must do more than simply present the results of such studies. They must discover how the policy process they are trying to affect operates, what the individual predispositions of the policymakers are, how the economic impact study results can be presented so they have the greatest possible effect, and so on. Economic impact studies of the arts do not supply this information but serve merely as vehicles around which to organize an entire effort and as temporary magnets that can attract persons to the cause. They are not the entire effort itself.

Just as the economic impact study is not the sole element in an advocacy effort, neither can the economic impact perspective indefinitely serve as the primary focus of such advocacy. As the policy environment changes, the economic impact of the arts may fade as a major consideration. If and when it does, advocates must be prepared to develop and use new arguments based on identification with the audience around new concerns and values. The concerns may be nationwide in scope, as is a focus on economic impact, or they may be regional or local. To be effective, arts advocates must identify these concerns and craft advocacy products and processes around them using identification strategies. In· this way, support will continue to be generated for the arts, even from audiences suspicious of or at least unfamiliar with the contributions of the arts to contemporary life.

Notes

1. Roger Richman, *The Arts in Tidewater* (Norfolk, Va.: Center for Urban and Regional Research, Old Dominion University, 1977).
2. Peggy Cuciti, *Economic Impact of the Arts in the State of Colorado* (Denver, Colo.: Center for Public-Private Sector Cooperation, University of Colorado at Denver, 1983).
3. Peat, Marwick, Mitchell & Company, *Report on the Economic Impact of the Arts in Texas* (Houston, Tex.: Peat, Marwick, Mitchell & Company, 1984).
4. National Endowment for the Arts, *Economic Impact of Arts on Cultural Institutions: Case Studies in Columbus, Minneapolis/St. Paul, St. Louis, Salt Lake City, San Antonio, Springfield* (Washington, D.C.: National Endowment for the Arts, 1981).
5. National Endowment for the Arts, *Economic Impact of Arts and Cultural Institutions.*
6. Thomas Wolf, *The Arts and the New England Economy* (Cambridge, Mass.: New England Foundation for the Arts, 1981).
7. The Port Authority of New York and New Jersey and the Cultural Assistance Center, *The Arts as an Industry: Their Importance to the New York-New Jersey Metropolitan Region* (New York, N.Y.: The Port Authority of New York and New Jersey and the Cultural Assistance Center, 1983).
8. John Paul Hanbury, Past President, Metropolitan Arts Congress, October 16, 1985: telephone interview.
9. Frances Musick, Former Board Member, Metropolitan Arts Congress, October 18, 1985: telephone interview.
10. Robert Brown, Former Board Member, Metropolitan Arts Congress, October 17, 1985: telephone interview.
11. Jerry Haynie, Former Executive Director, Virginia Commission on the Arts, October 17, 1985: telephone interview.
12. Robert Brown, Past President, Virginia Stage Company, October 17, 1985: telephone interview.
13. Richard Huff, Executive Director, Texas Commission on the Arts, October 18, 1985: telephone interview.

14. Tim Sublett, Former Executive Director, November 12, 1985: telephone interview.

15. Mari Portman, Former Columbus City Council President, November 14, 1985: telephone interview.

16. Sublett: telephone interview.

17. Ellen Sollod, Executive Director, Colorado Council on the Arts and Humanities, September 12, 1985: personal interview.

18. Maryo Ewell, Director of Community Programs, Colorado Council on the Arts and Humanities, October 4, 1985: personal interview.

19. Sollod: personal interview.

20. Huff: telephone interview.

21. David Cwi, Research Director, *Economic Impact of Arts and Cultural Institutions,* October 23, 1985: telephone interview.

22. Hanbury: telephone interview.

23. Sollod: personal interview.

24. Huff: telephone interview.

25. Cwi: telephone interview.

26. Kenneth Burke, *A Rhetoric of Motives* (1950; reprint, Berkeley: University of California Press, 1969), p. 55.

27. Chaim Perelman and L. Olbrechts-Tyteca, *The New Rhetoric: A Treatise on Argumentation,* trans. John Wilkinson and Purcell Weaver (Notre Dame, Ind.: University of Notre Dame Press, 1968), pp. 14–26.

28. Herbert W. Simons, *Persuasion: Understanding, Practice, and Analysis* (New York, N.Y.: Random House, 1976), p. 123.

29. Perelman and Olbrechts-Tyteca, *The New Rhetoric,* pp. 142, 116; Chaim Perelman, *The Realm of Rhetoric,* trans. William Kluback (Notre Dame, Ind.: University of Notre Dame Press, 1982), p. 34; and Chaim Perelman, "The New Rhetoric and the Rhetoricians: Remembrances and Comments," *Quarterly Journal of Speech* 70, no. 2 (May 1984): 289.

30. Perelman, *The Realm of Rhetoric,* p. 21.

31. Richman, *The Arts in Tidewater,* p. 41.

32. Peat, Marwick, Mitchell & Company, *Report on the Economic Impact,* pp. V–12.

33. Richman, *The Arts in Tidewater,* p. 31.

34. Cwi, *Economic Impact of Arts,* pp. 33, 38, 45, 50.

35. Perelman and Olbrechts-Tyteca, *The New Rhetoric,* p. 149.

36. Richard D. Rieke and Malcolm O. Sillars, *Argumentation and the Decision Making Process* (Glenview, Ill.: Scott, Foresman, 1984), p. 324.

37. Ibid., p. 276.

38. Simons, *Persuasion,* p. 124.

39. Richman: telephone interview.

40. Peggy Cuciti, Director, *The Economic Impact of the Arts in the State of Colorado,* September 13, 1985: personal interview.

41. Sublett: telephone interview.

42. Simons, *Persuasion,* pp. 124–125.

43. Cwi: telephone interview.

44. Sollod: telephone interview.

45. Hanbury and Brown: telephone interviews.

Improving the Design and Policy Relevance of Arts Impact Studies: A Review of the Literature

by

David Cwi

The Cultural Policy Institute
Baltimore, Maryland

Arts economic impact studies of one form or another are the most widely funded form of arts research. In fact, more money has been spent on assessments of the impact of the arts than on any other arts policy question. This chapter provides for the first time a concise overview of 16 state arts impact studies conducted in the last five years. These studies are presumed to incorporate the best practices of earlier arts impact research.

This overview reviews the range of study objectives, the effects they sought to document, their methodologies, the scope of arts activities examined, and the types of organizations commissioned to conduct the studies. Strengths and weaknesses are detailed, with suggestions offered for improving study usefulness to policymakers.

This chapter also discusses several technical failures in the use of study data to estimate economic impact. The chapter, however, focuses particularly on the core issues underlying arts impact statements: the definition of the arts industry, the quality of the data, and the kinds of facts used to portray the industry to the general public and policymakers. If the studies are to become more useful, there are problems in each of these areas that must be addressed.

A Body of Literature with Little Policy Value

During the 1970s, at least 28 cities and 17 states sponsored arts impact studies. Some of the studies of the 1980s represent updates of this earlier work. All studies, early and late, are similar in approach. In fact, one is tempted to suggest that study sponsors simply shared an original report and replicated it over a period of years.

Some of the earlier studies sought to address serious policy issues. This underlying policy focus often was replaced by a type of study that had little or no public policy utility. And there is good reason for this.

One reason is that arts impact studies are sponsored by public agencies and private groups interested in advocating increased support for the arts. Since these agencies seek to argue a case for the arts as a whole, most studies present results in the aggregate for several categories of arts activity. This precludes discipline-based policy analysis because disaggregated data are simply not available.

Another failing is that by focusing solely on arts impact, the studies do not address the public policy issues underlying the goals of the larger advocacy effort. In particular, arts impact

studies shed no light on the need for additional financial support of existing activities, and they provide no information regarding the need to increase the supply of the arts. Most important, no evidence exists that the studies ever have been used or were even designed to be used by the sponsoring agencies as an aid to their own decision making.

To appreciate the current situation and the prevailing style of arts impact study, a review of the history of the genre is helpful.

The Roots of the Current Literature

Twenty years after substantial arts economic research began, it is difficult to locate and report on the early efforts. One thing is certain: Prior to 1973, very little literature existed in this area. After that date, a steady flow of work commenced and continues to the present. The roots of current approaches are evident in this material.

Baumol and Bowen, 1966

If there had been a significant body of arts impact literature available to Baumol and Bowen in the mid-1960s, they surely would have cited it as part of their defense of public support of the arts in *Performing Arts: The Economic Dilemma*. With no studies to cite, they improvised—imputing impacts to the arts that were undocumented but seemed obvious. More important, they adopted a welfare economics perspective.

The welfare economics syllogism is quite simple:

> Government must provide funds only where the market has no way to charge for all the benefits offered by an activity. When such a case arises, failure of the government to provide funds may constitute . . . a misallocation of the community's resources and a failure to implement the desires of the public.[1]

The argument seems straightforward. The benefits of the arts to others are not reflected in box office receipts and the public's willingness to buy tickets. The true value of those benefits is the price the public at large would be willing to pay for them should there be a way to charge for them. Proponents of the arts cannot impose a charge on the public at large; therefore, government,

107

through taxes, can and should remit a sum to the arts proportionate to the value of the benefits received by the public.

What sort of benefits to the public at large did Baumol and Bowen have in mind?

- The prestige conferred on a nation by its performing arts: "Many persons who themselves have no desire to attend . . . would be most unhappy if the United States became known as a cultural wasteland. . . ."[2]
- "The advantage that the availability of cultural activity confers on business in its vicinity—the fact that it brings customers to shops, hotels, restaurants and bars. On a national level, distinguished performing arts organizations may serve analogously, as a significant tourist attraction."[3]
- A "far more appealing type of social contribution . . . involves future generations." Americans support conservation programs "in part because few of us are willing to take the responsibility of passing on to future generations a country whose beauty has been destroyed."[4]
- Finally, "if, as is generally conceded, a liberal education confers indirect and non-priceable benefits upon the community, the same must be true of the arts."[5]

The educational contribution mentioned does not refer to the outcomes of participation and training in the arts. Such outcomes include, for example, increased self-esteem through artistic expression, socialization and respect for others through team work and interaction, or confidence in one's own abilities through the exercise of creativity and imagination.

According to this argument for subsidizing the performing arts, people are educated by viewing the arts, not by participating in them. Baumol and Bowen may have had in mind the types of effects cited by Alvin Toffler, who states:

> The arts play an important role in integrating individuals into larger sub-cultures within the larger society; they provide a running critique of social policy; they act on value systems that accelerate or retard change and they educate individuals to new role possibilities and styles of life.[6]

Baumol and Bowen treated public subsidy of the arts as a social cost that had a social benefit justifying that cost. They would not, however, have applied this standard to every grant

made to an arts group. They simply hoped to provide a basis for arguing that there was nothing wrong with government being in the business of arts support. They sought to demonstrate that arts were a business in which the benefits outweighed the costs.

In other publications, I have commented on "merit-good" and "market-failure" arguments in detail and found them lacking. The important point here is simply that Baumol and Bowen sought to link a discussion of arts impact to a public policy question—namely, to support a rationale for public subsidy. Their intent was to answer the question: Since government did not subsidize buggy manufacturers when cars came on the market, why subsidize the arts?

In subsequent literature, no sustained effort to assess benefits and costs has followed their lead. Costs might include opportunities foregone, that is, programs that were not funded since dollars were used instead for the arts. Baumol and Bowen themselves cite only the opportunities realized through arts support.

The benefits cited for the arts and the procedures used to place a value on such benefits call forth intriguing questions that are rarely pursued. The pressure to justify arts support from a cost/benefit perspective might have led to a larger inquiry into the social role and significance of the arts—including the impact of arts training and participation—but this direction is not pursued in the examined studies.

Of equal importance is the need to investigate the public's actual desire with respect to preferred methods of production. Buggies, for example, went out as a mode of transportation because of the public's preference for the car. Perhaps the public is equally dissatisfied with the subsidized production of symphonic music and would respond to alternatives.

Instead of addressing these fundamental policy issues, arts impact studies have taken a direction dictated by the arts council movement. The councils, whether public or private, seek to influence not only government but also the private sector. They are "arm's-length" advocates concerned largely with creating a favorable climate for reallocating scarce resources to the nonprofit arts.

For the councils, Baumol and Bowen's approach must seem like a philosophical argument in search of a practical application. People listen, they might say, to facts, not theory; and they are more likely to spend their money when the benefits are tangible. Two early public-sector studies make this perspective very clear and reflect the tone of most succeeding studies.

Massachusetts Governor's Task Force, 1973

In FY 1973, the Massachusetts Council on the Arts and Humanities received $279,556 in state funds. During that year,

Governor Francis Sargent appointed four task forces to make inquiries in areas relevant to the survival of the arts. Their effort resulted in the report, *The Arts: A Priority for Investment*. In the report, the arts had moved from an "economic dilemma," the title of Baumol and Bowen's work, to a troubled "industry," whose benefits could be secured for the people of Massachusetts only through a substantial increase in state funds.

The report was based on a census of nonprofit organizations with budgets over $5,000. Economic profile data were reported by discipline and included the fact that some organizations ran a surplus. The location of "rich" institutions by region was shown, as were the effects of deficits in terms of curtailed activities. The types of activities used to raise funds were shown together with data on types and sources of "earned" and "unearned" income.

The report advocated an "orderly increase" in arts council funding from under $300,000 yearly in 1973 to $5.6 million in 1976. The intent of the increase was to stabilize and develop the "industry." The report named the council programs to be supported with the proposed funding increase and recommended new programs to enhance arts education in the schools, create arts audiences, and promote accessibility.[7]

The premises of the report were that (1) the surveyed arts groups are priced so all can afford them; (2) thousands of programs and performances are offered and attended; (3) the arts and humanities "have become poor in serving the public"; and (4) "the state must begin to pay at a sufficient level for the services its citizens use."[8] This report moves from abstract economic principles justifying that it might be permissible for government to support the arts to hard facts relevant to an argument for a specific budget increase.

The arts impact portion of the report was the sweetener. The argument had two components. It was argued that

(1) state dollars would be returned "many times over to the people of the Commonwealth through contributions to increased tourism, attraction of new industry and residents, additional jobs, and growth of auxiliary services."[9]

(2) the arts make "a significant contribution to the well being of the Commonwealth," and "advocates of the arts and humanities might well argue that state funding is inappropriately low in the light" of that contribution.[10]

The first argument, in effect, says: "Don't worry. It seems like a lot of money, but the state is getting it back due to the enhanced

economic impact of the arts." The second argument is a variant of the Baumol and Bowen thesis. The Massachusetts report argued that those who attend arts events—the general public—are not asked to pay full price. The report suggests that if people had to pay the full price arts programs would not be accessible to everyone. In addition, it notes that the private sector could not pick up this difference in cost and price. Therefore, the state should.

The argument that the increase will be returned through more economic activity did not lead the task force to include a study of the impact of the proposed budget increases. In later years, the California Arts Council paid for just this type of study, the only known one of its kind. The approach to the second argument (that the arts industry itself has an economic impact) and the use of both arguments as a budget increase "sweetener" set the stage for most later impact studies.

The impact argument set forth by the report included the following elements:

- The "industry" employs over 10,000 people and has a payroll of $31.5 million;
- The "industry" pumps an additional $39.5 million into the economy through the purchase of goods and services and capital outlay;
- "Moreover, their audiences spend money on auxiliary services such as parking and restaurants";
- According to a study commissioned by the State Department of Commerce and Development, the state's "environment for culture" is a factor in business attraction and relocation;
- The "tourist industry is important to Massachusetts; the cultural organizations are vital to tourism."[11]

In short, the arguments focused on the significance of the non-profit arts and humanities to the economy of the state expressed in terms of jobs, business volume, and new business attraction, either through business relocation or tourism.

From the perspective of a member of the Massachusetts Arts Council, the report's purpose is to motivate the legislature to increase the arts budget. Those outside the council may suppose that the information about the economic impact of the arts is also relevant to decisions about how that budget increase will be spent.

For example, if the impact of the arts on attracting businesses is reason to support the budget increase, analyzing the level and type of cultural activity that appeals to the types of business the state seeks to keep and relocate might be useful. If a reason to

support the arts is how they affect tourism, an in-depth look at how the arts can promote tourism is appropriate.

By the same token, if an arts advocate cites economic benefits as a reason to support the arts, it is not unreasonable to presume that he or she seeks this support as a means to achieving those economic benefits, rather than arts support as an end in itself. Following this logic, it is also reasonable to expect that a concern to promote the cited economic benefits would enter somehow into agency policymaking. But it never does.

Economic benefits from the arts do exist. But bringing those benefits about is not the business of an arts council. Supporting the arts is. Consequently, there is no point in linking a study of arts impact to agency policymaking. If a council did that, it would have to consider impact in its program decisions. This is seen very clearly in the following example.

New York City Report of the Mayor's Committee on Cultural Policy, 1974

In February 1974, New York Mayor Abraham Beame appointed the Committee on Cultural Policy, which he asked to address a number of questions regarding the city's approach to supporting the arts and to advise on improvements to the existing apparatus. He also asked it to "evaluate the role of artistic and cultural activity in the economic life of the city."[12] The committee's report argued that New York's cultural assets always will be available to its people only if provided with the "continuous civic nourishment that healthy artistic and cultural efforts require. And in providing this nourishment New York is also strengthening its social and economic life."[13]

The committee staff found only one other "study" of the impact of the arts—the Massachusetts report. After examining it, the committee, in its arguments, mirrored the Massachusetts approach. In addition, to make its case, they not only used the term *economic impact* for the first time but also, unwittingly, in a footnote in an appendix, introduced the concept of an *economic multiplier.*

The report suggested that the city's artistic and cultural activities were a $3-billion-a-year business. The committee widely publicized this news. The message electrified arts agencies nationally, and many agencies requested the report.

The appendix to the report revealed that 33 percent of the impact was attributed to art galleries and only about 2 percent to the nonprofit arts organizations on which the city was spending $50 million annually. Committee staff attributed 25 percent of all tourism to the arts and cited a range of indirect effects on the climate for business; for example, the arts attract and hold busi-

ness and act to strengthen and stabilize real estate development in surrounding areas.

The staff also estimated that the industry accounted for over $100 million in tax revenues (twice what the nonprofit organizations received from the city), with the nonprofit industry responsible for roughly $8 million. An appendix says that this estimate was based on "premises furnished by the New York City Department of Finance," in particular, what was referred to without explanation as a "2.0 multiplier on salaries and a 1.5 multiplier on purchases."[14]

The committee's strategy in estimating tax effects is significant for two reasons. First, it introduced the concept of an economic multiplier. Second, without alerting the reader, committee staff changed the frame of reference.

The staff carefully stated that the industry had $3 billion in annual receipts and expenditures. The next sentence of the report said that the industry also contributed $102 million in tax revenues, implying that this also was annually.[15] In fact, the calculations in the appendix demonstrate that the staff used the concept of a multiplier as a vehicle to project forward all future rounds of spending based on the annual $3 billion and estimated tax revenues in later time periods based on spending this year. This approach also allowed the staff to count taxes paid by the industries with which the arts trade as opposed to taxes paid directly by the "industry" and its employees.

Later studies seized on this concept of a multiplier. Advocates recognized that New York's committee could have applied the multiplier concept to the annual $3 billion, characterizing it as an eventual $6 billion, by taking into account what other industries benefiting from trade with the arts spend and their trade, in turn, with others.

The New York study had an important policy purpose: "to advise on the City's cultural policy and on the kind of municipal structure needed to carry out such policy effectively." From the perspective of this analysis, a major effect of the effort was to validate within the arts community that the arts are significant economically and that their true economic significance must take into account their multiplier effects. Succeeding studies simply have refined this approach.

Recent Studies

The remainder of this chapter reviews 16 state impact studies.[16] These core questions are addressed:

- Why did the agency sponsor the study?
- What activities were studied?
- What methods were used to collect data?
- What types of findings were presented?

In answering these questions, this chapter will point out any technical or design problems with the study and offer suggestions for improving its usefulness and impact.

Study Objectives

First, the most primitive question: Why did states conduct economic impact studies of the arts? From a research design perspective, the first finding is rather startling. As a group, the state studies do not discuss the rationale for the research. For example, from a technical standpoint, the Iowa study is one of the better efforts. It is clear that the researchers had the complete cooperation of the state agency. Yet, it is also clear that the researchers were left to develop their own terms of reference. It was their study, not the state agency's. They were funded to conduct an impact study, and the "purpose of the study was to measure the economic impact of the arts." From a public policy perspective, this is not an adequate statement of purpose.

In order to be adequate, the statement of purpose must be specified by the sponsoring arts agency and should include a rather specific set of policy questions or purposes to be addressed. At a minimum, the statement of purpose should include: (1) a rationale for the definition of the "arts" activities in the study; (2) a specific definition of the various components of "the arts" (whether to treat the arts, for example, as one industry or many); and (3) a discussion of the facts needed by the agency to understand the arts (given the agency's objectives and policies), including the relevance of those facts to the specific policy questions prompting the study. Some studies make an effort to address these issues. Their statements provide a benchmark against which to evaluate the adequacy of all state studies, assuming that their aspirations capture the unstated motivations leading most, if not all, states to sponsor impact studies.

Some agencies seem to have a desire simply to provide numbers about the arts. The audience for such research is not the

agency itself but others interested in "quantifiable" facts about the arts. The South Dakota study illustrates this in its statement of purpose:

> Before this study was conducted, the number of non-profit arts organizations in South Dakota, the kinds of existing art forms, and especially their economic value was not well known. In order to get a better understanding of the quantifiable aspects of nonprofit arts organizations, the South Dakota Arts Council and the Business Research Bureau of the University of South Dakota conducted a survey of the nonprofit arts organizations in South Dakota.[17]

The terms of reference for the effort are unclear except that it will be a study of the nonprofit arts.

The Michigan study goes a bit further. As with the South Dakota study, it notes a "void in available arts related economic information" and seeks as well to (1) "quantify the economic impact of the arts" and (2) "develop an economic profile of Michigan's nonprofit arts institutions." The impact data are intended to assist "legislative bodies, corporations, and foundations . . . in determining the 'economic value' of arts expenditures. . . ." The profile data are intended to provide information arts groups can use "for planning, for comparison with other groups, and for fund raising and development purposes."[18] Taken literally, these statements suggest that the study was not designed to inform the members of the state arts agency—it was sponsored by a statewide citizen advocacy group—but to inform other funders in making decisions and to help the arts plan.

The Oregon effort casts the impact study against the background of genuine policy questions. Suggesting that the "subjective nature of the arts . . . defies the sort of measurement which we apply to other facts," the authors pose two questions:

> How can the contribution of the arts be measured so we can define appropriate policies for public support of the arts? From what perspective and base of information can we determine adequate levels of support?[19]

Although the study seeks to measure "contribution" and provide a "base of information," it does not outline the policy options and issues first. The study never presents a rationale for defining "adequate level of support," which may vary by type of activity. One cannot know, therefore, if the information it presents is complete or relevant. Matters are compounded when the stated objec-

tive includes a desire to address the planning and policy needs of others—for example, arts groups together with foundations and other funders.

All the studies fail to outline the policy questions they are intended to answer. This is a crucial failure because one cannot know what information needs to be collected until the policy questions are identified.

The practical outcome of this failure is quite simple. The studies' objective is to fund a research team to determine facts relevant to understanding the economics of the arts and arts impact. The methods used and the approach taken, however, are driven by (1) the researchers' interests and experience; (2) the level of direction they choose to take from the arts council; (3) the examples from other studies the council gives them that seem to capture what its members have in mind; and (4) the study budget.

Definitions of "the Arts"

Various aspects of the 16 studies illustrate the lack of an underlying policy milieu. They use different definitions of "the arts," while gathering and reporting different facts about "the arts." These differences are driven in part by whether the study emphasizes impact statements or statements about the economics of the arts industry. When the objective is a statement of the largest possible arts impact, studies cast their net widely. When the emphasis is on the economics of the industry as implicitly defined by a state agency's programs, there is a narrower definition and more consideration given to industry finances.

Identification of the range of state activities covered in each study proved difficult. Only six of the studies actually list the specific organizations, programs, and activities included in their research. The rest simply give general descriptions of the types of institutions included.

As difficult was identification of the sources of information used to develop a list of target activities. While seven studies did not report the source of their lists, most studies began with the state arts council's list. A few sought to supplement this through contact with local arts agencies, the statewide advocacy group, local tourism directories, newspaper listings, and so forth. One used a list of those who filed a Federal Form 990.

Did the studies cover the entire arts industry in each state? They seem to span the entire nonprofit sector eligible to apply for a grant to the state arts agency and known to that agency.

Vendors of arts supplies and specialized services (piano tuners, agents, and the like) are included only indirectly and to the extent

that they trade with the nonprofit arts. Only two studies covered individual artists. Only one study listed commercial activities.

Because of an inadequate definition of the arts, most studies represent a veritable stew of different kinds of activity. A majority of studies included university departments or programs, while at least four listed public broadcasting. Presenters and sponsors such as libraries or recreation departments often are put together with local arts councils and service organizations. Texas covered a wide range of for-profit activities.

With respect to sector definitions, studies tend to define the industry by discipline although there is no consistency across studies. Presenters and producing organizations both may be lumped together by discipline (say theatre or even the performing arts), or they may be listed separately. Educational programs are cited within discipline categories. Arts councils and service organizations may be joined or separated into the discipline category they service.

Any economic profile of an industry should define the industry in some relevant way. Discipline categories may be a beginning. But these categories should not be too large. For example, the broad category of music would include both symphonies and choirs. Presenters are not producers. Training programs are neither. Public broadcasting is yet another category. Matters are more complicated than they appear since researchers may want to distinguish types within a sector. Emerging groups, for example, probably have a different economic profile than established groups. These differences should be accounted for. The National Endowment for the Arts has tried to establish a standard set of classifications for (nonprofit) arts activities. The National Information Systems Project (NISP) may be worth considering as a starting point since states have had to report to NEA using categories and terminology of NISP.

Whatever categories are used, the situation is further complicated if aggregate results are distorted by a few activities. If this occurs, such activities should be treated separately—as in the Ford Foundation's handling of the Metropolitan Opera in its landmark study on the finances of the performing arts.

Typically, the state studies are less concerned with presenting an economic profile and more concerned with following the imperatives of their principal objective, namely, a statement of arts impact. If the objective is to collect and present certain aggregate data needed to state "industry" impact, then reseachers may feel little need to spell out the parts that make up the sum. After all, they may argue, the bottom line from an impact standpoint is simply the sum of the parts—the sum of items such as employment and spending. This approach, however, has the effect of

masking both the principal components of impact and particularly important organizations or types of activities.

Only seven of the studies analyze the extent to which some of the numbers are driven by a few activities. These studies usually present that information in the context of the total industry, not by sector. That is, it is revealed that total industry spending is X dollars and that Y percent of the activities sampled account for Z percent of this impact. It is usually not revealed whether the Y percent is concentrated in one sector or another. (Since sample sizes are small, the unstated implication in several cases is that a handful of activities account for the bulk of the impact.)

There are then three basic issues: (1) the best way to define the arts industry when presenting an economic profile and impact statement; (2) the best approach to presenting whatever relevant information is collected so that an authentic picture of the industry is reported; and (3) the types of information deemed important and relevant.

Types of Information Presented

While most of the studies attempted to go beyond simply presenting aggregate numbers for an ill-defined "industry," only one study presents any significant set of information by type of activity; thus, most information is shown in a way that masks the relative significance of any single element in the study universe. As noted earlier, only seven studies make any effort to sort out whether aggregate totals are driven by a few activities.

Most of the studies have not included all policy-relevant economic profile information. Half the studies do not identify paid admissions to the performing arts and are content with total attendance data that include unpaid admissions. Only three studies indicate whether the examined groups own their own building. Only two present data on ticket pricing. Only three offer data on the growth of "the arts" over time. There is no effort to identify whether groups are filling the halls. Most researchers seem to think that since no meaningful difference exists across disciplines in the economic profile, it is not important to present profiles by discipline. There are no data on the base of contributors compared with total contributions.

The studies emphasize service to the public (number of activities and attendance), together with evidence of financial need and the role of contributed income. If the emphasis is on economic impact, the studies focus on industry receipts or spending, jobs provided, and the multiplier effects of trade with other sectors of the economy.

The central purpose of these studies is to state aggregate impact numbers such as total employment in the arts and total budgets—to present the big picture, not the brush strokes. At the same time, the researchers often gathered the information by discipline or type of activity and could have presented the data by discipline, if asked, for the sponsor's own use.

Sampling, Data Collection, Extrapolation

A glance at their titles would indicate that the 16 studies presented economic profile and aggregate impact data for the entire statewide arts industry. Most make it clear, however, that they assess the impact of only those organizations that completed a survey questionnaire. Only six studies actually attempted to estimate the impact of the entire "industry."

Response rates to study questionnaires were modest. Three studies did not report the number of activities surveyed, so a response rate cannot be computed. Two studies had response rates of 50 percent or better (50 percent and 57 percent). Two had response rates as low as 17 percent. By not counting the two highest and two lowest response rates, one finds an average response rate across the remaining studies of 29 percent.

Three studies never make the source of data clear although one can assume that they relied on a return-by-mail questionnaire. Louisiana reports that it reached the entire universe of some 1,500 activities using personal interviews. Texas relied on public data sources for needed facts about selected commercial activities and used census data on artists and entertainers as defined by the census. Some states relied on studies done for other purposes as the basis for assumptions, in particular, Florida and Arizona with respect to tourist volume and tourist interest in the arts.

As noted earlier, six studies sought to extrapolate responses in order to make statements about the entire universe of activities receiving questionnaires. Some of the approaches are clever; some are better than others.

The researchers had a problem, however. If they sent a questionnaire to a list of organizations and most did not respond, they could not assume that the responding organizations were a representative sample. It is possible, for example, that only those organizations with bigger budgets and the staff to complete such a questionnaire bothered to fill it out. Since the studies usually were done in the name of the state arts agency, it is also possible that responses might have been biased in favor of organizations receiving a council grant that had an interest in satisfying the council. Finally, respondents might have fallen into certain disci-

plines. Perhaps, for example, if theatres were overrepresented in the sample, their economic profile, if extrapolated, would provide a false picture of all other organizations.

A state arts agency should be able to tell the researchers whether all groups with big budgets are in the sample. There may be, however, a number of activities in sectors that do not traditionally deal with the state arts agency about which the agency is unfamiliar. For certain sectors of the industry, though, one can presume that the state agency has an opinion as to whether the responding groups in that sector (for example, the responding orchestras) represented the vast majority of economic activity in that discipline.

The six studies that extrapolated from a sample of responses dealt with these issues in different ways. The Mississippi study took the simplest approach, which was simply to ignore the problems. Since the sample was one-third of the universe, researchers multiplied aggregate results by 3. This approach probably overestimated all aggregate data since it was likely that all groups with big budgets were already in the sample. Therefore, those that did not respond had much smaller budgets than the average budgets of the one-third that did respond.

The Colorado study tried something more sophisticated that is akin to the much simpler approach adopted by Oregon. Oregon simply assigned all nonrespondents to the lowest survey category. If the smallest annual budget category was $5,000, all nonrespondents were assumed to have a budget of $5,000. The state agency knew that the groups with big budgets were already in the sample. In addition, the agency assumed, correctly, that this approach would be conservative, especially since the result, when added to the sample data, was not significantly different.

Colorado used much the same method but implemented it in a more roundabout manner. Researchers subtracted from the sample 15 groups with budgets over $500,000. These groups represented 15 percent of the sample. They then divided the original universe list minus the 15 major groups into five geographic regions, corresponding to state planning districts, and similarly divided their sample. (For example, 273 activities located in the Denver metro area received questionnaires, and 84 responded.) They then used the Mississippi approach (by geographic area) to extrapolate to the universe in a region and cut the results in half. The approach reduced the average response per region by deleting all big-budget institutions and cut the extrapolated result in half before adding that result to the data from the sample. Functionally, this method probably had a practical result similar to that in Oregon.

The Florida study used another interesting approach. Researchers began with a list of state arts council grantees and deleted from the list all awards to individuals and nonarts institutions. The resulting adjusted gross total of grants was $1,253,741 (in 1978). Grants to all organizations responding to the survey then were identified. These totaled $892,763, or 71.2 percent of all grants. Thus, "it was concluded that the sample represented 71.2% of the universe and that, reciprocally, universe magnitudes were 1.4 times the corresponding sample figures."[20]

This approach is worth noting because the number of non-respondents is clearly immaterial. Unlike the other approaches, the research is not implicitly using the percentage of responses to the sample as a base for extrapolation. The approach, however, is completely arbitrary. The nonrespondents in the universe could have had budgets in aggregate 10 times that reported by the sample, and it still might be the case that the respondents got 71.2 percent of state grants. The supposed connection between grant awards and nonrespondent budget size is a mystery.

South Dakota's approach is somewhat like Florida's. The researchers saw that "although 45 percent of the organizations responded, about 90 percent of the population having access to arts groups was represented in the survey."[21] That is, the returned questionnaires came from organizations located in communities with 90 percent of the state's population.

Researchers assumed that the budget size of a group reflected the size of the community the group served. Small town meant small group. Researchers divided the population of all towns with resident arts groups by the population of the responding towns. That suggested to them that 89.46 percent of arts activity was reported "based on population." The reciprocal (1/.8946) was used to extrapolate data to the entire population. "Thus, the study concludes that the total state-wide economic activity is 1.118 times larger than the survey findings."[22]

This procedure assumes that all nonresponding groups from major cities have budgets akin to the average budgets of the nonresponding groups from small towns. It also assumes that there are no groups with big budgets in the small towns. In any case, it would have been easy to draw a small sample of nonresponding groups to determine if their annual budgets were consistent with the implicit average budget resulting from their procedure. This sampling was not done.

The Iowa approach is clearly stated. Researchers acknowledge that their "process may have led to under or overstatement of economic activity in certain categories depending on the reliability of the sample used."[23] It is worth noting because although they attempted to project by category, they recognized the pitfalls.

When they felt uncomfortable using the responses from any one category as a basis for projecting to all institutions in that category (for example, nine libraries as a basis for projecting to 443 in the universe), they dropped the category.

Researchers began with a sample drawn from the larger list. While the state agency used 15 different discipline categories organized further into 47 different types of "institutions," the researchers' random sample of the council list aggregated these into larger categories. Instead of music/band/college and similar sector "cells," they combined activities to form symphony-opera-theatre, other performing arts, and 10 other larger categories.

From this point on, the approach is as one would expect from the previous examples. The sample universe contained 53 arts organizations ranging from symphony to opera to theatre. There were 7 respondents (13 percent). The sample multiplication factor is 7.60 (1/.13). Similar multiplication factors were developed for the other categories. The researchers did the best they could with what they had, given their desire to extrapolate based on a sample.

Summing Up: Improvements to Research Design

As a group, the 16 state studies could have provided more policy-relevant information. The absence across studies of a consistent definition of the arts industry also has been noted. If information had been provided by industry sector, one at least could have compared and contrasted sector data from one study to the next. But there are no consistent sector definitions, and little of the information collected is presented by sector. If certain activities distort the picture of a typical economic profile of institutions within a sector, these distorting effects are not identified.

In general, the studies are not conducted with an interest in supporting policy debate. Selected information crucial to answering the policy questions that surfaced in the introductions to several studies was omitted later or never collected. These include such basic data as unsold seats and ticket prices in the performing arts, together with contributors and data on contributions for all the nonprofit arts.

The quality of the data cited in these studies is more difficult to assess. Most studies did not include the survey questionnaire. There were weaknesses in data presentation and data extrapolation. The greater weakness, however, was simply the willingness of state agencies to let researchers control the terms of reference for the study. Given the charge to develop economic profile statements and economic impact statements, researchers went at it from their own perspectives and with limited budgets. The results are arts advocacy studies that are not especially policy relevant.

Economic Impact Statements

Since other authors contributing to this volume will be commenting on the technical quality of arts economic impact estimates, I will not address it here. Elsewhere, I have discussed at length that economic multiplier means "respending coefficient" rather than some magical creation of additional dollars for the state economy. However, since the impact statements are the "sweetener" to the advocacy argument and the whole motivation in some instances for conducting a study, something must be said about areas for improvement.

Most of these studies did not attempt to extrapolate from questionnaire respondents to the entire universe of organizations and activities. They simply cited the impact of organizations choosing to participate in the study; in most cases, those organizations represented less than one in three known activities. One can presume that the researchers did not feel comfortable using their sample as a basis for extrapolation.

Clearly, room for improvement exists in either coverage of the universe or existing approaches to extrapolation. Ultimately, the quality of the extrapolation reflects the quality of sample designs. This outcome probably has never been a concern since most of the impact in some states can be traced to activities known to the sponsoring state agency. If the state agency felt that those organizations with big budgets and a few second-tier groups accounted for most of the impact, they may have seen no need for better research designs. The extra effort would capture little additional impact information.

There is also room for improvement in the procedures used to arrive at impact estimates. The precision of the impact assessment is a function of the procedures used to estimate multiplier effects. A majority of the studies played fast and loose with their descriptions of these procedures. For example, available estimating models did not include the arts "industry." Most states used either proxy industries assumed to have the same types of effects as the arts or an aggregate proxy, namely, the average of all industries.

Several studies simply said that "the statewide multiplier effect is X as determined by state agency Y using model Z." This statement implies one multiplier for all industries, which may mean the average of all.

The better studies show arts industry spending patterns by type of expenditure with wages treated separately. Available statewide input/output tables then are used. This approach treats arts impact as the impact of spending by the arts on other sectors that trade with the arts. Although this is the preferred approach technically, a proxy-sector approach may yield much the same results. A proxy

sector is acceptable if there is reason to believe that results would be similar to a more technically adroit approach.

The Iowa study provided the best discussion of the idiosyncrasies of the model used. Models may not include the impact of wages or that of tax expenditures. The Iowa state model did not, and the researchers dealt with this in an appropriate way.

Implicit in the typical approach is the thought that the impact of the arts must be similar to that of other industries or at least no better. Studies did not address the respects in which the arts are to be preferred over other industries, although mention was made of their role in tourism development and their contribution to making the state attractive to business. The two studies that tried to document statewide effects on tourism used extreme leaps of faith from general tourism studies. Such leaps of faith should be avoided, if possible.

"Leap of faith" refers to assumptions that may or may not be consistent with the data. For example, a study of tourists may find that X percent cited "cultural attractions" as important to their visit. This finding leads to an assumption that these tourists stayed a day longer in order to take advantage of "cultural attractions" or some similar attempt to use the data as the basis for assumptions about arts impact.

Some valid impact statements were not made—tax impacts in particular. If the researchers knew the industry's resident wage bill, they should have been able to estimate income taxes paid. Retail sales tax revenues also should have been easy to estimate.

Various components of industry impact often were ignored. If the study includes university-training programs, then it seems appropriate to include spending by out-of-state students enrolled in those programs. Only one study included an estimate of the impact of in-kind spending (actual dollar spending on behalf of the arts that would have been part of the industry's expenditures). Spending by out-of-state guest artists typically was not cited.

Of greater concern is the fact that only half of the studies clearly identified in-state arts spending as opposed to the total budget of the arts. The better studies applied the multiplier to in-state spending only. This approach is clearly more conservative than assuming that a proxy sector has the same percentage of initial leakage.

If the purpose of the effort is to indicate the order of magnitude of arts impact, then virtually all the studies are fine. From a technical standpoint, they can be improved, but most made acceptable stabs at the task given budgetary and other restrictions.

The real improvements that need to be made in these studies are at the front end of the exercise. State agencies must control the terms of reference, or else there must be a more ruthlessly

simple approach that adequately focuses on the narrow task—the impact "sweetener" argument—in a cost-effective way. If these studies intend to gather policy-relevant economic data, however, then agencies must gain control of their terms of reference. That is the lesson in this overview of example studies. This review leaves one with the impression that either agencies did not know what they wanted or they knew what they did not want to know.

Notes

1. William J. Baumol and William G. Bowen, *Performing Arts—The Economic Dilemma* (New York, N.Y.: Twentieth Century Fund, 1966), p. 386.
2. Ibid., pp. 382–383.
3. Ibid., p. 383.
4. Ibid.
5. Ibid., p. 385.
6. Alvin Toffler, "The Art of Measuring the Arts," in Bertram Gross, ed., *Social Intelligence for America's Future Explorations in Societal Problems* (Boston, Mass.: Allyn and Bacon, 1969), p. 263.
7. Governor's Task Force on the Arts and Humanities, *The Arts: A Priority for Investment* (State of Massachusetts, 1973), p. I–4 ff.
8. Ibid., p. I–3.
9. Ibid., p. I–5.
10. Ibid., p. II–32.
11. Ibid., p. I–3.
12. *Report of the Mayor's Committee on Cultural Policy* (New York, N.Y.: Mayor's Committee on Cultural Policy, 1974), p. vii.
13. Ibid., p. 6.
14. Ibid., p. 37.
15. Ibid.
16. The following studies were surveyed; full citations can be found in the Bibliography: Arizona, 1981; Arkansas, 1984; Colorado, 1983; Florida, 1979; Hawaii, 1982; Iowa, 1985; Idaho, 1978; Louisiana, 1980; Michigan, 1985; Mississippi, 1983; Nebraska, 1984; Oklahoma, 1985; Oregon, 1981; South Dakota, 1981; Wisconsin, 1976; and Texas, 1984.
17. Mara Lemanis Cunningham, *Economic Survey of Non-Profit Organizations in South Dakota* (Pierre, S.D.: South Dakota Arts Council, 1981), p. 1.
18. Touche Ross, *Michigan: State of the Arts; An Economic Impact Study, Summary of Findings* (Detroit, Mich.: Touche Ross, 1985), p. 2.
19. Oregon Arts Commission, *Dollars and Sense of the Arts: Summary of an Economic Impact Study* (Salem, Oreg.: Oregon Arts Commission, 1981), p. 5.
20. George C. Steinike and Dana N. Stevens, *The Economic Impact of the Arts in Florida* (n.p.: Division of Cultural Affairs, 1984), p. 14.
21. Cunningham, *Economic Survey of Non-Profit Organizations in South Dakota,* p. 9.
22. Ibid.
23. John W. Fuller, *Economic Impact of the Arts in Iowa* (Iowa City, Iowa: Institute of Urban and Regional Research, University of Iowa, 1982), p. 12.

The Role of the Arts in State and Local Economic Development

by

R. Leo Penne
Partners for Livable Places
Washington, D.C.

and

James L. Shanahan
Department of Urban Studies
University of Akron
Akron, Ohio

Portions of this chapter are excerpts from Robert H. McNulty, R. Leo
Penne, and Dorothy R. Jacobson, *The Economics of Amenity: Community
Futures and the Quality of Life* (Washington, D.C.: Partners for Livable
Places, 1985).

Because the arts can generate significant economic benefits, it is easy to jump to the conclusion that performing arts centers, ballet companies, theatres, music festivals, and other concrete manifestations of the arts can play central roles in state and local economic development strategies. That may or may not be the case, depending on local circumstances, including the characteristics of the state or local economy and the project or activity in question.

The arts advocate wants to be able to demonstrate the plus factor created by a particular amenity in terms of jobs, personal income, and public revenues. The economic development professional needs to understand how to maximize economic benefits from amenities and to weigh the relative benefits of alternative investment opportunities. Community leaders want to be able to make the most productive links possible between these two important objectives of their efforts: quality of life and economic vitality. Neither overvaluing nor undervaluing the economic impacts of amenities serves the interests of any of the parties involved.

Some portions of such assessments involve hard numbers—quantifying either projections or past performance—whereas other portions involve informed judgments. Determining how many people are employed by a performing arts institution is relatively easy; so is finding out the amount of entertainment taxes paid by those who attend performances. It is somewhat more difficult to trace spending by the institution and its patrons through the local economy. These are the direct and indirect impacts. Going beyond them involves making informed judgments about things such as the degree to which the facility stems economic and physical deterioration that otherwise might occur and the contribution that the particular institution or class of institutions makes to the area's overall livability and competitive advantage.

Development, whether carried out by private- or public-sector institutions, is an art, not a science. Judging the development benefits of a particular project, whether or not it involves amenities, requires not only assessing the viability of the project itself but also taking into account other considerations, such as the relative benefits of other investment opportunities, the possibility that the project might be undertaken without development subsidies, the risk of competing with businesses that already are operating, the net effect on the economy, and the duration of the effect. A business decision is based on the likely profitability of a particular establishment. The public balance sheet includes many more factors that are much more difficult to assess. To understand the potential roles of the arts in state and local economic development strategies, it is useful, if not essential, to see the arts in the

context of economic development and, in turn, to see economic development within the context of the nation's changing economy.

Economic Transition and State and Local Economic Development

Powerful forces are reshaping the economy. The decline of the manufacturing sector relative to services and "high tech," combined with changes in manufacturing organization and processes, have produced an economy that is very different in terms of investment, output, and employment from the economy of several decades ago—and one that is not yet well understood. For example, many persons continue to think of the service sector as limited to consumer services—laundries and household help—and do not yet perceive the significance of the expansion in financial and producer services. Similarly, figures on the "information industry" do not express fully the impact of advances in telecommunications on businesses in all sectors. The changes now in progress involve revisions in the organization of business and in the relationships among businesses that translate into terms of great economic importance to cities. As a result, job losses because of closings, contractions, and transfers of operations have an impact on cities and, in some cases, entire urban communities. Hardest hit are the older urban areas in the northern and midwestern cities in all regions that were built as production centers with a heavy manufacturing base. Loss of manufacturing jobs provided by larger corporations accounted for the largest source of job loss from the Frostbelt to the Sunbelt and Far West regions.

It is clear that the transformation of the national economy is resulting in the transformation of many individual local economies and of the relationships among local economies. In one view, some areas will capture a central role in the new economy, being the sources of direction for widely dispersed activities. Others will have less diversified, more concentrated economies tied more tightly to a single function. And some will retain their affiliation with the industrial economy and continue to be centers of manufacturing. The first will experience the greatest growth and the greatest stability; the last will experience the least. How change will play out in particular communities will depend on their specific characteristics and local actions to take maximum advantage of the opportunities offered by changing circumstances. The issue is not whether cities will change, but whether

the change will be for the better or worse. Realistic transition should be the objective.

State and local governments must bear much of the burden of facilitating the nation's economic transition. Macroeconomic policies, influencing aggregate supply and demand, will not trigger the mechanisms that must work to restore viability to the economy's mature industries and stimulate and capture the economic benefits of new-growth industries. In response to this challenge, the practice of state and local economic development has undergone a revolution in recent years. As the practice of economic development has spread, the perspectives have shifted in a number of respects. Today's programs embrace the full range of goals and initiatives described in Figure 1.

Figure 1.

Turning Economic Development Goals into Initiatives

Source: R. Leo Penne, *The Economics of Amenities* (Washington, D.C.: Partners for Liveable Places, 1985), p. 123.

A decade ago, many state programs put most of their resources into general promotion and industrial attraction, and many localities had no economic development programs at all. Today, economic development programs at both the state and local levels are common, ambitious, varied, and sophisticated. They employ tools such as incubator facilities, enterprise zones, equity investment funds, and technology transfer. Such programs:

- Focus on retaining and expanding businesses and on creating new ones as well as attracting outside businesses, recognizing that most jobs are generated by businesses already in place or by business start-ups, not by outside firms moving into the community;
- Pay attention to service-sector firms as well as to manufacturing;
- Put greater stress on small business and entrepreneurship as sources of growth and vitality in the local economy;
- Employ a wide range of tools to encourage investment, not limited to traditional techniques such as the provision of land, tax abatements, or advantageous financing;
- Give higher priority to factors contributing to a favorable general climate for investment relative to firm-specific assistance;
- Blur the distinction between public and private functions.

In general terms, one or more of three broad strategic options may be pursued to retain, expand, or change the mix of investment in a city: retention and expansion of existing businesses, creation of new ones, and attraction of businesses from outside the community. Within the broad strategic options, development programs need priorities for focus. They may focus on firms within a particular sector, such as manufacturing, retailing, services, or tourism; or on specific areas such as the downtown, neighborhoods, or a waterfront. These categories obviously overlap; for example, a downtown redevelopment program may focus on the retention of retail establishments, the expansion of local service-sector offices, and the attraction of "back-office" facilities of a national corporation.

The most common and important of the goals of economic development are job creation, tax generation, and physical revitalization. Other goals include diversifying the economy, improving the provision of local goods and services, and using untapped resources. The methods used for achieving these goals vary from place to place and over time.

Wilbur Thompson, eminent urban economist, sets forth an important framework for judging the relative importance of strategies aimed at immediate industry growth versus those directed toward improving the region's capacity to provide jobs in the future. Near-term economic development objectives should focus on stimulating investments by businesses with the greater potential for producing net new jobs for the region—either through expanded export sales or reduced import sales. Longer term economic objectives, in contrast, should concentrate on improving what Thompson terms *developmental services* (see Figure 2): those public as well as private

Figure 2.

The Local Economic Base: Short Run and Long Run

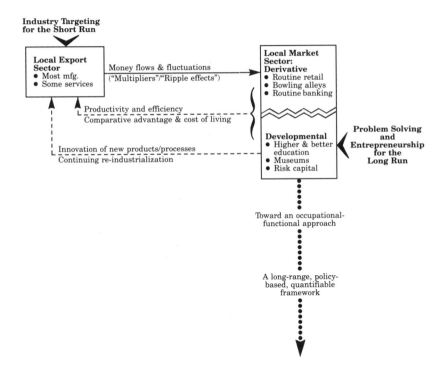

Source: Wilbur Thompson and Philip Thompson, "From Industries to Occupations," *Economic Development Commentary* 9, no. 3, National Council for Urban Economic Development, p. 13.

enterprises within the region that "largely determine the efficiency and creativity of the full local economy."[1] It is these services that determine local "comparative advantage and disadvantage" in competing with other regions for new industry. The quality and mix of these industries reflect the level of sophistication and maturity of the local economy. To Thompson, this mix is essential for successful problem solving and entrepreneurship for the long run.

Developmental services cut across all segments of enterprises primarily serving customers based in the local economy. These include some manufacturing services but also include intermediate services to businesses and institutions as well as to households. Only those elements of the local service sector that support and enhance business opportunities at costs competitive with other locations are considered developmental services.

In summary, developmental services include:

The area as a place to live:
Quality higher education;
Museums, zoos, and other cultural services.

The area as a place to do business:
Research and development laboratories;
Transportation services;
Business and other professional services (specialized and sophisticated, such as computer services);
Communication systems;
Risk capital.

In this context, these services are important to the region's economic future not because of the jobs, tax base, and the like that they provide directly, but because they constitute a base of resources that are important in creating opportunities and influencing decisions of businesses and people in the future: "Most export industries come and go; the key local services abide."[2]

The clear implication for formulating economic development strategies is that short-term strategies should be directed toward stimulating investments, creating jobs and income, and reducing cyclical unemployment. Long-term strategies, in contrast, should be directed toward enterprises and projects that would enhance the comparative economic advantage of a place, both to live and do business.

Importance of Quality of Life
to Local Economic Development

One of the most important changes in recent years has been the increasing significance accorded to the quality-of-life factor in economic development programs. Over time, the quality-of-life factor has become stronger relative to other traditional investment factors. Jobs follow people in two respects: Businesses that depend on markets tend to follow population (although density, as well as total size, is important); and business investment is more likely in places that are attractive to educated, highly skilled workers, managers, and entrepreneurs.

Business location decisions are influenced by a number of factors. Quality of life is one of these factors; better yet, quality of life is a set of factors that combine to determine whether a particular community is an attractive, appealing place to live, work, and do business. Quality of life—including items such as housing, education, health care, security, and entertainment and cultural activities—can influence private investment in a variety of ways. By holding and attracting residents, a community's quality of life contributes markets for certain kinds of service-sector firms. By increasing the interest value in its downtown through entertainment and cultural facilities and high-quality design, a city can strengthen its potential as a headquarters and financial-services center as well as buttress its retail sector. Offering the schools, housing, and amenities that are important to highly skilled workers and managers strengthens an area's attractiveness to high-tech businesses. Being known as a good place to live or an interesting place to visit enhances an area's image and improves the odds that it will succeed economically in ways that are real but difficult to quantify.

As the services sector and technology-driven industries expand, quality of life is becoming a more important location factor relative to the other factors, such as the proximity to materials and cheap transportation that are more important for manufacturing. Development strategies can and should integrate quality-of-life considerations and actions into programs involving other economic development concerns such as land, financing, and management assistance. But generalizations will not satisfy the need to understand the relationship of quality of life to economic development in a particular community. What matters and what should be done depend on local conditions, objectives, and resources. It is important, therefore, to pay serious attention to quality of life in the development of an overall strategy and not

to treat it as a matter that can be handled casually or that is too vague to be dealt with systematically.

Analyzing Competitive Advantage

In considering the local urban economy as a competitive location in which to start or expand a business enterprise, firms and potential entrepreneurs must be understood in terms of the *geographic reach* of their markets—is their (potential) business export oriented or local-market oriented? In different ways, the future changes in the population base of the local economy are important to both types of economic activities. For the export-oriented firms, the trends in the size and qualifications of the area's work force have important bearing on the region's comparative advantage. For local-market-oriented firms, the trends in size and mix of the population base greatly affect market potential. Economic development strategies aimed at retaining and attracting the more mobile and skilled population are critical to the future of the local service sector.

Livability is just as important to those entrepreneurs, businesses, and their workers providing Thompson's developmental services. In most sectors, locational decisions made in larger national service companies headquartered elsewhere do affect the local services sector—legal, public relations, accounting, engineering, management, consultants, and the like. Just as with upper management in the manufacturing sector, these executives are influenced by the image and reputation of a community and the quality of life.

As the National Academy of Sciences' urban policy committee put it, there is "considerable latitude for transforming [cities] into livable places that perform important economic functions."[3] The link can be stated even more strongly: Cities that are not livable places are not likely to perform important economic functions in the future. Enhancing livability, therefore, should be a central objective in every city's economic transition strategy, and the elements of livability should be employed as economic development tools. Cities that are attractive as places to live and work will be attractive as places in which to invest. Not every "amenity-rich" city can expect a future of unending economic prosperity, but few cities that do not offer an attractive quality of life can expect their fair share of the growth that will occur in the nation's economy over the coming years.

During the late 1970s and early 1980s, the role of the arts in urban economic development was the center of discussion among policymakers at all governmental levels and among economic development officials. Since then, the problems of U.S. industry and the national economy have become the focus of discussion in local

economic development. A more competitive U.S. industry for both foreign and domestic markets, linked to increased technology generation and utilization, is seen as the path to economic development. To aid industry, local strategies geared toward long-term pay-offs have shifted their emphasis to enhancing university laboratories and training in science and engineering technologies. The ultimate pay-off for economic development is measured in terms of new products, processes, and services created within the region, not lost to other locations. The successes of Salt Lake City; Lowell, Massachusetts; and the Research Triangle of North Carolina helped ignite interest in economic development strategies that could capture technology-driven companies and industries for their regions. Concerted efforts, such as long-term strategies, reinforce the importance of considering the issues of amenities—cultural amenities in particular—in creating livable environments.

Attention has been focused on the fact that many businesses are likely to start up or to locate in areas where highly educated innovators and highly skilled managers and workers want to live. This phenomenon accounts for some surprising economic growth in areas that have experienced overall population decline. Schmenner, one of the country's leading authorities on corporate location decisions, emphasizes this view:

> For high-technology industry especially, the most fearsome competitive advantage it can wield is a happy and productive staff of engineers. Since proximity to markets or suppliers is not required in such companies, they can be extraordinarily footloose, locating in areas that are attractive to their engineers and managers.[4]

Quality of Life: Potential and Limits

Despite the weight of these findings, one should not claim too much for the influence of the quality-of-life factor on urban economic development. Ultimately, businesses can exist only where they can make a profit. As noted above, quality of life is most important to businesses whose profitability relates directly to this factor—retail establishments and local service firms, including financial institutions, which depend mostly on local markets. The group that is the next most influenced includes firms that depend on well-educated entrepreneurs and highly skilled workers, has complex networks of service relationships, and is least concerned with traditional location factors such as proximity to materials or rail or water transportation. Firms that must consider such location factors or whose profitability is most affected by the cost of labor are the least influenced by quality-of-life factors.

Role of Amenities in Economic Development Strategies

Planners of an economic development program, whether directly involving the arts and other amenities, normally seek to apply the right tool or technique to solve a particular problem or achieve a certain objective. Where, for example, financing is unavailable for small-business expansion, a revolving loan fund may be created. If a business is considering relocating because skilled labor needed for a new product line is scarce, program developers may offer customized training. If businesses complain about red tape, a city may institute one-stop service for permits and licenses. (It is important for program developers to distinguish between matters that can be controlled locally and those that cannot in order to avoid wasting resources. If, for example, no market exists for a product of a failing firm, local aid will not save that firm.)

The starting point is to consider amenities along with the other approaches and tools available for urban economic development. In every city, there are opportunities for strengthening the performance of development programs through the more systematic inclusion of cultural resources. Developing the various potential roles to fit local circumstances probably will require more than a business-as-usual approach and will depend on the development of a strategy more inclusive than that guiding most traditional development programs.

For amenities to be effective parts of an economic development program, they, too, must be applied as tools for solving problems and achieving objectives. Economic program developers should recognize at the outset the potential role that amenities can play in various strategic options. As discussed later in this chapter, Pittsburgh provides an example of one city's view of amenities in its overall economic planning.

The strongest, most direct, and most frequent connections between amenities and urban economic development are those involving tourism and downtown development. Tourism is, by its very nature, an amenity industry, and the retail and office facilities that make up downtowns depend heavily on the ability of the central business district to compete with suburban malls for shoppers and to offer pleasant surroundings for office workers. Where tourism and downtown development are priorities, elements such as animation, design quality, cultural resources, and natural and scenic resources are likely to play significant roles. Amenities have a similarly strong relationship to neighborhood development, both commercial and residential. With industrial

development, such amenity elements are not a direct profit factor but more a function of their contribution to the overall business climate or their attractiveness to owners and managers. And, as discussed earlier, there are businesses in a middle category—services and the innovative components of high tech—for which amenities provide either markets or desirable settings for highly educated owners, managers, and workers.

What Do We Mean by the Arts?

The term *the arts* is used inclusively in this chapter as: (1) an industry in which individuals, institutions, and organizations are functioning as businesses interrelated with other local businesses; (2) broad-based to specific cultural amenities; or (3) cultural education, tools, and processes.

Hendon, founder of the International Association of Cultural Economics, delineates the arts as follows:

> The term "arts" as we use it includes the activities of artists and craftsmen, consumers, and institutions such as performing arts groups, arts education and production theatres, orchestras, and other on-going permanent arts organizations. In addition, we would include transitory or temporary arts activities such as exhibitions, festivals, and fairs. Further, we think in terms of the popular arts so that we may include popular music, the artistic elements of media such as certain types of television, film, publishing, and radio. Taking a broad definition of arts industries we include those institutions which do not produce art for consumption, but which make the production of art possible, such as the basic educational institutions, and the support goods and services of various arts activities. This extends the interest to music and photo shops, libraries, theatres, public and private schools, professionals engaged in instruction, performing arts halls, sound studios, printers, and such things as art supply stores. Finally, we also include architecture to the extent it deals with aesthetics either as an output such as historic preservation, or as an input. This can include art in public places, actual architectural development of new buildings, and rehabilitation of aesthetically interesting and historically signifi-

cant buildings. Part and parcel of these latter forms would be the inclusion of landscape as part of an aesthetic motif.[5]

These vestiges of art, aesthetics, and culture can be considered among the amenities of community life. *Amenities* refer to perceived positive attributes. Broadly defined, an amenity provides opportunities, conveniences, or pleasure in daily life. Cultural and environmental amenities form a catch-all category for all aspects and impacts of a community's cultural and leisure industries. Just as important to cities are the natural amenity sources—climate, bodies of water and waterfront areas, hillsides and mountains, and so forth.

By implication, *disamenities* refer to the aspects of community life that engender a negative view of the area because they detract from the quality of life, limiting or reducing opportunities and creating barriers or inconveniences. Disamenities, such as pollution, overcrowding, crime, traffic congestion, blight, and litter, serve no useful purpose.

The perceived mix of amenities and disamenities in an urban area improves when the environment can support an increased number of amenity sources and when disamenities such as crime levels and personal safety diminish. Since cultural and leisure resources represent an important source of amenities, they can affect improving the quality of life and rebuilding economic and population bases significantly.

The Arts and Development[6]

The arts are linked to the development process in many ways and toward diverse objectives.

Arts as industry:

(1) The arts are a part of the local economic base, providing jobs and income to local residents.

(2) The arts industry involves minimal use of exhaustible resources.

(3) The arts industry will be an integral economic part of the service economy in the postindustrial era.

(4) The arts industry is the single most significant source of amenities that clearly favors the central city economy as a location.

139

Arts as cultural amenities:

(5) In reshaping and rebuilding the physical environ-
ment in urban centers, one must take care to apply
artistic skills for an aesthetically pleasing and in-
tegrated physical fabric. These efforts will enhance
and expand the economic objectives.

(6) The availability of artistic and cultural activities
and cultural amenities can be a decisive factor in
both industrial and population relocation and re-
tention of a rich human resource mix.

Arts in education and human development:

(7) Arts appreciation encourages consumption pat-
terns that are less wasteful of exhaustible re-
sources and do less harm to the environment than
other types of consumption.

(8) The arts can fulfill the human need for nurturance,
support, and identity, which is important to the emo-
tional well-being and mental health of city residents.

(9) Many of our unemployed and underemployed can
be retrained by using the arts and artistic skills
development.

Arts in neighborhood development:

(10) The arts can provide the ethnic and cultural glue
for neighborhood identity and cohesion—an intan-
gible element of neighborhood revitalization.

(11) Neighborhood economies can be strengthened by
using arts and artists.

In examining the relationship of the arts to development, some
problems of definition may be minimized if one considers develop-
ment to have three components: (1) economic, emphasizing the
importance of the industry mix for a vital local economy; (2) physi-
cal development, encompassing the importance of the physical
environment as the skeleton of the urban fabric; and (3) human
development, focusing on the importance of meeting the total set
of human needs. Obviously, any strategy for setting development
objectives requires an integration of these three aspects.

Economic Development

In the short term, local economic growth largely depends on the local industry mix, particularly as it is made up of new manufacturing and services with income-elastic product demand and any other fast-growing industry with a regional or national base of operations. Also, in the postindustrial (manufacturing) era in the United States, additional development criteria have emerged: environmental safety and energy efficiency, if not conservation. In the previous list, items 1, 2, and 7 view the arts as a local industry capable of promoting qualitative development in both production and consumption.

Over the long term, however, the viability of any urban economy depends on its capacity to invent and/or innovate or otherwise acquire new export bases. But what must be accomplished now and what kinds of processes should be set in motion if the transition to a service economy is to be made? In this context, items 3 and 6 would apply: The arts industry is an integral part of a future service economy, and a broad set of cultural amenities may act as a magnet for attracting and retaining future generations of people and jobs.

Physical Development

Physical environment provides a considerable amount of place value for society. On the one hand, the aesthetic design of the physical environment may be an important social amenity in the quality of life. Hence, item 5 says that the arts can apply skill and use cultural tastes in the design of a pleasant physical environment. Bacon, for example, refers to the arts as the "paradigm for urban planning."[7]

The present physical environment also provides cultural ties with both the past and the future, a cultural inheritance for immediate future generations with some parts even preserved for the more distant future. Hence, youthful U.S. cities, when compared with cities like Edinburgh, and the development process of the American "disposable city" reduce the historical significance of the nation's cities.

The physical environment is the skeletal framework for the economy. Development of physical resources over time must be compatible with changing social and economic activity. The arts industry, as an integral part of a developing service economy (item 3), may contribute to important economic returns—at least in portions of the local economy—even though the arts industry may not be directly responsible for generating these benefits.

Human Development

The idea of quality of life includes the full range of human needs, not merely economic gains. Indeed, many needs can be satisfied outside the economic market.

Much work has been done to identify measurable dimensions of social, economic, and cultural factors for the purpose of monitoring "improvement" in the urban quality of life. Social indicators, for example, can measure increased schooling or decreased infant mortality that, by definition, are assumed to indicate the increased well-being of the population. Such achievements are positive, and as an individual one feels positive about them. Unless one experiences them personally, however, he or she has no effective need or means to place a real value on them, and one's life in the city may be largely unrelated and unresponsive to many of the elements of social indicators.

Items 7 and 9 suggest that the arts and their appreciation have an aesthetic potential that permeates all human experience; that is, for some people, the arts can provide the aesthetic thread from which the quality of life's fabric is woven. This provides the context for the claim that the arts can be related directly to emotional well-being and mental health.

Not surprisingly, then, the development of human potential has become linked to the arts in education. The arts can be an educational tool if aesthetic values and artistic methods enhance the building of production skills while developing consumption skills. In other words, the arts may be an integral part of developing human potential for production and consumption.

An important link exists here with the economic development objective of achieving an urban life style that is not wasteful of exhaustible resources or environmentally unsafe. Meeting any of these needs outside the marketplace is problematic, however, since the urban area functions best as a market center—for production and for meeting final demand by residents for consumption and investment. Urban institutions work very well to satisfy the economic needs of the cities within the limits of their individual control over resources, but they work very poorly at meeting noneconomic needs. Scitovsky presents cogent evidence of the institutional and cultural bias in American society against meeting human needs for social comfort and stimulation outside the marketplace.[8] The net result is that Americans—when compared with citizens of other Western countries—satisfy their need for status, self-fulfillment, recreation, and so forth with the aid of many durable goods that may be bought for other reasons. Window shopping, driving for pleasure, and gauging status in terms of durable goods collected are examples. If the arts are used as

an educational tool, individuals in the future may choose less materialistic consumption patterns and life styles as a result of taste developed through the educational process.

The Arts as a Growth Industry: A Direct Contribution to the Economy

Can expansion in the local arts sector generate new jobs, income, and tax revenues? What kinds of jobs will be created? Is the arts industry a leading industry rather than one that responds to growth in other sectors of the local economy?

New economic growth for the urban area results in two ways: (1) expansions within the local economy's services to satisfy a larger share of existing local business and household demands, demands that otherwise would be imported from "foreign" firms — import substitution; and (2) increased demand for domestic production from anywhere outside the area — export expansion.

In order for arts institutions to make a real contribution to the growth of the local economy, at least one of three conditions must be met: (1) residents must begin to purchase locally produced art in place of art produced elsewhere; (2) new visitors must begin to purchase locally produced art; or (3) local artists must export their art and spend the income locally.

In meeting economic development objectives, the importance of "multiplier" and "ripple" effects should be minimized. What is more important is the rate of growth in jobs, income (sales or expenditures), and tax revenues resulting directly from an expanding arts sector.

The arts as an industry seldom become a major component of a community's export base. As Hendon argues, the basic fact of economic life in the arts is the control of the most profitable elements of arts production by a relatively few large national and international firms in each arts industry.[9]

The profitable arts are big business, and often they are sufficiently interrelated to cause them to locate near each other. This propensity has the practical effect of creating a few cities or regions that are rich in arts products and leaving most other cities bereft of much arts export activity. In the United States, one thinks of New York and Los Angeles; in England, London; in France, Paris:

> [F]ew cities can decide to become broad based exporters of arts products. . . . Most cities do not have a true arts

identity except in a minor or regional context. . . . We become importers in most other arts goods, unique in one export but utterly homogeneous in most other arts imports. The cultural life in any community becomes homogenized and the artistic life in a community, a balance sheet in which activity must meet a market test to endure.

As a result, only those elements of the arts that are relatively unprofitable will be left to develop in most cities resulting in the local cultural nonprofit organizations.[10]

The typical nonprofit arts institution has been likened to a car wash or a McDonald's franchise in terms of the size of its business volume; all three are small, personal, commercial enterprises. While the absolute growth impact still is small, there well may be growth impacts during certain phases of qualitative shifts in local fine arts institutions, artists, and the production of cultural services. As purchased amenities, locally provided fine arts—live performing arts most prominently—are one of the last local business sectors to develop. During their formative years, performances seldom are considered quality art, when *quality* is defined as an acceptable alternative to either a touring group or a trip "out of town." While it may take one or two decades, a local performing company eventually might replace the need for local art consumers to import "good" performing art. In economic terms, this shift means that more local cultural expenditures go to businesses and workers who live in the area and spend their money locally. As Hendon describes, a few aspiring performing companies may be able to expand their audience to the regional or national level.[11] The company can serve regional and national audiences by going on tour or by attracting out-of-towners to local performances.

Like most (especially personal) service industries, the arts provide services not only to local consumers but also partly to those from other communities. Initially, most service industries exist to satisfy local, not export, demand. (Yet, it is probably true that most small independent manufacturing and processing enterprises start up with only local customers.)

In short, arts as industries, in all but a few places, will not be among the stronger producers of net new jobs and income for the regional economy for several reasons:

- The potential for profitable arts enterprises with regional or national/global markets is limited; therefore, growth of export demand, while possible, cannot compare with certain other industries.

- The local market for arts consumption is not growing as fast as those markets for other consumer goods and services.

While the rate of job creation within the local cultural sector is comparable to other parts of the local service sector, the arts' major contribution to economic development is indirect. For most cities, therefore, the greatest economic development potential of the arts is in indirect effects. As Cwi writes:

> The true significance of the arts in economic development may not lie so much in the quantifiable direct and indirect effects on the economy of a community as it does in the improvement and attractiveness of the city and center city. . . . The arts can contribute to changing a city's image, retaining downtown retail trade, drawing more tourists to the city, creating markets for new business, encouraging new private investment from suburban to city locations. They may also develop community pride and spirit and improve the chances for success of larger downtown development projects such as convention centers.[12]

The arts can fit into city development programs in various ways:

- The arts can contribute to an animation strategy for a specific development or city area.
- Entertainment and cultural facilities can be components of mixed-use projects, serve as anchors for larger development programs, or be used to structure area development and redevelopment.
- The arts can be incorporated explicitly into a strategy for attracting business.
- The arts are an attractive and productive focus for private investment in civic improvement efforts.
- The arts can improve a city's overall image, offering increased potential for tourism and for business investments.

A growing number of economic development programs are employing the arts in these ways.

Cultural Planning

In most cities with organized economic development programs, development officials have paid at least some attention to the role of cultural resources. In some cities, this factor has been judged important enough to warrant ambitious efforts, and cultural planning has been integrated into the overall development effort.

Cultural planning is an organized public and private effort to generate and coordinate artistic and cultural activities that enrich a community's quality of life and increase the excitement and enjoyment available there. Ideally, it involves integrating the arts, cultural facilities, and events with all aspects of community and economic development and with physical planning and design, tourism, and city promotion.

Cultural resources figure prominently in most major current or recent downtown development efforts. Arts-facility investments contribute to the success of real estate development in different ways, depending on the circumstances. One prime opportunity for linking the two is in mixed-use developments. "Mixed-use developments," reports the *Development Review and Outlook: 1984-1985* of the Urban Land Institute, "are coming of age." "They are becoming a more integrated and interesting part of the urban environment as mid-decade approaches."[13] In addition,

> the developers of mixed-use projects are making the natural connection with the arts, and the arts community, faced with shrinking budgets, is looking for cooperative ventures. So, office buildings become art galleries. Retail marketplaces transform into performing arts stages, and plazas and museums host concerts. The arts not only decorate and enliven new projects, but also create environments that attract people willing to spend time and money. . . . [Culture, Amusement, Recreation, Entertainment activities (CARE packages) in mixed-use developments] are neither frills nor inexpensive add-ons. Rather, they are planned carefully from a project's inception, helping to establish the minimum critical mass necessary for a successful market image and to ensure that a cultural presence will provide quality programs in places where people live and work.[14]

Cultural facilities may serve as anchors for development of a larger area. In Portland, Maine, for example, the expansion of the Museum of Art with the new Charles Shipman Payson Building

is not only a striking architectural achievement and a major cultural contribution to the city but also a strong, positive influence on the adjacent area and on the entire Portland downtown.

Cultural facilities in themselves may have sufficient critical mass to serve as major attractions with the attendant development benefits. On the basis of this expectation, Kentuckians have spent $26 million on the Kentucky Center for the Arts. The center, which opened early in 1984, is the home for the Louisville Orchestra, the Louisville Civic Ballet, the Kentucky Opera Association, and the Louisville Children's Theater. It has a 2,400-seat main performance hall and a more intimate 610-seat theatre, plus three rehearsal spaces, a multitiered lobby, a restaurant, and a drive-through ticket window. It will serve as Kentucky's leading performance venue for native folk art specialties such as fiddling contests and bluegrass concerts, as well as for the fine arts. The development objectives for the center are to increase tourist spending in the city and to contribute to the revitalization of the northern, riverside edge of downtown Louisville.

Adapting to the new economic functions of city downtowns and capitalizing on development potential of arts facilities and activities, several cities—including Dallas, St. Louis, Cleveland, and Pittsburgh—are structuring large-area development and redevelopment programs with cultural districts. Underlying these cultural districts is the general proposition that a reciprocal relationship exists between cultural investments and investment in downtown retail and office development. In light of this relationship, making the major cultural investment and hoping that the other investment will follow is, in some situations, too risky a proposition. Or, viewed from the other side, where downtowns have been weak, few private developers want to undertake projects without the insurance of people-generating investments in cultural and entertainment projects.

True to its image of thinking big and spending bigger, Dallas has launched one of the largest urban developments ever undertaken in the United States, the 60-acre Dallas Arts District. This mixed-use project, located on the northeastern edge of the central business district, is expected to attract investments of $2.6 billion. When completed, late in the 1990s, facilities for Dallas' major cultural institutions and smaller arts groups will be interwoven with 15-million square feet of retail, office, hotel, and residential space over a 20-block area.

New construction mingles with the few old landmarks that remain—the Arts Magnet School, the historic Belo Mansions, the Gothic-style Cathedral Santuario de Guadelupe, and St. Paul's Methodist Church. The district's cornerstone, the Dallas Museum of Art, designed by Edward Larrabee Barnes, opened in January

147

1984. I. M. Pei's concert hall is scheduled for completion in 1986. The 50-story LTV Center was finished in late 1984, and the Harbord Lone Star project—a $600-million skyscraper and retail complex—is underway.

The district is the result of a remarkable collaboration among all sectors of the community, including government and business as well as arts organizations. The expectation is that the complementary contributions of culture and business will help revitalize a large downtown area, provide employment for 30,000 people, and add $1.5 billion to the city's tax base by the year 2000.

The revitalization of the Grand Center historic district in St. Louis centers on four cultural assets: the Powell Symphony Hall, home to the St. Louis Symphony; the Fox Theatre, which reopened in 1982 and now features Broadway productions and other live entertainment; the Sheldon Memorial, a concert hall noted for its fine acoustics; and the Lyn, formerly a 1,200-seat vaudeville theater, which, when renovated, is expected to serve as a performing arts facility. Surrounding these anchors are several significant historic structures in the process of being turned into other cultural, commercial, and residential facilities.

The Fox Theatre, once the nation's second largest movie palace, underwent a $2-million restoration and reopened in 1982. In its first year of operation, it sold more than a million tickets and grossed $11 million. It and the Powell Symphony Hall also serve as catalysts for complementary activities such as restaurants, shops, and other theatres. Projections show 1,000 permanent new jobs for the district and $4 million in increased sales, payroll, entertainment, and parking taxes.

Cleveland's Playhouse Square involves the renovation of the State, Palace, and Ohio theatres, downtown facilities of historic significance that had fallen into disuse. The district includes 60 acres of planned revitalization; the long-term expectations include new hotels, office space, parking structures, and a pedestrian plaza. Several new restaurants have opened in the area. A landscaped mall has been built where Huron Road joins the theatre district. Just to the west, the 1915 Lindner building has undergone a $3-million renovation, and at least four major corporations have relocated offices in Playhouse Square.

In Pittsburgh, the initial project in the city's downtown cultural and entertainment district is the planned $100-million headquarters building of Allegheny International, Inc., which will be built in conjunction with the $35-million renovation of the 60-year-old Stanley Theatre. The Stanley Theatre will be turned into a world-class performing arts center (the Benedum Center for the Performing Arts). Allegheny International made its decision to locate its new headquarters building in the city contingent on the

creation of the performing arts center. The intent is to encourage the development of multiple theatre and performance spaces; related restaurants, shops, and galleries; park and streetscape improvements; convention business; and renewed attention to the riverfront. The chair of the Allegheny County Board of Commissioners has declared the district "a key factor in our economic advance, just as surely as industrial parks and industrial development bonds."[15]

In some cities such as Winston-Salem, North Carolina, the arts have been given a strong, central role in an overall development strategy. The Roger L. Stevens Center for the Performing Arts in a revamped movie palace and the Arts Council's "Winston Square" in a former textile mill, both part of a multimillion-dollar "culture block," are going concerns and are fulfilling their intended roles as catalysts of city-center revival. Both opened in 1983; other downtown projects underway a year later included a $34-million office building, a $22-million hotel, and a $5-million retail mall. In all, the two cultural facility projects are credited with having stimulated $160 million in downtown investment.

Other cities that have not made the arts the core of their development programs have established major cultural events that contribute significantly, directly and indirectly, to their economic well-being. Charleston's Spoleto Festival, for example, draws as many as 100,000 visitors, half of them from out of state, and injects about $40 million into the state and local economies.

The Cultural Factor in High-Tech Growth

The potential for taking advantage of the indirect economic effects of the arts is increasing and will continue to increase as firms in growth sectors put more weight on factors important to highly educated managers and skilled workers. Under the leadership of Mayor Henry Cisneros, San Antonio has developed what is perhaps the most comprehensive, ambitious program for attracting high-tech investment of any major city in the country. At the core of this strategy are education and the arts. *San Antonio: Target '90,* the city's development strategy document, contains a number of objectives that would shock the traditional industrial developer. They include the following:

- Making the San Antonio Symphony one of the 10 best in the country;
- Enacting a long-term plan to make the city's museums interpreters of the region's cultural and historical attributes;

149

- Establishing San Antonio as the nation's leading center for Hispanic music and visual and performing arts;
- Making the San Antonio Festival, the city's annual 23-day-long celebration of itself, an international attraction;
- Developing a first-class ballet company.

Cities such as San Antonio view encouragement of the arts as being as important to economic development as installing water and sewer pipes in an industrial park or improving access to freeways for manufacturing firms.

Cultural Tourism

Tourism is an established staple of state and local economic development programs. A visitor's dollar is worth as much to the local economy as one earned from exporting manufactured goods, and in recent years tourist dollars have been increasing much more rapidly than manufacturing dollars. The growth in tourism and the transformation in its character, although widely experienced, are not yet well understood, so the potential benefits are unrealized in many cities.

In the past, tourism offered the best or possibly the only development option for some areas struggling to maintain a favorable balance of trade without benefit of manufacturing firms. Today, tourism is much more likely to be integrated into the overall development strategies of cities and to serve as a complementary and supporting element rather than a free-standing activity. Traditionally, many mainstream economic development officials have viewed tourism as a relatively weak development opportunity because of the industry's perceived seasonality and instability and its generally low-skill, low-pay employment.

The potential is obviously great. Nationally, expenditures related to tourism amount to $160 billion annually. Tourism directly supports jobs for 5 million people and contributes $16 billion a year in federal, state, and local taxes.[16] Tourism is the nation's third-largest industry, trailing only food and automobile production. Its growth has exceeded that of the gross national product every year of the past 10. Increases in disposable income over the long term, substantial changes in family size and household composition, and attendant changes in life styles and patterns of discretionary spending have expanded the development potential of tourism at a time when capturing a larger share of the tourist dollar also may support the achievement of other development objectives.

There is no news in the fact that "world-class" cities or cities with spectacular natural advantages are magnets for travelers. There are, however, good news and great promise in the ap-

proaches to tourism that are being developed and carried out in some cities—among them a few cities that seem to be unlikely tourist attractions. Numerous examples already have been cited of how cities are using animation, design quality, cultural resources, and natural and scenic resources to generate tourism. Many of them illustrate new approaches to tourism that have several important characteristics that distinguish them from the more traditional tourism programs:

- Attraction is created by developing a city's "interest potential" that may be found in features previously ignored or unrecognized. The process brings out distinctive features of the particular place, rather than creating ersatz attractions.
- Efforts to promote tourism are integrated more closely with other development activities or objectives, such as downtown development.
- Residents as well as outside visitors are the object of tourism promotion, not only to generate maximum revenue by capturing more resident leisure spending, but also to strengthen the connection between external and internal promotion.
- The effort to strengthen the overall image of a city as a good place to live, work, and invest is combined with the effort to portray it as an interesting place to visit.
- "One-shot" tourism investments can be transformed into permanent community assets.

Something definitely has changed when cities such as Baltimore become centers for tourism. Baltimore's Harborplace, the showpiece of its Inner Harbor revitalization project, attracted more visitors in 1981 than Disney World; 18 million residents and visitors flocked to the Inner Harbor's 135 shops and restaurants. They also endured long lines to gain entry to the popular National Aquarium or the Maryland Science Center, toured the harbor in a pedal boat, or attended one of the city fairs or ethnic festivals held at the Inner Harbor. An out-of-town visitor would be fortunate to stay directly across from the Inner Harbor at the new Hyatt Regency Hotel, which had an astounding first-year occupancy rate of 92.3 percent—the second highest in the entire Hyatt chain. As a result of these attractions, travelers spent nearly $679 million in Baltimore during 1981, generating $10.3 million in local tax revenue and approximately 16,000 jobs, compared with the $5.8 million local tax receipts and 12,000 jobs generated before the opening of Harborplace in 1979.

What Baltimore is offering is "urban tourism," the diversity, excitement, stimulation, human activity, interesting settings, and events that are available only in a city. Baltimore and cities like it present to visitors and residents an "urban theme park" that appears to have sufficient appeal to compete successfully with the more traditional types of tourist attractions.

Conservation and Tourism

Memphis, Tennessee, and Lowell, Massachusetts, have capitalized on their historic assets to generate substantial tourist activity and income in a manner consistent with the cities' other development objectives. Memphis is turning two pieces of its past into part of its economic future—Beale Street and Mud Island. Beale Street, the "Home of the Blues," is now a two-block, nine-acre historic district that is intended to capitalize on entertainment facilities to attract visitors. Mud Island, once a nuisance that occasionally threatened to close the port of Memphis as a result of silting and flooding, has been transformed into a $63-million entertainment and recreation complex that celebrates the Mississippi River. The showpiece of the island is a 2,000-foot-long replica of the Mississippi from Cairo, Illinois, to the Gulf of Mexico, with markers identifying locations and historic events.

Lowell's National Historical Park (the first in the nation) has been an important part of that city's rejuvenation. The park, which preserves many of the city's old red-brick textile mills and water-power canals left over from the city's heyday between 1821 and 1912, attracted more than 400,000 visitors in 1983. The park also has played an important role in Lowell's revival by generating new cultural activities that make the city a more attractive place to live. Outdoor concerts, recreational activities on the renovated riverfront, canal boat and trolley rides, and an annual performance of the *Lowell Play,* which celebrates the city's industrial and ethnic heritage, have stimulated new downtown activities, shops, and restaurants. The renewed interest in Lowell has been capitalized on with an aggressive development program that has produced impressive results in terms of residential and commercial reuse projects in the city's industrial buildings. "Gritty" cities as well as "glitter" cities have their special appeal.

Importance of Image

Image is a critical element in a city's effort to realize its full amenity-development potential. A city's success depends on what people—residents and outsiders—think of it and what they want it to be. If a city has a weak image, a bad image, or no image,

initiating or sustaining effective action will be difficult. Since image is closely tied to reality, problems with image must be addressed with the same competence and determination as other development problems. Image includes:

(1) A city's identity, personality, or character, which is made up of a combination of its strongest, most distinctive features;
(2) A vision of what a city should and could be;
(3) Self-image, the sum of the feelings that residents have about their city, which is related closely to civic spirit;
(4) The reputation a city has beyond its borders, whether accurate or inaccurate;
(5) Selling what a city has and, in the process, reinforcing its strong features.

A number of cities have recognized the importance of image in one or more of these respects and have acted to remedy perceived problems. In "A Strategy for Growth: An Economic Development Program for the Pittsburgh Region," a report prepared by the Allegheny Conference on Community Development, negative perceptions about the quality of life in the Pittsburgh area—at odds with the reality—were identified as a serious and continuing problem for the Pittsburgh area:

> From an economic development standpoint the single greatest problem facing the region is not an aspect of the quality of life at all, but rather negative perceptions about the area's livability by people within, and, particularly, outside the region. Time and time again, Pittsburgh's negative image was mentioned as a barrier to recruiting talent, attracting businesses, and giving the Pittsburgh market area the economic stature it deserves. And, while Pittsburghers seem to be gradually overcoming their collective inferiority complex, much still remains to be done in communicating with area residents and involving them more actively with the region's many, many assets. . . . The Pittsburgh area has still not successfully communicated its many assets and it lacks a clear, new identity with which to replace the old label as a smokey, steel industry town.[17]

The State Role

Most concrete development activity involving the arts will be carried out at the local level by public development agencies, private developers, arts organizations, and others. States, however, can make significant contributions to linking arts and economic development in both supporting and leading roles. The starting point is to consider amenities along with other approaches and tools available for urban economic development. Little is likely to happen, however, without those responsible for economic development recognizing that the arts can contribute significantly to the accomplishment of stated objectives.

Based on that recognition, the first action should be to take the appropriate institutional steps that can turn the abstract proposition into results. The state-level agency responsible for the arts should be included in the planning and implementation of development strategies as they pertain not only to tourism but also to attracting, retaining, and expanding business. For example, if a state has a development cabinet or coordinating committee, the arts agency should be at least an occasional if not regular participant in it. On the other side, state economic development agency personnel may need to know much more about the arts and the experience of other states and localities before considering the arts more than window dressing or linking arts and development to specific programs or activities.

For both arts and economic development agencies, staff and organizational development probably will be needed if the institutional collaboration is to be more than formal. Sharing information, staff orientation, training sessions, and joint discussions of program activity all can build understanding that undergirds action.

Assuming that those involved with arts and economic development can see that their responsibilities intersect and offer opportunities for productive collaboration, what then? Within every state, opportunities exist to strengthen the performance of development programs through systematically including cultural resources. These opportunities vary from place to place. In general terms, however, probably each state can benefit from doing at least the following:

- Incorporating information on arts institutions and activities in its promotional packages to recruit businesses, giving the same attention to detail as information provided on schools, taxes, and utility rates;

- Treating support for arts institutions with more than local reach as opportunities to strengthen the state's investment climate;
- Making arts institutions and arts-related businesses eligible for state development financing programs;
- Incorporating local arts-related development into state-initiated programs that provide information or technical assistance;
- Encouraging sound economic assessments before undertaking major arts projects that have economic development objectives;
- Investigating arts industry opportunities as well as support for the nonprofit arts;
- Involving artists in the planning and implementation of programs;
- Establishing programs for strengthening management of arts institutions.

Building on elements such as these, states can generate significant economic development benefits from the effective use of their arts assets.

Summary

Amenities can play the following roles in urban economic development:

Near-Term Objective of Net New Jobs
in the Local Economy

- Certain amenity facilities or events, such as zoos, aquariums, performing arts centers, and festivals, in themselves, can make important contributions to the local economy.
- Cultural and leisure industries, such as tourism, sports, and recreation, are growth sectors in the economy and are likely to have growth potential in most localities.
- Through the effective use of amenities, a city can capture a larger share of the disposable income of its residents and generate more visitor spending to improve the local balance of payments.

- An amenity project or facility, such as a museum, park, or theatre, or a combination of such facilities, can anchor an area development or redevelopment program.
- An amenity element, such as an attractive plaza, a well-designed retail complex, or public art, can improve the chances of success for a larger development project.
- An attractive quality of life and amenity package will make the community more appealing to managers and workers in high-growth sectors and will maintain and expand markets for service-sector firms.
- Amenities help create and sustain a positive image for a city among residents and outsiders.
- Amenity projects can become the basis for cooperation between the public and private sectors in economic development efforts. They can energize the community, and successful projects can build the foundation for additional collaboration.

Notes

1. Wilbur Thompson and Philip Thompson, "From Industries to Occupations: Rethinking Local Economic Development," *Economic Development Commentary* 9 (Fall 1985): 13.
2. Ibid.
3. National Research Council, Commission on Behavioral and Social Sciences and Educators, Committee on National Urban Policy, *Rethinking Urban Policy: Urban Development in an Advanced Economy* (Washington, D.C.: National Academy Press, 1983), p. 182.
4. Roger W. Schemenner, "Location Decisions of Large Firms: Implications for Public Policy," *Economic Development Commentary* 5 (January 1981): 3–7.
5. William S. Hendon, "Arts and Their Impact on Economic Life," *Poetics* 14 (1985): 126.
6. This section is extracted from Shanahan's "The Arts and Urban Development," *Economic Policy for the Arts* (Cambridge, Mass.: Abt Books, 1980), pp. 295–305.
7. This phrase was used by Ed Bacon in a discussion with James L. Shanahan.
8. Tibor Scitovsky, *The Joyless Economy* (Oxford: Oxford Press, 1976), Chapter 11.
9. Hendon, "Arts and Their Impact," p. 132.
10. Allegheny Conference on Community Development, "Quality of Life," in *A Strategy for Growth: An Economic Development Program for the Pittsburgh Region* (Pittsburgh, Penn.: Allegheny Conference on Community Development, 1984).
11. Hendon, "Arts and Their Impact," p. 132.

12. David Cwi, *The Arts Talk Economics* (Washington, D.C.: National Assembly of Community Arts Agencies, 1980), p. 12.

13. Urban Land Institute, *Development Review and Outlook: 1984-1985* (Washington, D.C.: ULI-Urban Land Institute, 1984), p. 10.

14. Ibid., p. 112.

15. Allegheny Conference, "Quality of Life."

16. Public Technology, Inc., *Tourism and Urban Economic Development: An Information Bulletin of the Urban Consortium* (Washington, D.C.: Public Technology, Inc., 1982), p. 4.

17. Allegheny Conference, "Quality of Life," pp. ix–5.

Evaluating Cultural Policy Through Benefit/ Cost Analysis

by

William S. Hendon

Department of Urban Studies
University of Akron
Akron, Ohio

\mathbf{T}he year in which the arts were born in the United States is of some confusion to economists. There are those who reckon that the year was 1965 with the passage of the Endowment Acts. Others assume that the arts were born with the publication of Baumol and Bowen's *Performing Arts: The Economic Dilemma* in 1966.[1] While such dating is not really an issue in the literature of economics, it does suggest either the innocence or the arrogance of economists in recent years in beginning to apply economic theory to the arts.

With the field of cultural economics a newborn (some may say stillborn), there is considerable reservation among arts professionals as to whether economics can be useful to the arts. Indeed, many feel that the economist is either irrelevant or dangerous. On the other side, from their narrow world, many economists looking at the decisions of arts organizations may think that the arts people are irrational ninnies.

No one knows what the final result will be of mixing the two groups. It is clear, however, that although within the two human endeavors of the arts and economics a good deal of misunderstanding and even mistrust exist, a good deal can be learned each from the other. Profitable interaction, however, is impossible without people in the arts learning a bit of economics and economists learning a bit about the arts. With the preceding difficulties in mind, one can consider local public policy as it relates to the arts and how to examine it in economic terms.

This chapter discusses one means whereby an arts organization may evaluate the economic effects of its policy and program decisions. There are two basic means developed in cultural economics for such evaluation: impact analysis and benefit/cost analysis. Impact analysis, as one has seen in earlier chapters, is used widely in assessing the income and employment effects of arts locally—i.e., major developmental aspects of the local economy. Benefit/cost analysis can be used to assess these same larger economic aspects, but it also can be used to assess the efficiency whereby arts investments are made for middle-sized projects such as museums and theatres, and major, but single institutional decisions. While impact analysis is quite useful in larger development schemes, benefit/cost analysis is useful not only in large and middle-sized projects but also in small arts projects. Although such projects have little direct effect in terms of urban economic employment or incomes, they do have considerable merit as elements of economic demand and can enhance economic welfare in the community. Impact analysis is well documented,[2] but benefit/cost analysis applied to the arts is limited to a few sources.[3] Yet, it seems that this policy tool has greater usefulness than impact

analysis in evaluating the kinds of decisions that local arts councils make every day.

For all the money spent on economic impact analysis of the arts, these studies have not led to significant improvements of the arts or the cities in which they reside. First, the impact study is not policy useful because of the extremely high cost of employing the model and the necessity of repeating that cost regularly. Not a cost-effective analysis, it, therefore, has not fulfilled its promise as a policy tool for policymakers. The second reason lies in its conception. Impact analysis in the arts starts with all the institutions within a geographic space. This viewpoint was built into the first impact analysis sponsored by the National Endowment for the Arts, the now-famous Baltimore study. At that time, the study could have been framed in the arts investment language of benefit/cost analysis. Instead, it took on the econometric modeling ideas of environmental impact analysis. By doing so, the method limited itself to a high-cost, data-hungry, input-output approach that doomed subsequent users to do the similar data set for their regions, and then as in the Baltimore study, never to have the funds or the interest to do it again. Thus, the incorrect aspect of impact analysis is that it had been conceived in that aggregate sense. Because it is aggregative in conception and methodological in execution, it is not useful to developers, artistic institutional managers, policymakers, or funders of the arts. The method does not permit analysis of an individual institution without having access to data and rerunning the entire econometric model. Thus, once a study is done, it must be housed in a central computing facility and updated regularly. Who is willing to do that? Thus far, no one.

Does benefit/cost analysis overcome these problems? Yes, to the extent that a small project can be analyzed at a low cost and that partial analysis can be made on a single project, institution, or other art investment without having an enormous quantity of local and regional economic data. Studies can be repeated and, if well done, compared. The technique is cost-effective and can be a regular part of an ongoing decision process if so desired.

The approach to benefit/cost analysis is not exhaustive. Other models may be useful, depending upon the kind of project analyzed. This case uses the benefit/cost methods worked out in recreational economics.

Economic Benefits
in Benefit/Cost Analysis

The economics of recreation argues that the demand curve for a particular activity provides the appropriate statement of value for that program or site, that is, an estimate of value gained by measuring the area under the demand curve. Such a measurement provides an estimate of the monetary value of a particular recreation program at a particular point. The primary benefit that is deemed useful for most recreation projects is the esteem or value (stated in economic terms) that users or potential users place upon the service. This correct measure of esteem is couched in terms of the maximum price that individual consumers would be willing to pay to participate in an activity. This idea can be applied to visits to art museums, theatre performances, art classes, and so forth.

If one wants to know the maximum price that people are willing to pay, then the simple prices they pay multiplied by the number of visits to a museum is not a sufficient statement of value since consumers do not always pay a direct price to visit museums. Even when there is a fee, the implication of market price is that at higher prices there were still a number of persons who would have been willing to pay for units of the service. Thus, any particular price-quantity relationship implies that, for some people, the good or service is a "bargain" at the stated price (or, in this case, the indirect price) because, in fact, they would have been willing to pay more. In essence, each price on a demand schedule represents somebody's maximum willingness to pay. The difference between what individual consumers have to pay and what they would be willing to pay is called the *consumer's surplus,* a concept posited by neo-classical microeconomics.

Consumer Surplus

The idea of consumer surplus is based on the marginal valuations that the consumer makes of a particular good available in various quantities. What would individual consumers be willing to pay for a first visit to an art museum? What would they pay for a second? A third, etc.? If, in the short run, there is a direct price of 10 cents, as in Figure 1, consumers gain a surplus (the shaded area) with the first through the fourth visits; there is a consumer surplus attached to each chance. By the time consumers select the fifth visit,

Figure 1.

Consumer's Surplus in the Individual Demand Curve

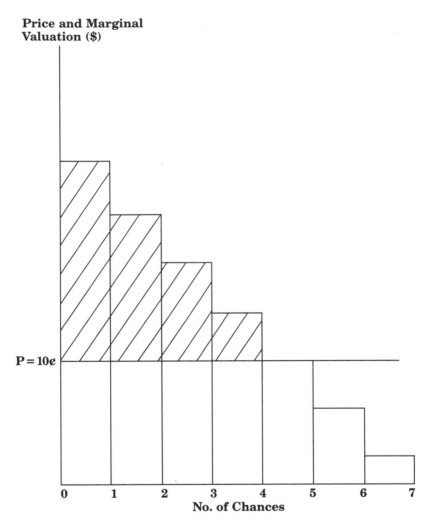

the price equals their valuation of the visit. They will not elect to go the sixth time because the value to them is less than the price, but the value exceeds the price (a surplus) for each of the first through fourth visits. The shaded area in the demand curve in Figure 1 represents the consumer surplus. If there is no direct price, then the individual demand curve of Figure 1 is all shaded, that is, all consumer surplus. In reality, however, even a zero price has costs associated with it even if there is no admission price. Consumers do expend time and money to go to the museum; thus, they pay an indirect price in travel-cost terms.

Part of the difficulty in visualizing the demand curve for a museum visit is the fact that the price line (PT) in Figure 2 is a composite; that is, consumers do not all face the same price.

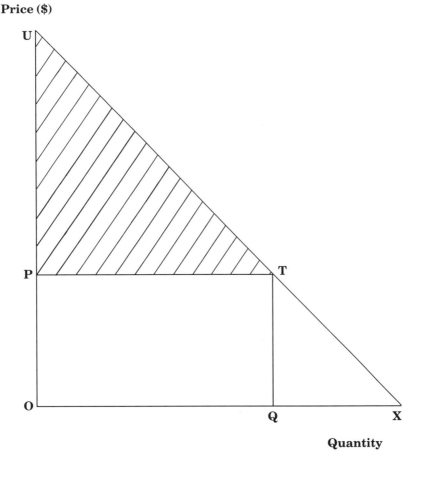

Figure 2.

Market Demand for the Good and Consumer's Surpluses

Rather, they face a differential price depending on how far away from the museum they live. One characteristic of a normal private good is that consumers may adjust their desired and different quantities to a given market price. In the case of this public good, however, each consumer is faced with a different price and must adjust to a common quantity. Thus, this picture of the aggregate

demand curve, while accurate for a normal good, is not accurate as a true picture of the aggregate demand curve for a museum.

The demand curve for a particular museum will look like Figure 2, in which all the marginal valuations of consumers have been added together to form the market demand curve, but the price must be thought of as an average. At a price of 10 cents, the rectangle OPTQ represents the price-quantity aspect, the triangle UPT represents the consumer's surpluses, and the triangle TQX represents unmet or latent demand. Each point along the demand curve UX represents someone's maximum willingness to pay. The net value of benefit of the particular good at a price of OP is represented by the surplus UPT. The triangle TQX at a price of OP leaves some potential value unrealized.

This discussion uses the example of a museum with a price, but it also could have used a museum with no fees; a theatre performance or season; any other performing arts; or indeed even art classes, exhibitions, lessons, or most any artistic experience where consumers can be identified. The primary benefit of the artistic goods and services produced then becomes the maximum price that consumers are willing to pay. For a service or good for which there is a charge, the value is the price-quantity area of the demand curve plus the consumer surplus triangle—the entire area of QUTQ in Figure 2. If, as in the case of many art goods and services, there is no charge of any kind to consumers, then the value of the art good or service is the entire area under the demand curve, OUX, less consumer costs in going to the museum where the service is offered. The problem in measuring the primary benefits of a museum or any art program is one of deriving the appropriate demand curve.

Clawson-Knetsch Demand Curves

In 1959, Marion Clawson proposed a means of estimating the demand curve by estimating consumers' surpluses accruing to a recreation site.[4] The estimate was based on the idea of using travel costs to the site as an estimate of what consumers were willing to pay when no charge is levied to enter the site. If travel costs are used as an estimate of consumers' willingness to pay, then one needs to know something about the experience that people have in going to a particular program or site. In the discussion of Figures 1 and 2, assumptions were implicit such that all other things were held constant. Changes in taste, the price of other goods, and the income of consumers would shift the results. Similarly, the values were for

specific quantities or volumes of the good or service. In any event, the experience of consumers represents the source of knowledge of the demand for the good or service. The method developed by Clawson for deriving demand proceeds in two stages:

> one curve for the *total recreation experience,* a second one for the *recreation opportunity per se.* The first can be estimated from the actual experience of considerable numbers of people engaged in outdoor recreation; the second can be derived from the first.[5]

Deriving the Demand Curve

The following discussion draws heavily from Cesario and is based on the Clawson-Knetsch demand curve.[6] There is posited a group of consumers who are willing to give up a certain amount of income in the pursuit of leisure goods and services. In a trip to a museum, a consumer gives up income (in the form of transfer costs, such as travel costs and time costs, for example). Assume that for a given museum, let C_{ij} be the cost to a person who lives in population zone i to visit museum J;

$$V_{ij} = f(C_{ij}, P_i) \tag{1}$$

or let the per capita visit rate be a function of cost:

$$V_{ij}/P_{ij} = f(C_{ij}) \tag{2}$$

Letting X_{ij} equal V_{ij}/P_i, the function relating visit rates and costs for museum J is called the demand curve for the total arts experience as shown in Figure 3. This curve represents, at each point, the number of visits per capita, per unit of time that consumers will take at various costs. Visitation rate means the per capita visitation rate to the museum among the total population of a set of concentric distance zones drawn around the museum site. In recreational analysis, it is known that a distance decay function exists; that is, the more distant from the park consumers are, the less frequently they will visit the park site. As would be expected from the curve above, the fact is that as travel costs (or all transfer costs) increase, the visitation rates decline.

The first demand curve that Clawson refers to is the entire recreation experience. The total experience can be seen as a set

Figure 3.

Demand Curve

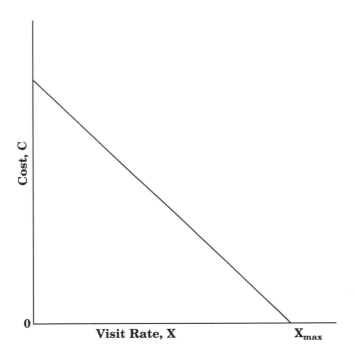

of stages that descriptively can be called anticipation of the visit, travel to the site, activity at the site, return travel, and finally, recollection of the experience.

Using the museum example, total visits are estimated by multiplying the population in each distance zone or population center within the zones by its visitation rate as given by the curve (Figure 3). Total visits to the museum are then:

$$\sum_{i=1}^{N} f(C_{ij})P_i = V \tag{3}$$

when one assumes an initial price of zero, that is, no admission fees. Now add an additional cost C on each visit. Visits per capita will change in the demand curve for the total experience (as in Figure 3) such that:

$$\sum_{i=1}^{N} f(C_{ij} + \Delta C)P_i = V^1 \tag{4}$$

with the result that total visits at V^1 are less than total visits at V^0. Continuing in this fashion, incremental increases to cost are calculated at V^2, V^3, etc. for each zone until the expected visitor rate has been reduced to zero. Figure 4 shows the result of this manipulation in which visits are related to added cost.

Figure 4.

Function Relating Visits and Added Cost for Recreation Site

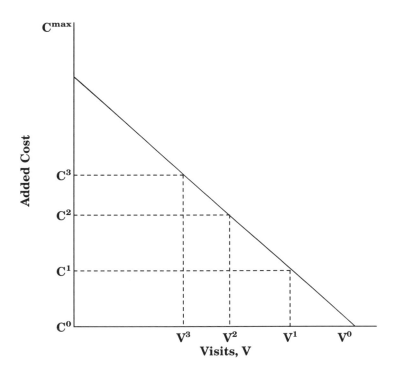

If the added costs are assumed to be in the form of admission fees and labels on the curves change accordingly, then Figure 4 can be restated as the demand curve for the recreation site as shown in Figure 5. As such, the demand curve for the visits to the museum (as a function of added cost) indicates the maximum prices consumers would be willing to pay at different levels of total visits, that is, total unit of consumption. This demand curve representing the site demand for the relevant population living in the various zones (1, 2, 3, etc.) is therefore based on the notion that a difference exists between the demand for the experience as shown in Figure 3 and the site demand curve of Figure 5. As noted, the demand for the arts experience consists of travel to

Figure 5.

Demand Function for Recreation Site

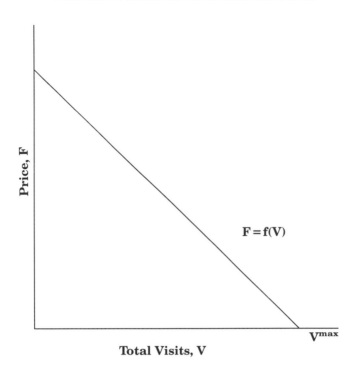

Total Visits, V

and from the site as well as whatever anticipation of the visit occurs and whatever recollection results from the visit. If, for example, one plans a visit to a museum, then there is some value to the anticipation and planning. Similarly, the travel to the museum and the return trip may have positive value to the consumer. If the visitor takes slides of the visit, then recollection may be positive (except for the nonparticipants who may be coerced into watching the slides). Clawson and Knetsch were interested in isolating the value people find in the entire recreation experience (in this case, the artistic experience) from that segment of the value that could be defined as the value at the site, or in other words, that portion of the value that can be seen clearly as the value of the activity at the museum. As a result of this concern, the demand curve for the total experience (Figure 3) was thought to be too inclusive and the correction, therefore, was made to derive a demand curve that isolated the site value (Figure 5).

Another important point to be made in the derivation of the demand curve for the site is that consumers buying in the marketplace gain, in many instances, what was shown earlier to be the

consumer surplus; the derived demand curve for the site captures the consumer surplus and represents, therefore, the maximum price that consumers would be willing to pay as opposed to what, in fact, they have to pay. This inclusion of consumer surplus is thought to be a better measure of economic value than simply the price that the consumer pays. Returning to Figure 5 and calculating the sum of the various prices, or the area under the demand curve, the economic value of the site is:

$$B_T = \int_0^V MAXf(V)d(V) \tag{5}$$

The above integral (total willingness to pay) measures the total economic value of the site and its services to society at any point in time. This formulation also can be stated as the total consumer's surplus at a price of zero. This valuation statement is the benefit to the customers, that is, the value they hold for the particular visit. This total benefit for a particular period of time (for example, a year) can be compared with the allocated annualized public costs of providing the activity (or site) to ascertain if the activity or site generates benefits in excess of costs. Of course, these are only primary benefits and do not include any potential secondary or spillover benefits or costs.

At this point, it might be wise to point out that the sum total value of a museum would be the total of all uses to which the museum is put, expressed in terms of the consumer's maximum willingness to expend time and money to gain those satisfactions. Thus, the evaluation of a particular exhibition program offered in a museum is a part of that museum's total value. One should use caution in assessing the value of a single exhibition since the possibility of the consumer's making use of other museum services or galleries at the same time also must be considered. Double counting is a significant problem when one is engaged in evaluating a program among all programs (a part of the whole).

An Example of Estimating Demand

To initiate the estimate of value for a museum or other arts program, one needs to know the extensiveness of the service zone for that facility or program location. How far from the location are consumers willing to travel? Recognizing that there is a distance-decay phenomenon, one must divide the estimated service area into a set of distance zones that roughly approximate

concentric circles. The service or distance zone will vary widely by the size or importance of the activity or facility and the location. Such geographic zones may reflect the distances people will come to a location for particular programs or to the facility in general for planned and unplanned activities. The actual number of zones is arbitrary, but the guiding idea would be that each zone represents a clustering, that is, a series of points that relate to a coordinate on the demand curve.

Analysis of regular user surveys showing distance, origin, and destination figures shows that larger numbers of visitors come who live near the museum than those who live farther away. The total number of persons in distance zones who come for a particular period of time reflects a particular demand schedule. Table 1 reflects such a schedule. Note that a set of distance zones has been defined—the number of persons coming from each zone, the distance they come, and the total population in each zone have been determined. Since travel involves transfer costs, the various groups of people are paying different "prices" (in terms of travel costs) to visit. This is similar to a demand curve for which there are a number of different, relevant prices (or a different demand curve for each zone).

Table 1.

Number of Persons Arriving
(By Distance They Travel and by Zone)

Zones	Number of Visits	Population in Zone[a]	Visits Per 1,000 Population	Round Trip[b]	Round Trip Travel Costs[c]
1	1,000	2,000	500	0.50 miles	$0.050
2	800	2,000	400	0.75 miles	0.075
3	600	2,000	300	1.00 miles	0.100
4	400	2,000	200	1.25 miles	0.125
5	200	2,000	100	1.50 miles	0.150

[a]Not a completely circular zone but roughly so on a grid basis of city blocks.
[b]Based on a weighted mean of actual access distances (not a straight line) from the zone in question.
[c]Assuming two persons per car at $0.10 per mile; variable costs only (no depreciation—that is, capital costs).
Note: The survey must represent one year's pattern of seven days of use, accounting for seasons, days of the week, and time of day.

These prices become real if one assumes that among the relevant transfer costs, travel is 10 cents per mile, given the stop-and-start, short-distance trip. A figure is used for auto cost on the basis not that all people drive alone but that the number in each group is known (persons per car or transit). Zones 1 through 5 are of increasing distance and, as expected, the proportion of visitors declines from the nearest zone to the most distant zone (1,000 visits of 2,000 people in Zone 1 compared with 200 visits of 2,000 persons in Zone 5). Distances people traveled range from 0.5 miles to 1.5 miles.

Table 1 also reflects the auto costs involved in travel for the consumer groups when it was ascertained that they came in groups of two persons. The prices people paid are reflected in the various costs per trip to the consumers. The sum of these costs and quantities would be similar to the area OPTQ in Figure 2 if one could imagine various prices in operation (OP would be an average of prices, not an addition here). There is no single equilibrium price for the use of the museum because, at a zero charge for admission, people pay according to the travel costs that they incur. In a sense, a composite of zone demands is being constructed.

Plotting these results in Figure 6, the various prices that persons are willing to pay are reflected in the price axis for particular quantities per 1,000 population read on the quantity axis. Note that the data in Figure 6 are gained from Table 1 and include, on the Y axis, the cost per visit, and on the X axis, the number of visits per 1,000 population. This function permits one to derive the demand curve for the museum visits. The first point on the demand curve was at zero admission or added price and generated 3,000 visits (Table 2). When the price increases to 2.5 cents, what happens to people in Zone 1 whose previous rate was 500 visits per 1,000 population? They are now forced to pay at the rate of 7.5 cents per visit (their original 5 cents plus the 2.5 cents increase) and presumably will behave as do the people in Zone 2, whose initial cost was 7.5 cents per visit and whose rate of visitation was 400 per 1,000 population. The increase of 2.5 cents means that people in Zone 1 no longer will make 1,000 visits (at the 500 rate) but only 800 visits (at the 400 rate). Zone 2 visitors will decline from their initial 800 visits to those applicable to Zone 3, or 600 visits. Similarly, people in Zone 3 will behave like people initially did in Zone 4; 400 visits will be made instead of 600. Persons in Zone 4 likewise will come at the rate of 100 per 1,000 population or a total of 200 visits; and persons in Zone 5 will be priced out of the market, that is, no visits. Thus, the second pair of coordinates on the demand curve has been calculated; that is, at a price of 2.5 cents, there will be 2,000 visits.

Figure 6.

Demand Function

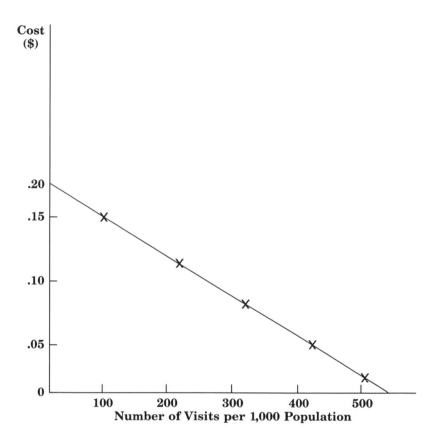

Table 2.

Total Visitors from Zones by Various Changes in Price

Zone	Charge				
	$0.00	**$0.025**	**$0.050**	**$0.075**	**$0.100**
1	1,000	800	600	400	200
2	800	600	400	200	0
3	600	400	200	0	0
4	400	200	0	0	0
5	200	0	0	0	0
Visitors	3,000	2,000	1,200	600	200

Dollars	Quantity of Visits Demanded
0.000	3,000
0.025	2,400
0.050	1,200
0.075	600
0.100	200
0.125	0

If the price is raised to five cents, then Table 2 indicates that there will be only 1,200 visits; at various price increases, the number of visitors will diminish until, were one to set the price at 12.5 cents, there would be no visitors at all. There is now a demand schedule that represents the number of visits that consumers will make at various prices. These demand data can be plotted to create the demand curve for the museum within the time period analyzed.

Calculating the benefits from the demand curve can be done by the integral (Formula 5) or estimated crudely from the curve itself (Figure 7). Following this latter method and assuming zero admission charge, it is clear that 200 visits are valued at between $0.125 and $0.10, or an average of $0.1125 per visit. This creates a primary economic benefit of $22.50. The next 400 visits are valued at between $0.10 and $0.075, or an average of $0.0875 per visit; that is, a value of $0.0875 times 400 visits or $35.00. The next 600 visits are valued at $0.0675 or $37.50. The next 1,000 visits at $0.0375 generate $37.50 worth of value. Finally, the last 1,000 visits are worth $12.50. Based on this example, the value for the 14-day period is a total of $145.00 worth of benefits. Were one able to argue that the 14-day period was truly representative of the year, then benefits by this measure would total $3,770.00.

The total primary benefits so conceived are similar, in fact, to the total area in Figure 2 of OUTQ (and the total area in Figure 5), that is, the price quantity benefit and the consumer surplus.

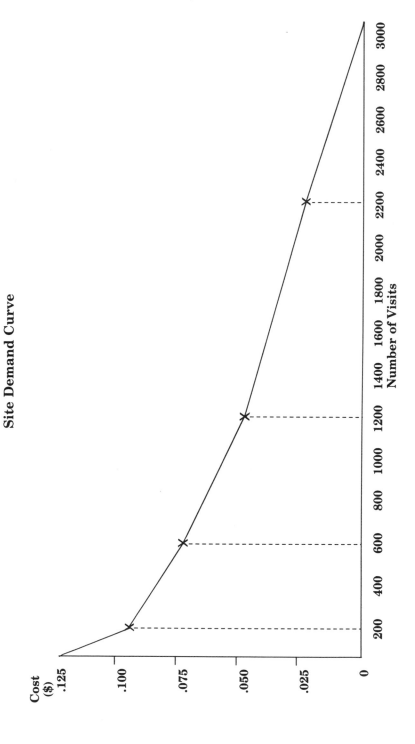

Figure 7.

Site Demand Curve

The latent demand (TQX in Figure 2) was not estimated because, in fact, no visit is costless to the consumer even if there is no fee. In other words, a zero charge for admission still would not be "free"; the initial position is free in the sense of no charge but is not costless to the consumer.

The economic benefits for a particular museum for a particular time period now have been estimated. One could have estimated the benefits for any arts experience by measuring the values that consumers hold for the experience. The next section looks at the assessment of costs and then turns to the impact of time and to equity questions.

Accounting for Costs

For the sake of convenience, it is usually possible to divide costs for arts projects into capital and operation costs. In analyzing a particular program proposal or existing program, the capital cost (the present market value) of the project (if capital costs are relevant) is simply the cost of capital including financing and planning construction costs. In other instances, there will be no capital cost at all, depending upon the nature of the proposed or existing program. Operational costs normally include staff costs, supplies, utilities, rental value of the space and equipment, and so on—costs that are part of the regular operation of the program. An additional form of cost is administrative overhead costs—costs that arise from having a system of administration. An appropriate allocation of these costs should be made to any program.

None of the aforementioned costs are particularly difficult to analyze. Accounting records make possible the various capital and operational cost items. Administrative costs, on the other hand, demand some allocation decision on the part of the analyst based on the total administrative time and budget that can be allocated to this particular project. In some instances, the time allocation of administrative time can be estimated, and a value (a proportion of total wages) placed upon that time. Whatever decision as to the amount of money to be allocated to the project under study is apt to be arbitrary; nonetheless, a crude, but logically correct estimate is better than none. While costing sounds simple, if one considers function, then determining costs becomes more difficult. Kavanagh, Marcus, and Gay argue that a single input can have several outputs (such as a park used for different purposes by different groups). Because of this, joint costs are a problem, as Kavanagh and others reveal: "Many formulas for al-

locating joint costs can be devised, and reasonable arguments can be made for using each formula. However, none can be shown to be economically meaningful; and in the end, any allocation of joint costs must be considered arbitrary."[7] As a result, the allocation of joint costs of space, administration, and so on to particular arts programs is no more than a better choice among several.

The Impact of Time

It is common in benefit/cost analysis to apply discount rates to the costs and the benefits of the project in order to depict the final statement of the investment criteria accurately (the present value of benefits should exceed the present value of costs). In this sense, one must know the present value of benefits compared with the present value of costs in order to have a comparable set of values. Costs and benefits occur over various periods of time and seldom at precisely the same time. Typically, heavy costs occur during the early parts of a project (particularly acquisition and developmental costs) while benefits normally occur later. Dollars in different periods are not comparable, whether they are benefits or costs.

Discounting Benefits: Social Time Preference

When discounting, one needs to know the life of a project, which is the time period in which costs and benefits will accrue. To illustrate, assume two projects, A and B, and note the costs and benefits over time.

		Year 1	Year 2	Year 3	Total
Project A	Benefits	$10	$10	$10	$30
	Costs	5	5	5	15
Project B	Benefits	0	10	20	30
	Costs	5	5	5	15

Both Projects A and B generate $30 worth of benefits and $15 worth of costs over three years of their useful lives. Which is the preferred

project? Assuming there are alternative ways to accomplish the same purpose, the project that generates benefits earlier is the preferred one. In this case, Project A is preferred to B because the benefits in B do not begin to occur until the second year.

To provide a discount rate appropriate to discern the above difference, one is concerned with what is called the social time preference rate of discount. To explain this rate of discount, one can look at an individual case. If an individual would rather have $500 one year from today than $100 now, the $500 in the future is worth more to him or her than the $100 now. On the other hand, if one leaves the $100 the same and begins to reduce the amount received at the end of one year, a point would be reached at which the individual would be indifferent as to whether he or she had the $100 now or the X dollars in one year. If, in this particular case, the future amount was $110, then one would say that $100 now is valued as equivalent to $110 a year from now, or that the present value of $110 (received at the end of a year) is $100. The $110 in the future has a present value of $100; thus, the time preference rate of discount is 10 percent.

To go from one individual to an entire society's view of time preference for benefits is only theoretically possible. What can be said is that decision makers are responsible for selecting some reasonable rate that they believe best states the public's rate of time preference. Since such a requirement is too much to expect, the analyst usually calculates benefits with three different possible discount rates to see if any of the rates seriously affect benefits compared with costs. Returning to the illustration, the benefits could be discounted using (for the sake of convenience) a 10 percent discount rate, which is, therefore, a reduction in benefits.

		Year 1	Year 2	Year 3	Total
Project A	Benefits	$10 (9)	$10 (8)	$10 (7)	$30 (24)
	Costs	5	5	5	15
Project B	Benefits	0 (0)	10 (8)	20 (14)	30 (22)
	Costs	5	5	5	15

On a time preference basis, Project A is clearly preferable to Project B because the approximate present value of benefits in A is $24, while the present value of benefits in B is only $22. The social time preference rate of discount always reduces the amount of benefits since some of the benefits will be attained in the future but must be expressed in present value terms.

Discounting Costs:
The Social Opportunity Costs

The idea of discounting costs means dealing with the problem of social opportunity cost and its assessment. The social opportunity cost rate of discount applies to costs and is an increase in total cost. Opportunity cost means the foregone yield in the next best alternative. To illustrate, if a saver puts $100 in a savings and loan and gains $106 at the end of a year, his return is $6 or 6 percent. If his next best alternative had been to put the money in a bank where he could gain a return of $5, then the cost of gaining the $106 includes the $100 he invested, plus the $5 opportunity cost, that is, the yield he did not receive from the bank. By so comparing yields, it is possible to know the better choice: saving in a bank or a savings and loan.

In the case of a public investment, the process is more clouded. Can the arts council invest money in alternative ways? Is the yield a real possibility? Does a social opportunity cost rate of discount really apply? If so, what is the appropriate rate? One would like to use a market rate of interest, but there is no single market rate. Generally, economists (although there is not widespread agreement) have argued that some rate of discount should apply and that the rate should be very low since there is little risk involved in the public sector compared with that in the private sector. The following illustration uses an unrealistically low (but sufficient for illustration) social opportunity cost rate of discount of 4 percent, which, if applied, would be an increase to costs. Turning again to the illustration of discounted benefits, Projects A and B would have increased costs with discounting, as indicated by the 4 percent rate revealed in the discounted costs in parentheses:

		Year 1	Year 2	Year 3	Total
Project A	Benefits	$10 (9)	$10 (8)	$10 (7)	$30 (24)
	Costs	5 (5.20)	5 (5.40)	5 (5.60)	15 (16.20)
Project B	Benefits	0 (0)	10 (8)	20 (14)	30 (22)
	Costs	5 (5.20)	5 (5.40)	5 (5.60)	15 (16.20)

Having discounted the benefits and costs, it is clear that the present value of benefits in Project A is $24, compared with the present value of costs of $16.20; in the case of Project B, the present value of benefits is $22, while the present value of costs is $16.20. Project A appears to be the more beneficial of the two projects and, thus,

is acceptable in the sense of benefits exceeding costs. But the question of distribution of the benefits has not yet been addressed, which is the second part of the dual investment criteria.

Redistribution Effects:
Who Pays and Who Gains?

Most of the major elements of a benefit/cost analysis have been discussed. As noted earlier in one element of the public investment criteria, benefits must exceed costs. But does the present value of gains to the winners outweigh the present value of losses to the losers? This other element is the distributional criteria; that is, the new income distribution must be socially preferred. Public investments and tax decisions cause redistribution of income. A depletion allowance, for example, taxes most people for the benefit of a few oil companies. A convention center in a city shifts income from the public (through taxes) to some business executives who profit directly from the center. Similarly, public arts expenditures shift incomes as different people pay from those who gain. How does one treat these redistribution effects?

The first thing to recognize is that tax burdens are not equal throughout cities. Different income groups bear different burdens of taxes since the incidence of local tax burdens varies. Thus, not all "pay" the same amount or to the same degree. On the recipient side, benefits go primarily to persons who participate.

With regard to the tax issue, funds for the arts come from so many sources (city, state, and federal taxes; grants; donations; tax relief; user charges) that it is not altogether clear who pays. For a crude approximation, however, it is possible to note that local tax burdens by income groups are distributed in the manner of Table 3. Total tax burdens vary widely among income groups based on their ability to pay. The lowest income groups pay 28.1 percent of all income for the three levels of taxes, while the most prosperous income group pays about 44 percent. Is this information of particular use? It is useful in providing a sense of the total amount of income that certain income groups pay toward urban services; the results clearly suggest that persons who live in cities pay widely differing amounts of taxes and that, relatively, the poor pay more. These data might be used to argue that public investments in the arts ought to be biased more toward low-income groups because, relatively, their burden is greater than that of middle- and higher income groups. On the other hand, some may argue that since low-income groups absolutely pay less, they should receive fewer bene-

Table 3.

Taxes from Federal, State, and Local Sources as a Percentage of Family Income (for 1965 by Income Class)

Income	Federal[a]	State and Local[a]	Total Tax as Percentage of Income
Under $2,000	13.0%	15.1%	28.1%
$2,000-2,999	14.0	12.7	26.7
$3,000-3,999	17.1	12.6	29.7
$4,000-4,999	17.3	11.8	29.1
$5,000-5,999	17.9	11.5	29.4
$6,000-7,499	17.8	10.8	28.6
$7,500-9,999	18.4	10.1	28.5
$10,000-14,000	21.1	9.6	30.7
$15,000-over	34.9	9.1	44.0

[a]Mean federal tax = 19.6 percent.
[b]Mean state and local tax = 10.8 percent.

Source: *Tax Burdens and Benefits of Government Expenditures by Income Class, 1961 and 1965* (New York, N.Y.: Tax Foundation Inc., 1967), pp. 20-21.

fits. This latter argument probably does not have the weight of the former, particularly when one adds the idea that low-income groups generally have less artistic opportunity. Whatever the choices, it is clear that the burden of paying for urban services, including the arts, generally creates a disadvantage for lower income groups unless there is explicit concern for their welfare. If this argument does not have merit for a particular group of decision makers who represent certain urban constituencies, then at least the fact of who benefits through redistribution of income should be explicit; then the decision makers will decide with the knowledge of who gains from the project at hand.

The more useful way to arrive at some simple notion of who gains from a recreation project is to detail the specific groups who will receive benefits and the number of benefits they will gain. Table 4 indicates a means for assessing the benefits among various recipients.[8] While the values in the table are purely imaginary, estimates for a real project would be quite possible if one knew the economic and social characteristics of the persons living in the service zones around the program or site project. In this illustration, total benefits were estimated by either survey methods

Table 4.

Hypothetical Distribution of Benefits for a One-Year Period

Age	Income $0-3,000 White	Nonwhite	Income $3,000-10,000 White	Nonwhite	Income $10,000-over White	Nonwhite	Total	Percentage
0-18	$10	$100	$50	$10	$5	$0	$175	86%
19-64	3	10	5	2	0	0	20	10
65 years and older	0	2	3	3	0	0	8	4
Total	$13	$112	$58	$15	$5	$0	$203	—
Percentage of total	6%	56%	29%	8%	2%	0%	—	100%

Note: Also calculate a per capita benefit for each cell.

or census data and then allocated according to specific characteristics of persons living in the zone areas.

In Table 4, it is clear that the greatest number of benefits is achieved by nonwhite children under 19 years of age who come from families where incomes are $3,000 or less. Such a project redistributes benefits downward. In addition to the estimated total benefits derived for particular groups, one might gain an additional insight by recasting Table 4 in terms of per capita benefits or per beneficiary benefits. Although the benefits illustrated in Table 4 are aggregates of benefits, per capita benefits according to these groups would provide an even clearer picture of the impact of the benefits upon recipient groups.

In such procedures, an analyst would estimate the aggregate benefits going to particular population groups and the per capita benefits going to particular individuals within the groups. Such data would allow one to decide whether the redistribution of income was, in fact, preferred. While not knowing preference, the decision maker must make the choice, and the analyst should detail explicit results.

Finally, then, the question of whether a particular new distribution is preferred is beyond the scope of the economics. The allocative efficiency is internal to the analysis, and although one can show the redistribution effects, it is a political or administrative choice as to whether the redistribution is preferred.

Consideration of Alternatives

In theory, a proposed project will be compared on a benefit/cost basis with other proposed projects designed to accomplish the same purpose. In reality, this is seldom the case. Usually, by the time an analyst gets a proposal to assess, the priorities already

have been established and alternatives discarded. In another way, however, the issue of alternatives is a significant one. When it is budget time in the city and projects are being proposed, the ongoing analysis of what is currently done should be compared with the anticipated outcomes of proposed changes or additions to the budget. Thus, proposals for funding the development of one arts project in an area of a city may have to compete for funding another arts project in a different part of the city; perhaps both of them will compete with a project to provide air conditioning to an existing office building or another to pave a number of streets. Site projects or capital projects will compete with each other for scarce local resources, and commonly, they will compete with program or service proposals. The effective or, perhaps one should say, the efficient public arts council in a city is one that analyzes what it is doing and what it plans to do and then makes the most efficient choices. If the goal is to maximize the satisfactions of the city's arts consumers, then the efficient selection of programs and activities to effect these satisfactions should be made carefully. In short, benefit/cost analysis on all phases of a publicly financed arts system would be a desirable goal if that analysis could be undertaken within a reasonable budget for evaluation.

A Final Note

This chapter has looked at some of the elements that might make up a local cultural policy. It has examined briefly how such a policy might be organized and might function and coordinate its efforts to assist economic efficiency through the aid of cultural economics and its applications of benefit/cost analysis. If arts councils will evaluate project funding on an ongoing basis, efficiency can be enhanced, and perhaps the arts as well as local residents can be served better. This chapter has challenged arts councils to think in a way that would lead them to develop precise goals and proceed *in a rational manner* to allocate funds to those activities that could demonstrably be shown to contribute to the goals of the council. It is almost always the case that once goals are set, one never looks back at them but gets completely involved with the programs themselves. What one may need is to ensure that the goals of local arts policy are addressed and that funds collected from local purses are used to benefit the community. Rational choice making with economic considerations could improve the quality of local arts policy and enhance the artistic as well as the economic welfare of the community. Unfortunately,

this happy event seldom occurs because as Mark Blaug and K. Kling noted, in looking at the work of the Arts Council of Great Britain: "It is not too much to say that in 29 years . . . they have failed to produce a single coherent and operational statement of their aims."[9]

Notes

1. William J. Baumol and William Bowen, *Performing Arts: The Economic Dilemma* (New York, N.Y.: Twentieth Century Fund, 1966).

2. David Cwi and Katherine Lyall, *Economic Impact of Arts and Cultural Institutions: A Model for Assessment and a Case Study in Baltimore,* Research Report #6 (Washington, D.C.: National Endowment for the Arts, Research Division, 1977); D. Roger Vaughan, "Making a Festival Pay," in *Economic Policy for the Arts,* ed. William S. Hendon, Alice J. MacDonald, and James L. Shanahan (Cambridge, Mass.: Abt Books, 1980), pp. 351–358; Port Authority of New York and New Jersey, *The Arts as an Industry: Their Economic Importance to the New York-New Jersey Metropolitan Region* (New York, N.Y.: Port Authority of New York and New Jersey, 1983); and Peggy Cuciti, "The Arts and Tourism: A Case Study of Aspen, Colorado," in *Economics of Cultural Industries,* ed. William S. Hendon, Douglas Shaw, and Nancy K. Grant (Akron, Ohio: Association for Cultural Economics, 1984), pp. 78–92.

3. William S. Hendon, *Analyzing an Art Museum* (New York, N.Y.: Praeger Publishers, 1979); and C. D. Throsby, "Social and Economic Benefits from Regional Investment in Arts Facilities: Theory and Application," *Journal of Cultural Economics* 6, no. 1 (June 1982): 1–14.

4. Marion Clawson, "Methods of Measuring the Demand for the Value of Outdoor Recreation," Resources for the Future Reprint No. 10 (Washington, D.C.: Resources for the Future, 1959).

5. Ibid.

6. Frank A. Cesario, "Operations Research in Outdoor Recreation," *Journal of Leisure Research* 1, no. 1 (Winter 1969): 43–47.

7. J. Michael Kavanagh, Morton J. Marcus, and Robert M. Gay, *Program Budgeting for Urban Recreation, Current Status and Prospects in Los Angeles* (New York, N.Y.: Praeger Publishers, 1973), p. 16.

8. Burton A. Weisbrod, "Redistribution Effects and Benefit/Cost," in *Problems of Public Expenditure Analysis,* ed. Samuel B. Chase, Jr. (Washington, D.C.: The Brookings Institution, 1968), pp. 177–222.

9. K. Kling and Mark Blaug, "Does the Arts Council Know What It Is Doing?" in *The Economics of the Arts,* ed. Mark Blaug (London: Martin Robinson, 1976), p. 124.

Economic
Structure and
Impact of the Arts:
Comparisons
with the Nonarts

by

James H. Gapinski

Florida State University
Tallahassee, Florida

I. The Sport of Comparative Impacts

At 8:05 p.m. on the second Thursday in November, Don Kehote hurried across the tarmac to the concourse. His flight from Atlanta to Talhavancy had departed late due to heavy air traffic, and a severe storm enroute had delayed his arrival further. Don held no car or hotel reservation, but he had learned from previous visits to the small college town that reservations were almost an affront to the informality for which the community was noted. Thinking mostly about the business meeting scheduled on Friday, Don gathered his luggage and went to the car rental desk only to learn that no cars were available; they had all been rented through Sunday afternoon. Unamused but unperturbed, Don hailed a cab and instructed the driver to take him to Talhavancy's Hotel Row, where the name lodgings were located. Once again, no availabilities at any of the establishments there. Finally, after a frantic search, Don settled for a one-star accommodation a few miles west of the Row.

By 11:35 p.m., Don's appetite, which had vanished during the turbulent flight, returned so he went to a nearby cafe. Despite the hour, it was packed with people celebrating a victory of some sort. A small, empty table beside the juke box caught Don's eye, and he made his way to it through the merrymakers. As he glanced over the menu for something light, the din of the revelers began to take coherent form and soon gave full explanation for his experiences since his plane landed: The Talhavancy Stompers had defeated their arch rivals, the Bayou State Swampers, by a score of 35 to 10.

The events making up the misadventures of Don Kehote differ markedly from the circumstances surrounding the one-week run of *Death of a Salesman* staged by the Talhavancy Theatre Company in September. On any particular night, there were plenty of cars for rent at the airport, plenty of vacancies everywhere on the Row, and plenty of empty tables at all lunchrooms in town. This contrast of experiences translates into a contrast of economics. The 55,000 fans who cheered the Stompers and Swampers boosted economic activity in Talhavancy by $700,000; the 4,800 patrons who fought back tears at the Talhavancy Theatre raised it by $60,000. In terms of these numbers, football wins, the arts lose, and the score is not even close.

Comparisons of this type are easy to find. The Superbowl, the World Series, Wimbledon, and the Olympics are recurring events that substantially boost the economics of their host communities. Similarly, continuing attractions such as Disney World in Or-

186

lando, the Strip in Las Vegas, or the Castle in Windsor elevate the pulse of local business permanently. The reverse is also true as the 57-day strike of professional football in 1982 and the 50-day shutdown of major-league baseball the year earlier attest. Big business gained or lost means big economic impact positively or negatively, and the numbers involved in these situations cannot be matched by the ones coming from a Talhavancy Theatre Company. Nor can they be matched by the statistics from, say, the London Contemporary Dance Theatre or Saddler's Wells Royal Ballet, each of whose *annual* attendance would pale against a *single* sellout of a soccer game at Wembley Stadium.

These comparisons have intuitive appeal, but they may conceal more than they reveal. Not all arts organizations are Talhavancy Theatre Companies; many are large-scale enterprises. Table 1, which is compiled from a variety of sources covering different time periods, provides illustrations from both sides of the Atlantic. On the American shore, the Metropolitan Opera annually draws 800,000 patrons. That figure would be the envy of every professional football team and some major-league baseball clubs, and it surpasses total attendance at a decade of Superbowls or a dozen World Series games. The seven New York companies together attract almost 5.5 million persons yearly, whereas Broadway pulls 10.1 million. Either total easily dwarfs the attendance records for any collection of sports franchises in most cities. To the west, the Philadelphia Orchestra plays for more than 300,000 admirers each year; much farther west, the Los Angeles Philharmonic does the same for 500,000. The story is repeated in Britain. The Royal Shakespeare Company and the National Theatre enjoy annual followings exceeding a half million patrons, while the English National Opera and the Royal Opera claim more than a quarter-million devotees. The eight London operations welcome just over two million persons per year, and the West End opens its doors to almost nine million. Touring exhibitions likewise have been very successful in attracting audiences. For instance, the King Tutankhamen exhibit drew 1.3 million people in Los Angeles alone, and attendance was solid at the touring works displayed at the Royal Academy of Arts on Piccadilly. Clearly, even without statements about dollar (or pound) magnitudes, the arts are big business, too.

In the sport of comparative impacts, the arts hold their own or at least make a commendable showing. They generate economic activity through the employment of skilled and unskilled workers and through the use of capital of various kinds. They sell their service in the marketplace. Moreover, they stimulate allied businesses and promote others further down the economic stream. Viewed broadly, they resemble the nonarts; that there is a re-

Table 1.

Paid Attendance at Major Arts Organizations and Centers

Reference	Source Code	City	Period	Annual Paid Attendance
Theatre				
National Theatre	ACGB	London	1971-1983	545,340
Royal Shakespeare Company	ACGB	Stratford	1965-1980	409,882
Royal Shakespeare Company	ACGB	London	1965-1980	238,086
Guthrie Theater Foundation	FORD	Minneapolis	1965-1974	234,067
American Conservatory Theatre	FORD	San Francisco	1965-1974	220,826
Mark Taper Forum	FORD	Los Angeles	1965-1974	196,307
Arena Stage	FORD	Washington	1965-1974	187,426
Circle in the Square	FORD	New York	1965-1974	90,726
Opera				
Metropolitan Opera Association	FORD	New York	1965-1974	792,115
New York City Opera	FORD	New York	1965-1974	334,776
English National Opera	ACGB	London	1971-1983	317,670
Royal Opera	ACGB	London	1971-1983	281,911
Lyric Opera of Chicago	FORD	Chicago	1965-1974	164,887
San Francisco Opera Association	FORD	San Francisco	1965-1974	164,244
Seattle Opera Association	FORD	Seattle	1965-1974	69,837
Symphony				
Boston Symphony Orchestra	FORD	Boston	1965-1974	553,005
Los Angeles Philharmonic	FORD	Los Angeles	1965-1974	498,768
New York Philharmonic	FORD	New York	1965-1974	392,552
Philadelphia Orchestra Association	FORD	Philadelphia	1965-1974	314,284
Cleveland Orchestra	FORD	Cleveland	1965-1974	288,527
London Philharmonic Orchestra	LOCB	London	1971-1983	117,463
Royal Philharmonic Orchestra	LOCB	London	1971-1983	96,794

Reference	Source Code	City	Period	Annual Paid Attendance
Dance				
New York City Ballet	FORD	New York	1965-1974	379,782
Royal Ballet	ACGB	London	1971-1983	233,506
American Ballet Theatre Foundation	FORD	New York	1965-1974	226,499
City Center Joffrey Ballet	FORD	New York	1965-1974	194,445
London Festival Ballet	ACGB	London	1971-1983	176,918
San Francisco Ballet Association	FORD	San Francisco	1965-1974	69,632
Pennsylvania Ballet Association	FORD	Philadelphia	1965-1974	44,983
Arts Centers				
Broadway	LEAG	New York	1981-1982	10,100,000
West End	SWET	London	1981-1982	8,750,000

Sources: Arts Council of Great Britain; Ford Foundation; League of New York Theatres and Producers, "Broadway Boosts City's Economic Picture," Mimeographed (New York, N.Y.: League of New York Theatres and Producers, 1982), p. 2; London Orchestral Concert Board Limited, *Annual Report of the Board of Management* (London: London Orchestral Concert Board Limited, various years); Society of West End Theatre, "West End Theatre Data—1981," Mimeographed (London: Society of West End Theatre, 1982), p. 2; and Society of West End Theatre, "West End Theatre Data—1982," Mimeographed (London: Society of West End Theatre, 1983), p. 4.

semblance can be confirmed through an examination of the economic structure of the arts.

This analysis begins in Section II with a brief review of both the magnitude of arts subsidies and the socioeconomics of arts enthusiasts. A few basics of production schedules and their implications for an arts inquiry follow in Section III. Sections IV and V report on the production structures in the arts, while Section VI addresses the demand for the arts. Section VII brings together the three main lines of thought by asking whether an arts company, conducting business subject to production and demand relationships, observes some rule of optimization inasmuch as its operation is subsidized. Answering in the affirmative, it leaves to Section VIII to highlight the consequences of subsidization. That section also provides an empirical justification for the subsidy.

After reiterating how the structure of the arts conforms to convention, Section IX looks at the direct economic impact associated with that structure. In doing so, it combines the spending by arts goers with the expenditure by the companies themselves.

As one may have guessed, the investigation deals primarily with nonprofit organizations. Moreover, for the sake of manageability, although perhaps without much loss of generality, it concentrates on the lively arts.

II. Surface Appearances

On the surface, arts companies differ from the majority of private-enterprise establishments because they are subsidized by private and public monies and because they sell their service, called a cultural experience, mainly to one segment of the population.

The subsidy, whose theoretical justification is given by Baumol and Bowen[1] and Abbing[2] in terms of mixed services and externalities and by Hansmann[3] in terms of voluntary price discrimination, constitutes a sizable portion of an arts company's income. Table 2 documents the point. In this table, subsidy is taken to be a company's total unearned income and hence includes gifts from all sources. The income entry is subsidy plus earned income, the latter reflecting box office revenue, fees, and the like. In the United States, theatre derives roughly 30 percent of its income from subsidy. Opera's income is 45 percent subsidy, symphony's about 50 percent, and dance's almost 40 percent. The subsidy also casts a big shadow in the United Kingdom, where the Royal Shakespeare Company registers a 40 percent figure and where orchestras approximate 25 percent. Although the subsidy varies across cases, it does not vary in the key respect of being large. From the standpoint of arts companies, subsidization is not merely a way of life; it is the means of life.

On the matter of audience characteristics, the evidence clearly indicates that the arts appeal primarily to the educated and affluent. For instance, Baumol and Bowen[4] observed that of the arts-going adult males and females in the United States, 55.4 percent and 31.6 percent, respectively, had gone to graduate school. For the urban population in general, only 5.3 percent of adult males and 2.0 percent of adult females did graduate work. The two researchers also observed that the median income of arts attenders in the United States was fully twice that of the general population. Similar circumstances held in the United Kingdom. There, according to Baumol and Bowen, 48.5 percent of the male

Table 2.

Profile of the Degree of Subsidization in the Arts

Reference	Source Code	Number of Companies	Country	Period	Per Company Annual[a] Subsidy	Per Company Annual[a] Income	Subsidy Ratio[b]
Theatre	FORD	27	US	1969-1971	238,654	705,855	0.338
Theatre	BB85	22	US	1982-1983	813,636	2,625,000	0.310
Opera[c]	FORD	30	US	1969-1971	292,729	640,027	0.457
Symphony	FORD	91	US	1969-1971	391,083	832,475	0.470
Symphony	BB80	160	US	1977-1979	640,543	1,233,757	0.519
Dance[d]	FORD	17	US	1969-1971	342,067	895,116	0.382
Royal Shakespeare Company[e]	CRST	1	UK	1978-1980	2,093,238	4,972,971	0.421
Metropolitan Opera Association	FORD	1	US	1969-1971	4,287,388	17,030,087	0.252
Royal Philharmonic Orchestra	LOCB	1	UK	1978-1980	327,221	1,197,062	0.273
London Philharmonic Orchestra	LOCB	1	UK	1978-1980	334,223	1,341,435	0.249
London Symphony Orchestra	LOCB	1	UK	1978-1980	393,996	1,823,795	0.216
Philharmonia Orchestra	LOCB	1	UK	1978-1980	284,715	1,354,536	0.210

[a] Entries are denominated in units of the domestic currency and are not adjusted for inflation: They are either current dollars or current pounds.

[b] Subsidy ratio = subsidy/income.

[c] Opera figures exclude those for the Metropolitan Opera Association.

[d] Dance consists of ballet and modern dance.

[e] Figures for the Royal Shakespeare Company pertain to all venues.

Sources: Hilda Baumol and William J. Baumol, "On Finances of the Performing Arts During Stagflation: Some Recent Data," *Journal of Cultural Economics* 4 (December 1980): 3; Hilda Baumol and William J. Baumol, "The Future of the Theater and the Cost Disease of the Arts," in *Bach and the Box: The Impact of Television on the Performing Arts*, Mary Ann Hendon, James F. Richardson, and William S. Hendon, eds. (Akron, Ohio: Association of Cultural Economics, 1985), p. 11; Council of the Royal Shakespeare Theatre, *Report of the Council* (Stratford-upon-Avon: Council of the Royal Shakespeare Theatre, various years); Ford Foundation, *The Finances of the Performing Arts*, Vol. 1 (New York, N.Y.: Ford Foundation, 1974), Appendices A and B; and London Orchestral Concert Board Limited, *Annual Report of the Board of Management* (London: London Orchestral Concert Board Limited, various years).

and 42.3 percent of the female arts aficionados age 20 or older reached the top educational category compared with only 3.7 percent and 2.7 percent, respectively, who did so from the population at large.[5] Moreover, the median income of aficionados was more than 150 percent of the general population's. Along the same lines is a finding for the United Kingdom reported by the Society of West End Theatre (SWET). The society noted that West End patrons from the professional and senior management social group were represented to a disproportionately high extent. Specifically, 37 percent of the patrons came from that stratum, which accounted for only 17 percent of the whole population.[6]

Looking further at the situation in the United States, a Ford Foundation study agreed: The arts play to the well-educated and the well-to-do. College graduates were found to comprise the largest single segment of the audience regardless of art form. For theatre, 33 percent of the attenders held college diplomas, while for opera, 38 percent did. Symphony and ballet registered 37 percent and 40 percent, respectively. These percentages contrasted sharply with the ones for arts goers who did not complete high school—namely, 18 percent, 20 percent, 21 percent, and 28 percent across the respective arts. Income mattered, too, judged Ford, but education appeared to be the more important of the two factors by far.[7]

This ranking of education first and income second has received corroboration from three recent studies of the socioeconomics of the arts. Arguing that arts organizations operate in an environment shaped by the particularities of the host communities, Gapinski used the Ford data on symphonies to assess the importance to attendance of various environmental agents, including education and income. Both factors demonstrated a positive effect, but education proved to be 50 percent more influential.[8] Horowitz extended the American inquiry to cover attendance at seven lively and visual arts: theatre (separated into dramas and musicals), opera, symphony, ballet, jazz, and galleries. For each of the seven, attendance increased with education and with income, but it followed education more faithfully.[9] Zuzanek and Lee took the ranking issue to Canada. Their data for London, Ontario, dealt with theatre, symphony, and visual art; in all three instances, attendance was tied much more closely to college education than to family income.[10]

Arts companies in the United States and beyond depend heavily upon subsidization for sustenance, and they sell their service chiefly to people of prestige. In these respects, they differ markedly from typical nonarts establishments, and it is almost natural to infer from these differences that arts concerns behave quite unlike those of the nonarts. Yet, as is often true, surface appearances are deceiving. In fact, arts companies behave much like any other producer.

They follow routine production schedules, they have conventional determinants to shape the demand for their product, and they even exhibit standard optimal behavior. Beneath the surface, the non-profit arts are not unique. The next sections present the arguments.

III. Production Functions: The Arts Context

Schedules relating inputs such as labor and capital to output have been a fixture of economic analysis at least since Charles Cobb joined Paul Douglas in 1928 to work with a mathematical function that has come to bear their names.[11] Although these schedules of production, alias production functions, possess many features, three deserve special attention.

One feature is the marginal product of an input, which can be defined as the change in output's quantity per unit change in an input's quantity. It measures the extent to which an extra unit of only the input under consideration changes the quantity pro duced, and hence it presumes that the quantities of all other inputs remain unchanged. The Cobb-Douglas function, which has been joined in popularity by other formulas through the years, normally takes the marginal products to be positive but declining. That is, a one-unit increase in, say, labor increases output, but the tenth labor unit adds more to output than does the hundredth. A second feature, closely related to the first, is output elasticity, which gives the percent change in output due to a 1 percent change in an input provided that all other inputs remain unchanged. Under the Cobb-Douglas, the output elasticity of each input is a constant.

Feature three is the elasticity of substitution. Essentially an index, it gauges the ease with which inputs can be substituted for each other in the production process. If inputs can be used only in strict proportion—say, 10 workers per machine without exception—then substitution is said to be impossible, and the substitution elasticity registers zero. Fixed factor-proportions prevail. On the other hand, if inputs can be employed in variable proportions—say, ten or six or five workers per machine—then substitution is possible. The elasticity is positive, and it becomes more positive the more easily substitution can be accomplished. Perfect substitutes, inputs that are exactly identical from the standpoint of production, have an infinite elasticity. By its nature, the Cobb-Douglas restricts the elasticity to unity, and this value has developed into a benchmark for classifying inputs. Inputs

with an elasticity below unity are called technically dissimilar, whereas those with an elasticity above unity are termed technically similar.

Table 3 presents a few estimates of the substitution elasticity obtained for manufacturing industries in the three countries referred to in the previous section: the United States, Britain, and Canada. Two inputs are supposed—namely, labor and capital. Characteristically, the estimates—even for a given industry—lie all over the map, but they cluster below unity.

Table 3.

Estimates of the Elasticity of Substitution Between Labor and Capital for Manufacturing Industries in Several Countries

	United States			Britain	Canada
Industry	by McKinnon	by Kendrick	by Ferguson	by Ryan	by Tsurumi
Apparel	0.69	0.09	1.08		0.53
Chemicals	−1.11	0.65	1.25	1.19	0.41
Electrical Equipment	0.43	0.80	0.64	0.86	0.27
Food	0.37	0.25	0.24	1.13	0.58
Lumber	0.80	0.40	0.91		0.23
Paper	0.09	0.55	1.02		0.56
Petroleum and Coal		0.51	1.30		0.90
Printing	0.84	0.18	1.15	0.91	
Textiles	0.16	0.59	1.10	1.12	0.84
Tobacco	0.92	0.88	1.18		0.89
Transportation Equipment	0.18	0.65	0.24		0.71

Sources: Marc Nerlove, "Recent Empirical Studies of the CES and Related Production Functions," in *The Theory and Empirical Analysis of Production,* Murray Brown, ed. (New York, N.Y.: National Bureau of Economic Research, 1967), p. 102; Hiroki Tsurumi, "Nonlinear Two-Stage Least Squares Estimation of CES Production Functions Applied to the Canadian Manufacturing Industries, 1926-1939, 1946-1967," *Review of Economics and Statistics* 52 (May 1970): 205; and Terence M. Ryan, "C.E.S. Production Functions in British Manufacturing Industry: A Cross-Section Study," *Oxford Economic Papers,* new series 25 (July 1973): 243.

This information suggests that the Cobb-Douglas, with its insistence on a unit elasticity, would be an imprudent choice for studying production structures in the arts. Asked simply, why impose a unit value beforehand, especially when the elasticity is known to vary widely and to "average" away from unity? Furthermore, as already observed, the Cobb-Douglas customarily restricts a marginal product to be positive for any practical amount of the input. In the context of, say, profit maximization, a firm theoretically hires labor until labor's marginal product equals the real wage, which is the hourly wage divided by the price level and therefore bears an adjustment for inflation. All other inputs are treated likewise. Since input and output prices must be positive, the presumption of everywhere-positive marginal products is quite consistent with a rule of profit maximization. But arts companies, leaning heavily on subsidies, might not heed that rule. They might not heed any optimization rule. Instead, they may hire labor, such as actors or ushers, and purchase capital, such as props or lighting equipment, with abandon; and, consequently, they might force the marginal products of some inputs out of the positive region and into the negative zone: The extra units of these inputs "clutter the work space" and cause output to fall. Again, the Cobb-Douglas would eliminate this possibility beforehand.[12] In studying the arts, a schedule more general than the Cobb-Douglas seems to be needed.

One such formulation that restricts neither the substitution elasticity nor the marginal products is the production function introduced by Halter and others[13] and applied by Reinhardt[14] and by Scheffler and Kushman[15] to health services. Dubbed here the General production function, it contains the Cobb-Douglas as a special case, and hence it does not impose fixed proportions among the inputs. At first blush, this absence of fixity may strike one as odd for an arts inquiry because staging a production frequently necessitates fixed requirements for at least some inputs. *La Mancha* definitely would suffer if Sancho were replaced by additional swords for Quixote. *Macbeth* would lose in a translation that omitted the witches' cauldron, and the *Nutcracker* hardly would be the same if a custodian were swapped for a ballet dancer. The fixed-proportions argument collapses, however, when it is recognized that output in the arts refers to cultural experiences enjoyed by patrons. From that perspective, substitution can occur among artists, capital, and other inputs without altering the output level. Input substitution would be accomplished by substituting among the productions to be staged.

IV. The Production Structure by Art Form

In order to uncover production structures in the arts, the General function is examined empirically by art form with the aid of a Ford Foundation data tape that accompanied the Ford entries in Tables 1 and 2. While full details of the exercise are left to Gapinski, it should be noted at this juncture that the tape spans nine fiscal years (1966-1974) and involves 164 nonprofit companies drawn from theatre, opera, symphony, ballet, and modern dance in the United States.[16] Because of the paucity of information on modern dance, that art form, with its eight troupes, is set aside.

The output of cultural experiences is measured by the sum of ticketed attendance and attendance at contracted fee performances, those for which a fee is determined in advance regardless of actual audience size. Labor is broken down into two groups. Artists include performing and guest artists, directors, conductors, stage managers, instructors, designers, and technicians. Staff includes everyone else: administrators, supervisors, clericals, stagehands, maintenance help, and front-of-house personnel. Both artists and staff are expressed in man-hours. Capital captures the use of facilities and equipment, the latter being defined broadly to include sets, costumes, scores, and scripts. Capital is denominated in real dollars—namely, dollar value adjusted for inflation.

Each arts organization operates in a setting that influences its productive activity. One company may be located in an area having rich cultural traditions and marked by a well-educated, affluent citizenry sensitive to the arts. Another may be more of a pioneer in an area previously denied exposure to live performances; it may be blazing a trail through a cultural wilderness. These considerations, the environmental factors alluded to earlier in relation to the socioeconomic analysis by Gapinski,[17] enter the empirical examination of the General function. So does a check of the role played by technological advances in generating cultural experiences.

Consistent with the assertion by Baumol and Bowen,[18] Ford's data plainly show that technical progress is not a major force in the production of culture. They also show, as Table 4 reports, that artists and capital have positive marginal products across the four arts. Staff, too, have positive marginals except in ballet. More concretely, increasing the artist input by one man-hour in theatre increases output by 0.59 cultural experiences. Doing so in opera raises it by 0.29 experiences. Buying an extra dollar's worth of equipment expands production by 0.03 experiences in symphony

Table 4.

Properties of the Production Structure by Art Form in the United States

Property	Theatre	Opera	Symphony	Ballet
Marginal Product				
Artists	0.5943	0.2909	0.0870	0.5899
Capital	0.2051	0.0849	0.0347	0.1136
Staff	0.6483	0.1489	0.2053	−0.2768
Marginal Product Change				
Artists	Minus	Minus	Minus	Minus
Capital	Minus	Minus	Minus	Minus
Staff	Plus	Plus	Plus	Plus
Output Elasticity				
Artists	0.3490	0.5719	0.5619	0.8529
Capital	0.2820	0.1878	0.0936	0.2646
Staff	0.3273	0.1831	0.2478	−0.1661
Substitution Elasticity				
Artists, Capital	0.7533	0.7198	0.8510	0.7223
Artists, Staff	1.4134	3.6444	2.1612	1.5506
Capital, Staff	1.1225	1.3308	1.1189	1.7114

and by 0.11 in ballet. Similarly, working a staffer an extra hour raises theatre's output by 0.65 experiences, opera's by 0.15, and symphony's by 0.21. Ballet's, however, actually drops by 0.28 experiences. The entries for the marginal product change indicate whether an input's marginal product is rising (plus) or falling (minus). Thus, artists and capital exhibit positive but declining marginal products across the arts, while staff sees positive but increasing marginals everywhere except in ballet.

The output elasticities coincide nicely with the romantic notion that art is the artist's medium. They are always greatest for artists and, therefore, boosting that input by 1 percent always has a stronger effect on output than does augmenting either capital or staff by 1 percent. The showing by staff should not be taken lightly, however. Even though staff may occupy a secondary position in an arts operation, it contributes to output; from the results concerning output elasticities and marginal products, it contributes handsomely, ballet excepted.[19] The secretary, the usher, and the parking-lot attendant matter for production.

Table 4 concludes with the substitution elasticities, which are calculated pairwise for the three inputs. Those for artists and capital resemble the bulk of the evidence on manufacturing reported in Table 3. They fall below unity independently of art form and, thus, identify artists and capital as technically dissimilar

inputs. The exact opposite holds for artists and staff and for capital and staff. Those pairs have elasticities that exceed unity; they are technically similar. In keeping with a common-sense belief that an input should be most easily substitutable with itself, the greatest elasticities ordinarily occur when the input pairing involves the two labor variables.

Before the study plunges deeper into production structures, it may be worthwhile to note that a production function represents one side of a coin that has a cost function on the other. By linking inputs to output, the production function serves as the mechanism for linking cost to output when prices of the inputs are applied to their quantities.

Cost functions, like their production counterparts, have been examined for the arts, and as usual, Baumol and Bowen[20] led the way. Concentrating on symphony in the United States, they estimated curves for 11 orchestras taken separately and found a U-shaped pattern: Cost per concert first fell and then rose as the number of concerts increased. In a related effort, Globerman and Book considered symphony in Canada. Treating 33 organizations collectively, they, too, detected a U-shaped configuration for unit cost. The U also held for Canadian theatre, which Globerman and Book explored through data on a group of 27 theatre companies.[21] Recently, Lange and others brought the cost function back across the mighty Niagara and applied it to 111 American orchestras viewed in toto and in subsets.[22] Either way, the U characterized unit cost.

These U-type cost curves are hardly unique to the arts. Henderson and Quandt note that they frequently underlie economic analyses of the firm,[23] and McConnell points out that they often describe endeavors in retail trade, farming, and banking.[24] That they rule even more widely is suggested by Cohen's work on hospital cost.[25]

V. The Production Structure More Sharply Focused

Information provided by the Arts Council of Great Britain and by Gambling and Andrews makes it possible to investigate the production structure at the organizational level.[26] The frame of reference is the Royal Shakespeare Company (RSC). Since the RSC stands at center stage in this and later discussions, a sketch of it is warranted.

Although dating back to David Garrick's Shakespeare Jubilee of 1769, celebrated at the Bard's birthplace of Stratford-upon-Avon, the RSC had its formal debut in 1961, the year of its christening by Queen Elizabeth. Its early repertoire, variously starring Peggy Ashcroft, Vanessa Redgrave, Diana Rigg, and Paul Scofield, was staged at the Shakespeare Memorial Theatre (also known as the Royal Shakespeare Theatre) in Stratford or the Aldwych Theatre in London. From these two proscenia, as Table 1 shows, the RSC captivated more than a half-million people annually until 1982, when it moved from the modest, cramped quarters of the Aldwych to the lush, vast surroundings of London's then newly completed Barbican Centre.

The company is one of four nonprofit lively arts concerns in Britain to be designated as national. That appellation is most apt because, historically, the company has striven to reach beyond the artistic and physical confines of its twin headquarters. Since the mid-1970s, for instance, it has been performing experimental works at its studio arenas, The Other Place in Stratford and The Warehouse—now relocated to The Pit—in London. It regularly stages productions in Newcastle-upon-Tyne, and it frequently televises its efforts. It also tours internationally, its latest overseas achievements including the New York engagements of the *Life and Adventures of Nicholas Nickleby* in 1981, *Good* in 1982, and the repertory companions *Cyrano de Bergerac* and *Much Ado About Nothing* in 1984. Associated with these ambitious endeavors is an ambitious budget that, as Table 2 discloses, neared five million pounds at the end of the 1970s.

Given its long tradition, its enormous audience, its international presence, and its sizable budget, the RSC is a major cultural influence. Ascertaining its production structure is equivalent to ascertaining the structure of a major segment of British theatre, which escaped attention in Section IV.

Preliminary to the investigation, two methodological adjustments are made owing to data constraints. First, artists and staff are merged into a single variable, thereby reducing the inputs to two—labor and capital. Second, the General function is sidestepped in favor of its special case, the Cobb-Douglas. Apart from the data issue, this move can be defended in terms of the substitution elasticity. The substitution estimates reported by Table 4 for the two labor and capital combinations in theatre fall on either side of unity, and they average 0.94. Since 0.94 lies within hailing distance of unity, the Cobb-Douglas does not appear to be an unreasonable representation for a theatrical outfit.

With environmental considerations taken into account, the Cobb-Douglas is examined for the Aldwych and Stratford theatres over the financial years 1968-1969 to 1977-1978, a financial year

running from April to March. The output of cultural experiences is quantified by paid attendance; the inputs of labor and capital are measured by man-hours and real pounds, respectively. Full description of the undertaking is given by Gapinski,[27] but the findings needed for present purposes are reported in Table 5. Specifically, the labor and capital marginal products are positive but declining at both theatres; reinforcing romanticism, labor's marginals exceed capital's. Likewise, labor's output elasticity exceeds capital's—by almost a factor of two. The substitution elasticity registers unity, but that value is imposed rather than derived. These properties, while differing numerically from those cited for theatre in Table 4, do not differ substantively; and together the two tables underscore regularities in the production structure. As before, technological advance proves to be rather unimportant for creating culture.

Table 5.

Properties of the RSC Production Structure at Each Theatre

Property	Aldwych	Stratford
Marginal Product		
Labor	0.2974	0.4455
Capital	0.2592	0.3678
Marginal Product Change		
Labor	Minus	Minus
Capital	Minus	Minus
Output Elasticity		
Labor	0.6241	0.6241
Capital	0.3319	0.3319
Substitution Elasticity		
Labor, Capital	1.0000	1.0000

VI. Demand for Cultural Experiences

On routine theoretical grounds, the demand for a product depends upon the price of that product (own price), the price of similar products (substitute price), and the income of those doing the demanding. On the same grounds, each of these Big Three determinants is expressed in real terms to correct for general inflation. Demand falls as own price rises, and it rises as substitute price or income rises. Such standard relationships are often summarized by means of demand elasticities.

Own-price elasticity indicates the percent change in quantity demanded that results from a 1 percent change in own price provided that all other demand determinants are held constant. Since demand and own price move in opposite directions, this elasticity is negative. When it lies between zero and minus one (say, -0.50), demand is referred to as own-price inelastic: A 1 percent increase in price causes the quantity demanded to decrease by less than 1 percent. In this situation, demand is insensitive to a price adjustment. When the elasticity equals minus one, demand is unitary elastic: A 1 percent rise in price causes exactly a 1 percent fall in quantity. When it falls below minus one (say, -1.50), demand is price elastic: A 1 percent climb in price induces demand to decline by more than 1 percent, and demand is sensitive to the price maneuver.

Substitute-price elasticity and income elasticity have definitions and interpretations that parallel those for own-price elasticity, but their frame of reference is the positive zone. Substitute-price elasticity says something about the competition between products. As the price of a substitute moves upward, demanders of that item turn to the one in question, causing its demand to expand. The stronger the competition, the greater the elasticity should be. Income elasticity says something about the attractiveness of the product. In particular, a value below unity is understood to signify a necessity, whereas an above-unity value is taken to identify a luxury.

Such general propositions concerning demand elasticities apply straightforwardly to the specific case of the arts; for that case, Table 6 reports the numbers deducible from several studies of recent vintage. Looking at the lively arts in the United States as a whole, Withers quantifies the demand for cultural experiences by attendance and gauges the price of substitutes by a price index for reading and recreation. For the overall period 1929-1973, he finds the lively arts to be own-price and substitute-price inelastic but slightly income elastic. Insensitive to price changes, they are a borderline luxury. The subperiods 1929-1948 and 1949-1973 portray them differently, however. In the earlier years, they are own-price sensitive but substitute-price and income insensitive; in the later years, they are sensitive on all three counts.[28]

Touchstone, who appeals to Ford Foundation data for 1965-1974, approaches the U.S. circumstance from a more disaggregated point of view by splitting the lively arts according to form: theatre, opera, symphony, and dance. Cultural experiences are quantified by attendance, and in the spirit of Baumol and Bowen,[29] substitute price is defined as the admission price to cinemas. Touchstone concludes that all four art types are own-price inelastic. Furthermore, opera and symphony are income inelastic, theatre is income elastic marginally, and dance is so decidedly.

Table 6.

Elasticities of Demand for Cultural Experiences on Either Side of the Atlantic

Investigator Region Period	Withers United States 1929-73	Withers United States 1929-48	Withers United States 1949-73	Touchstone United States 1965-74	Gapinski A Britain 1965-80	Gapinski B London 1971-83
Own-Price Elasticity						
Lively Arts	-0.90	-1.07	-1.19			
Theatre				-0.11	-0.66	-0.07
Opera				-0.11		-0.18
Symphony				-0.14		-0.27
Dance[a]				-0.12		-0.29
Substitute-Price Elasticity						
Lively Arts	0.68	0.80	1.25			
Theatre				na		0.12
Opera				na		0.14
Symphony				na		0.53
Dance[a]				na		0.50
Income Elasticity						
Lively Arts	1.08	0.64	1.55			
Theatre				1.03	1.33	0.06
Opera				0.54		0.09
Symphony				0.19		0.27
Dance[a]				2.28		0.26

[a]For Touchstone, dance consists of ballet alone; for Gapinski B, it consists of ballet and modern dance.

na = not available.

Sources: Susan Kathleen Touchstone, "A Study on the Demand for Four Non-Profit Performing Arts" (Ph.D. thesis, Florida State University, 1978), pp. 59, 121; Glenn A. Withers, "Unbalanced Growth and the Demand for Performing Arts: An Econometric Analysis," *Southern Economic Journal* 46 (January 1980): 740; James H. Gapinski, "The Economics of Performing Shakespeare," *American Economic Review* 74 (June 1984): 462-463 for Study A; and James H. Gapinski, "The Lively Arts as Substitutes for the Lively Arts," *American Economic Review* 76 (May 1986): 21-22 for Study B.

The demand analysis is pitched even more disaggregatively by Gapinski, Study A in Table 6.[30] A single organization provides the setting: the Royal Shakespeare Company at the Aldwych and Stratford Theatres. Again, attendance represents cultural experiences, but now substitute price takes on three different formulations. One version, consonant with Withers, is a price index for entertainment and recreational services. A second variant, à la Baumol and Bowen, is the admission price to cinemas in Great Britain, whereas a third reflects cinema prices in the Aldwych's South East and the Stratford's West Midlands regions. Despite this emphasis on substitute price, the data, which originate from the Arts Council of Great Britain and elsewhere for the years 1965-1980, reveal it to be unimportant for RSC demand. They also show the own-price and income-elasticities to be -0.66 and 1.33, respectively, indicating that demand is price insensitive and that an RSC cultural experience is a luxury. These findings nicely match the theatre results of Touchstone.

By their treatment of substitute price, the three inquiries stipulate that substitutes for the lively arts come from outside the arts—from reading or recreation or movies. But surely, if reading or recreation or movies are substitutes for the arts, then so are the arts themselves. Should *Richard II* become dearer, an individual might elect to attend *La Boheme* or *Fidelio* or *Swan Lake* rather than sit through *Superman II*. The lively arts are not perfectly homogeneous. Each has its own set of distinguishing characteristics, and consequently, substitutes can come from within. Shakespeare, Puccini, Beethoven, and Petipa are competitors, a point that escapes all three analyses. Also escaping is the importance of tourism in arts demand. Based on information for 1982, SWET estimates that tourists from overseas account for 25 percent of total attendance in the West End and that tourists from the United Kingdom account for another 35 percent.[31] On a more formal level, Kelejian and Lawrence underscore the moment of tourism in the demand for Broadway theatre.[32]

These two themes—competition from within and demand from without—are combined in a revised demand inquiry by Gapinski, Study B in Table 6.[33] As before, a lion's share of the data originates from the Arts Council, but this time a substantial portion emanates from the London Orchestral Concert Board and the London Tourist Board as well. Covered are 13 London outfits for the years 1971-1983. Two represent theatre. Two represent opera; four, symphony; and five, dance. For each of these 13, substitute price is constructed in keeping with the notion that arts consumers search other art forms in contemplating substitutes. Specifically, for any company, it is the average of the own prices charged by the companies in the other arts. To illustrate, each theatre's substitute

price is the average of the prices posted by the 11 organizations in opera, symphony, and dance. Likewise, each opera's is the average of the prices set by the 11 in theatre, symphony, and dance.

As Table 6 informs, all four arts are own-price and substitute-price insensitive. However, theatre and opera are more so: They have the smaller (absolute) own-price and substitute-price elasticities, while symphony and dance have the larger. In other words, theatre and opera feel less audience response to price changes initiated by themselves or by their competitors. Conversely, symphony and dance feel more.

The income-elasticities remain below unity across art types. In this regard, they agree with Withers' conclusion for the 1929-1948 period and with Touchstone's for opera and symphony. They also agree with evidence provided by Moore,[34] Globerman,[35] Netzer,[36] and Kelejian and Lawrence[37]; they have a reasonable explanation. A cultural experience is a consumable that calls for a large amount of time from the patron. As income rises, patrons desire more experiences, but they also value time more preciously and therefore desire less time-expensive kinds of consumption—they simultaneously seek more and fewer experiences. Adding the time cost of commuting only strengthens the reasoning for low income-elasticities.

Tourism's influence on the demand for cultural experiences is determined from Study B by specifying characteristics of London tourism, including its scope, which averages 18.7 million visitors annually from overseas and the United Kingdom. Filling in those characteristics reveals tourism to be responsible for 20 percent of the attendance at the companies examined. That this sizable figure still may be conservative is suggested by the aforementioned 25 percent and 35 percent tourist shares recorded by SWET. To SWET, half of the West End audience is tourism based.[38]

From these four studies, it should be evident that routine properties hold on the demand side of cultural experiences just as they do on the production side. Demand depends negatively upon own price, positively upon substitute price, and positively upon income. Substitutes may come from outside the arts, as Withers' research indicates, or from within, as Gapinski's Study B confirms. Demand is inelastic with respect to both own price and substitute price, but with respect to income, it may be either inelastic or elastic. On that score, a consensus has not yet emerged. Tourism's involvement in demand may set cultural experiences apart from many products but probably not from the ones provided by the nonarts amenities. Thus, despite the atypical socioeconomics of arts goers, arts demand follows rather routine theories.

VII. Do Arts Companies Behave Optimally?

A firm ordinarily is examined under the presumption that it optimizes. For instance, it might be taken to maximize profit, revenue, or output currently or to minimize cost currently. Perhaps it is treated as managing its affairs toward some "best" level over the long haul. Satisficing, a behavioral pattern by which a firm conducts business subject to only modest performance criteria, quietly is acknowledged as a possibility and just as quietly is dismissed as an exception. Yet satisficing, discussed at length by Simon,[39] might well be the rule for the arts instead of the exception because, as Table 2 stresses, a substantial part of their life is subsidized.

With subsidy providing the blanket to cover those expenses that exceed earned income, arts enterprises might be content with modest attendance rather than maximum attendance, with modest quality rather than maximum quality, or with modest box office revenue rather than maximum revenue. Continuation of the subsidy is undoubtedly a principal concern of the companies, and continuation is undoubtedly tied to their performance records. Nevertheless, sustained subsidy need not require that performance be pressed to extremes; reasonable performance might suffice.

Although the argument for satisficing is theoretically strong in the context of the arts, the counterargument that the arts indeed do optimize is also theoretically strong, at least as Hansmann articulates it.[40] But the question of whether the arts optimize is more empirical than theoretical, and an empirical answer to it can be obtained from the data on the Royal Shakespeare Company. The details, given by Gapinski,[41] are quickly summarized.

A nonprofit enterprise can be thought of as operating under a budget constraint that says its total outgo on labor and capital must equal its total income whether earned through the box office or unearned through subsidy. This budget constraint limits behavior, but it still leaves the organization substantial room to decide how to run its business. One possible code of conduct for an arts establishment is optimization in the form of quantity maximization. Setting the price of a cultural experience at zero would fill the house completely although it simultaneously would yield zero earned income. Conversely, setting a very high price opens up the prospect of considerable revenue per ticket, but it could result in an absolutely empty house. Again, earned income would be zero. Either way, the budget constraint would likely be violated since input costs probably would outstrip the subsidy.

Evidently, to maximize cultural experiences given the constraint, price must be posed at some positive but modest level that enables the company to cover its input costs. In other words, input costs, which involve the quantities and prices of inputs, affect the constrained maximum.

The second possible code of conduct is maximization of box office revenue. The previous argument recognized that box office revenue registers nil both at a very high ticket price and at a zero price. As price falls from the prohibitive level, revenue per ticket necessarily falls, but ticket sales pick up sufficiently to allow total revenue to rise. These patterns continue until cultural experiences reach some mid-demand position, where the decline in revenue per ticket becomes dominant and causes total revenue to begin its descent to zero. By virtue of the production function, this adjustment in cultural experiences to maximize revenue under the constraint can be represented as an adjustment in inputs.

A third code abandons optimization altogether and instead calls for a casual walk along the constraint. The firm still exhausts its budget although now it does not do so optimally. It satisfices. Rather than adhere to a strict principle for maximizing quantity or box office revenue, it sticks to some rule of thumb consistent with acceptable quantity and revenue. It therefore uses inputs less precisely than it would if optimization prevailed.

Each of these three behavioral alternatives is applied by Gapinski to the Aldwych and Stratford theatres of the RSC, and each is examined by treating the proscenia jointly after allowing for environmental considerations. The examination, which addresses the financial years 1968-1969 to 1977-1978, proceeds from the input side and concludes in favor of optimization in the form of quantity maximization. Most important for present purposes, it testifies against the hypothesis that nonprofit arts establishments satisfice. The subsidy blanket does not smother conventional economics.

VIII. More on the Subsidy: Highlighted Effects and Empirical Justification

Decreasing the subsidy of an arts company tightens the budget constraint. In response, the company trims its input usage, cuts its output level, and boosts its ticket price. These first two reactions are investigated for arts in the United States by Gapinski,[42] who refers to the Ford data. He finds that reducing

the subsidy to theatre by the full amount of its public component slashes a theatre's employment roster by as much as 11.6 percent and its output by as much as 12.1 percent. Analogously, eliminating the public subsidy to opera diminishes an opera's employment role by up to 5.4 percent and its output by up to 6.7 percent. Symphony shows 5.1 percent and 8.0 percent, respectively, while ballet tops the list with 12.6 percent and 16.9 percent, respectively. Touchstone, also relying on Ford, studies the reaction involving ticket price and calculates that a forfeiture of all public subsidy forces a theatre to adjust real price upward by 13.3 percent. An opera raises price 11.9 percent. In like manner, an orchestra advances it by 14.2 percent, and a ballet does so by 20.8 percent.[43]

Probing the subsidy's effects by a different route, Gapinski compares the behavior of a subsidized arts enterprise against that of a typical profit maximizer, which is unsubsidized.[44] Again, from the Ford tape, he concludes that organizations in theatre, opera, symphony, and ballet employ artists and capital to a greater extent than they would if they adhered to profit maximum dictates. On the other hand, staff is underutilized across the art forms.

The RSC, too, may be compared against a profit maximizer; and at the same time, the merit of the subsidy can be appraised on empirical grounds. Drawing from Gapinski,[45] the endeavor begins with Table 7, which profiles the RSC under actual subsidized conditions and under hypothetical profit-maximizing conditions. The differences between the two states are interpreted as coming entirely from the subsidy. Once again, the period being reviewed spans the financial years 1968-1969 to 1977-1978.

Table 7 acknowledges the Aldwych to be the smaller of the two theatres under actual conditions. It is smaller in labor and capital and thus in output, its output being roughly half of Stratford's. Real ticket price, which is lower at the Aldwych, combines with quantity to determine real box office revenue, Aldwych's likewise being about half of Stratford's. For either theatre, this earned income is insufficient to prevent real profit, which equals the difference between box office revenue and total input cost, from assuming a large negative value. Put another way, Aldwych and Stratford manage their affairs under the subsidy in a fashion such that earned income is outweighed by expenses: Both houses suffer huge losses according to traditional economic bookkeeping.

How do these profiles differ from the ones that would occur if the theatres operated on a profit-maximizing basis without subsidy? Appreciably. Table 7 presents the evidence. Relative to a profit maximizer, the RSC in actual practice overproduces cultural experiences by more than a factor of 14 at the Aldwych and by more than a factor of 2 at the Stratford. In turn, labor and capital are used excessively at the two centers, their multiples

Table 7.

**Profiles of Annual Operations at the Aldwych and Stratford Theatres
Under Actual and Profit-Maximizing Conditions**

Variable	Dimension	Aldwych Theatre		Stratford Theatre	
		Actual Conditions	Profit Maximization	Actual Conditions	Profit Maximization
Labor	Man-Hours	491,040	29,592	580,280	234,640
Capital	Real Pounds	299,680	20,053	373,870	162,402
Output	Tickets Sold	234,045	16,528	414,281	178,536
Ticket Price	Real Pounds	1.77	3.78	2.19	4.38
Box Office Revenue	Real Pounds	414,260	62,532	907,275	781,326
Profit	Real Pounds	−504,571	5,181	−213,843	316,848

paralleling those for output. Moreover, actual real ticket price falls decidedly below profit-maximizing levels. Aldwych's £1.77 is less than half of the profiteer's £3.78, and Stratford's £2.19 is exactly half of the profiteer's £4.38. While retrenchment undertaken in the name of profit would diminish box office receipts, it would improve box office profit enormously. Aldwych would be in the black by £5,181, and Stratford, by £316,848. The deep pools of red ink, £504,571 and £213,843, respectively, would dry up.

Figure 1 gives a visual account of the demand characteristics noted. As in Table 7, the quantity demanded is measured in tickets sold, while ticket price is expressed in real pounds. Points I and J identify the actual demand positions for the Aldwych and the Stratford, whereas G and H mark the profit-maximizing demand positions. Obviously, subsidization shifts the Aldwych from G to I and relocates the Stratford from H to J. Price falls, and quantity rises.

By repositioning the theatres, the subsidy creates some benefit and imposes some cost. If the benefit were to exceed the cost, then on the strength of accepted benefit-cost reasoning, one could conclude that the subsidy is justified economically.

Figure 1.

Demand Characteristics at the Aldwych and Stratford Theatres Under Actual and Profit-Maximizing Conditions

To a first approximation, cost can be taken as the real value of the RSC's total subsidy, and for the years in question, that estimate comes to £761,937 annually. Benefit can be measured as the resulting annual gain in real consumers' surplus. Consumers' surplus, which is the difference between the amount that consumers would be willing to pay for a quantity and the amount actually paid, has a neat graphical representation. For instance, the amount paid for X experiences from the Aldwych is depicted by the rectangle OFIX in Figure 1. The maximum amount that arts goers would pay for X is given by the trapezoid OCIX, thereby making real consumers' surplus the triangle CIF.

If the company were an unsubsidized profit maximizer, it would locate the Aldwych at G, creating the real surplus triangle CGD, which when quantified becomes £1,266. Under the subsidy, the Aldwych rests at I, with its real surplus CIF of £253,841. For the Stratford, profit maximization would yield the surplus triangle AHB as opposed to the actual AJE: £147,712 versus £795,341, respectively. In total, the subsidy increases real consumers' surplus by £900,204. This benefit set against its cost of £761,937 implies a benefit-cost ratio of 1.18: Each £1.00 of subsidy returns £1.18 in benefit. The subsidy more than "pays" for itself; therefore, it is justified on economic grounds.

This benefit-cost analysis takes place along traditional lines. West, however, argues that a different stance might lead to the opposite conclusion,[46] and yet refining the effort in response to West merely strengthens the subsidy's justification. In particular, recalculating the subsidy, first, to reflect only the activities at the Aldwych and the Stratford and, second, to account for the additional tax collections prompted by those activities, cuts the real cost to £245,300 and boosts the benefit-cost ratio to 3.67. Now each £1.00 yields a benefit of £3.67, not £1.18. Gapinski files the brief.[47]

IX. Convention, Structure, and Direct Impact

The usual laws of economics hold at the Royal Shakespeare Company. They hold at the 13 arts operations screened in the West End. They hold at the 60 arts establishments surveyed in Canada and at the 286 sampled in the United States. They hold across art forms, across time periods, across a Wonder of the World, and across an ocean. With little doubt, they hold even more broadly.

All three dimensions of the arts structure follow convention. First, inputs relate to the output of cultural experiences through a

conventional production format. The marginal product of artists is positive and declining. So is the marginal product of capital. The marginal product of staff is customarily positive although it increases. When artists and staff merge into a single labor variable, however, it exhibits a marginal that is positive and declining. Output elasticities tend to be positive and to drop below unity. The elasticity of substitution for the primary inputs clusters below unity while the elasticities for the other input pairs often locate near unity. Moreover, the schedule for unit cost exhibits a U shape.

Second, the demand for cultural experiences is determined by conventional forces. Real income has a positive effect on demand, and real own price has a negative effect. Real substitute price matters. Substitutes may come from outside the arts or from within, but in either circumstance, their price exerts the requisite positive effect on demand.

Third, arts companies display conventional optimization behavior. Operating subject to a budget constraint, they make business decisions, in essence, by observing a principle of vigilance rather than a guideline of complacence. They optimize rather than satisfice.

Admittedly, the arts are exceptional in certain respects. The marginal product of staff is occasionally negative, and technical progress is almost zero. Demand originates mainly from the educated and the affluent and depends heavily upon tourism. Subsidy is a mainstay of their finances. Still, despite such differences, *arts establishments are more like nonarts enterprises than they are unlike them, and hence, from the standpoint of economic impact, they have roughly equal footing with them.*

That the arts are big business is borne out by the attendance numbers in Table 1, by the income numbers in Table 2, and by the input and output numbers in Table 7. From these statistics, it is almost a foregone conclusion that the arts have a sizable direct economic impact, but to clinch the point, one might indulge in a simple computational exercise that involves the arts organizations and centers identified in Table 1.

According to Mathtech, the direct economic impact of an arts company can be interpreted as the sum of the spending by the concern itself and the ancillary spending by its audience.[48] Ancillary spending refers to the outlay on nonticket items that are associated with a cultural experience—namely, transportation, food and beverages, lodging, and the like.[49] Ticket cost is excluded from the audience's ledger because it becomes company revenue, which in turn funds company expenditure. To include ticket cost in the audience's tally would entail double counting.

Calculation of an organization's direct impact begins with box office revenue. From the subsidy ratios presented in Table 2, this revenue expands into a representation of total income, which, by

virtue of the budget constraint, equals expenditure. Thus, total income serves as an estimate of company expenditure. Ancillary spending can be estimated from the box office, too. Observations by Mathtech,[50] Steinike and Stevens,[51] Kelejian and Lawrence,[52] and Cuciti[53] suggest that ancillary spending exceeds ticket cost perhaps substantially; hence, box office receipts amount to a conservative statement of ancillary expense.

Summing these two estimates for each company cited in Table 1 leads to the direct impacts reported in Table 8. Presented there, too, are the direct impacts of Broadway, the West End, and the seven New York and eight London outfits in the catalog. As regards Broadway, its figure comes from the League of New York Theatres and Producers. As regards the West End, its entry involves a subsidy ratio that applies only to the portion of West End revenue that pertains to nonprofit proscenia. To facilitate comparison across organizations and centers, all impacts are expressed in terms of the general price level for the same year, 1983. For the moment, the reader should ignore the last column of numbers.

As Table 8 reveals, individual arts organizations can have a huge direct economic impact. In the United States, the Pennsylvania Ballet gives rise to $1.3 million in commercial activity each year. The Boston Symphony accounts for $17.5 million per year, and the Met does so by a spectacular $56.5 million. In Britain, the record is similar. To illustrate, the Royal Philharmonic Orchestra fashions a direct impact of £1.1 million annually, while the Royal Opera generates one of £9.6 million. The Royal Shakespeare Company, operating at both its Stratford (Sd) and London (Ld) addresses, adds £12.1 million to business volume. When treated in combination, arts enterprises have a profound effect. Broadway's direct impact on the Big Apple is almost a half-billion dollars each year; likewise, the West End directly stimulates London by well over one hundred million pounds per year.

X. Beyond the Direct Impact Comparatively

Bowing to strong pressure from the energy conservation lobby, Congress passes legislation requiring that $1 million be spent on the development of a fuel-efficient carburetor. Shortly thereafter, a contract in that amount is awarded to the Carburetion Systems Corporation, which immediately implements an overtime schedule for a third of its labor force. Those employees begin receiving heftier paychecks and soon spend their booty on clothes,

Table 8.

Economic Impacts of Major Arts Organizations and Centers

Reference	Sample Period	Annual Impact in 1983 Prices[a]	
		Direct	Total
Theatre			
National Theatre[†]	1971-1983	7.5	12.0
Royal Shakespeare Company, Sd	1965-1980	8.3	13.2
Royal Shakespeare Company, Ld[†]	1965-1980	3.8	6.1
Guthrie Theater Foundation	1965-1974	6.2	10.0
American Conservatory Theatre	1965-1974	6.0	9.6
Mark Taper Forum	1965-1974	5.4	8.7
Arena Stage	1965-1974	4.7	7.5
Circle in the Square*	1965-1974	3.4	5.4
Opera			
Metropolitan Opera Association*	1965-1974	56.5	90.4
New York City Opera*	1965-1974	15.0	24.0
English National Opera[†]	1971-1983	6.1	9.7
Royal Opera[†]	1971-1983	9.6	15.4
Lyric Opera of Chicago	1965-1974	11.8	18.9
San Francisco Opera Association	1965-1974	13.8	22.0
Seattle Opera Association	1965-1974	3.3	5.3
Symphony			
Boston Symphony Orchestra	1965-1974	17.5	28.0
Los Angeles Philharmonic	1965-1974	14.0	22.3
New York Philharmonic*	1965-1974	17.1	27.3
Philadelphia Orchestra Association	1965-1974	10.2	16.3
Cleveland Orchestra	1965-1974	12.5	19.9
London Philharmonic Orchestra[†]	1971-1983	1.2	2.0
Royal Philharmonic Orchestra[†]	1971-1983	1.1	1.7

| | Sample | Annual Impact in 1983 Prices[a] | |
Reference	Period	Direct	Total
Dance			
New York City Ballet*	1965-1974	15.2	24.3
Royal Ballet†	1971-1983	5.3	8.5
American Ballet Theatre Foundation*	1965-1974	8.7	13.9
City Center Joffrey Ballet*	1965-1974	5.1	8.1
London Festival Ballet†	1971-1983	2.3	3.7
San Francisco Ballet Association	1965-1974	2.1	3.3
Pennsylvania Ballet Association	1965-1974	1.3	2.1
Arts Centers			
Broadway	1981-1982	495.4	792.6
West End	1981-1982	124.4	199.1
7 New York Operations (*)	1965-1974	120.9	193.4
8 London Operations (†)	Varied	36.9	59.1

[a]Entries are expressed in millions of units of the respective domestic currencies. Total impact is computed by applying a multiplier of 1.60 to the direct impact; corresponding entries may not balance due to rounding error.

Sources: Arts Council of Great Britain; Ford Foundation; League of New York Theatres and Producers, "Update of Main Statistical Results," Mimeographed (New York, N.Y.: League of New York Theatres and Producers, 1982); London Orchestral Concert Board Limited, *Annual Report of the Board of Management* (London: London Orchestral Concert Board Limited, various years); Society of West End Theatre, "West End Theatre Data—1981," Mimeographed (London: Society of West End Theatre, 1982), p. 2; and Society of West End Theatre, "West End Theatre Data—1982," Mimeographed (London: Society of West End Theatre, 1983), p. 4. Subsidy ratios used to calculate company incomes are taken from Table 2.

fitness programs, microwave ovens, and video cassette recorders. Consequently, the businesses involved in apparel, aerobics, and appliances expand their employment roles, and that extra employment leads to extra income, which in turn leads to still more purchases, employment, and income. The iterations continue until in the end, total new spending equals some multiple of the initial $1 million. This multiplier might be 2.5 meaning that the $1 million ultimately raises spending by a total of $2.5 million. Income rises by a multiple, too.

The multiplier concept, whose history dates back to the writings of Kahn,[54] is now a commonplace tool that serves at any level of aggregation, be it an entire nation or a local community. The value assumed by a multiplier usually differs from case to case, however; and as Gapinski recounts, it often differs even for a given case.[55] Those differences can be large.

The upshot of these remarks for the arts inquiry should be obvious. The direct impact considered in the previous section tells only part of the story because it completely misses the second, third, fourth, and nth rounds of activity caused by the spending that comes from the pockets of the companies and their audiences. To obtain the total impact, the direct impact figure must be augmented by a multiplier chosen for the relevant geographic region. To guard against unknowingly exaggerated claims that could result from the unsettled nature of the multiplier estimate, a decidedly conservative choice is recommended.

For New York City, Mathtech uses a multiplier of 1.60.[56] This estimate, as shall become evident shortly, is a conservative one, and applying it to the New York organizations identified in Table 8 seems to be proper. But since the other companies there operate in cities that resemble the Big Apple in character, the 1.60 value might be applied to them as well. It is, the result being the column labeled *Total*.

Under the multiplier, the Pennsylvania Ballet claims responsibility for $2.1 million in annual economic activity. The Boston Symphony professes $28.0 million, and the Met avows $90.4 million. Overseas, the Royal Philharmonic accounts for £1.7 million in yearly trade, while the Royal Opera produces £15.4 million. The Royal Shakespeare Company generates an annual total of £19.3 million from its two headquarters. Broadway's total economic impact stands at $792.6 million each year, and the West End's stands at £199.1 million a year.

When the full story is told, the arts emerge as big business having big economic impact. This moral is reinforced by Table 9, which presents the direct and total impacts of several arts events and of the arts in various cities and states. The table's coverage, which is hardly complete, reflects the availability of research docu-

ments rather than a priority envisioned for the arts network. Except in "safe" cases, no attempt has been made to adjust the original impact numbers to fit some uniform set of computational assumptions, although the numbers have been amended to reflect the general level of prices in 1983. From the multiplier entries, it should be clear that the choice of 1.60 for Table 8 is truly conservative. The 2.03 value displayed for the New York-New Jersey nexus is especially informative.

King Tut is alive and well—at least in popularity. The Tut exhibit, as Table 9 reveals, fueled total economic activity by $60.5 million (Canadian) in Toronto, and from the comments by Allis[57] and the Oregon Arts Commission,[58] that circumstance was typically Tut. In Atlanta, as the table likewise shows, Alvin Ailey began a business wave of $2.8 million, whereas Bert and Ernie started a business ripple of $0.4 million.

Although it may be common knowledge that the arts play a key role in the commercial life of New York City and vicinity, the sheer size of that role might not be. In and around New York, the arts cause a chain reaction amounting to $5.8 billion each year, and even if the television and cinema endeavors are omitted from the arithmetic, their impact still exceeds $3.5 billion handily. Shown next in line behind the Big Apple is the Mini Apple (strictly, Minneapolis-St. Paul), with a total impact of $135.8 million annually. St. Louis registers an even $100.0 million, and Baltimore records $54.0 million. Springfield reports $9.8 million *a tergo*. Of the states noted, Massachusetts leads the way with a yearly total impact of $713.0 million. Florida finishes second with $247.3 million, followed closely by Connecticut's $240.3 million. Colorado and Iowa top the $100 million mark, too, while Rhode Island and Oregon almost do. These state magnitudes help to put the Broadway result into perspective: Broadway's annual impact of $792.6 million exceeds the impact for the entire state of Massachusetts or, equivalently, the combined impacts for all listed states except Massachusetts, Florida, and Connecticut. By the same token and notwithstanding the problem of currency conversion, the West End's total impact of £199.1 million may be likened to that for all of Florida.

How do these impacts of the arts compare with those of the nonarts? Table 10 provides an answer by looking at various nonarts pursuits. Again, the availability of research material determines the coverage, which is limited to services in the interest of fair play.

Relative to the economic contribution of educational institutions, the Boston Symphony's yearly $28.0 million impact displayed in Table 8 is about half that associated with a junior college, as the figures for Gulf Coast Junior College and Tallahassee

Table 9.

Economic Impacts of the Arts by Event, City, and State

Reference	Source	Sample Period	Effective Multiplier	Annual Impact in 1983 Prices[a]	
				Direct	Total
Event					
Alvin Ailey in Atlanta	Southern Arts Federation (pp. 15, 17)	1977	3.30	0.9	2.8
Barnum Festival in Bridgeport	Davidson and Schaffer (pp. 27-28)	1977	2.26	1.5	3.5
Muppets in Atlanta	Schaffer and McCarty (p. 31)	1981	1.40	0.3	0.4
Tutankhamun in Toronto	Wall and Knapper (pp. 50-55)	1979	1.60[b]	37.8	60.5
City					
Aspen	Cuciti (pp. 3-9, 3-17, 3-24, 3-25)	1982	2.15	11.9	25.5
Baltimore	National Endowment Arts (p. 9)	1975-1976	2.61	20.7	54.0
Columbus	National Endowment Arts (pp. 20, 24, 33, 38)	1977-1978	2.66	10.0	26.7
Denver	Cuciti (pp. 4, 6-7, 6-8, 6-20)	1981-1982	2.55	17.8	45.4
Minneapolis-St. Paul	National Endowment Arts (pp. 20, 24, 45, 50)	1977-1978	3.00	45.3	135.8
New York-New Jersey Metro Region	Port Authority and CAC (pp. 91, 106)	1982	2.03	2,850.4	5,799.8
St. Louis	National Endowment Arts (pp. 20, 24, 57, 62)	1977-1978	3.02	33.1	100.0
Salt Lake City	National Endowment Arts (pp. 21, 24, 69, 74)	1977-1978	2.64	9.6	25.4

Reference	Source	Sample Period	Effective Multiplier	Annual Impact in 1983 Prices[a]	
				Direct	Total
San Antonio	National Endowment Arts (pp. 21, 25, 81, 86)	1977-1978	2.66	5.9	15.7
Sarasota	Steinike and Stevens (pp. 60-61)	1978	1.60	29.1	46.6
Springfield (IL)	National Endowment Arts (pp. 21, 25, 93, 98)	1977-1978	2.08	4.7	9.8
State					
Arkansas	Arkansas (pp. v, 1)	1974-1975	1.78	7.7	13.7
Colorado	Cuciti (pp. 2-11, 2-14 to 2-16)	1981-1982	2.55	49.4	126.2
Connecticut	New England Arts (pp. 20, 45, 60, 142, 146-47)	1978-1980	2.88	83.4	240.3
Florida	Steinike and Stevens (pp. 34-35)	1978	1.99	124.2	247.3
Georgia	McCarty and Schaffer (p. 7)	1977-1978	2.62	26.0	67.0
Iowa	Fuller (pp. 9, 16, 20)	1981	2.16	52.1[c]	112.6[c]
Maine	New England Arts (pp. 20, 45, 73, 142, 146-47)	1978-1980	2.10	37.6	78.7
Massachusetts	New England Arts (pp. 20, 45, 84, 142, 146-47)	1978-1980	2.97	240.1	713.0
New Hampshire	New England Arts (pp. 20, 45, 97, 142, 146-47)	1978-1980	2.28	33.5	76.5
Oregon	Oregon Arts (pp. 6, 8-9)	1979	2.79	34.9[d]	97.2[d]
Rhode Island	New England Arts (pp. 20, 45, 109, 142, 146-47)	1978-1980	2.47	40.4	99.8
Vermont	New England Arts (pp. 20, 45, 121, 142, 146-47)	1978-1980	1.98	21.0	41.5

Notes to Table 9:

[a]Entries are expressed in millions of units of the respective domestic currencies.

[b]Wall and Knapper ignore multiplier effects; the 1.60 multiplier value is assumed here.

[c]Fuller excludes ancillary spending by the audience. That spending, estimated here to be $9.5 million in 1981 prices, is reflected in the figure reported.

[d]Oregon Arts rules out the audience's ancillary spending. Taken here as $9.9 million in 1979 prices, it is represented in the entry posted.

Sources: Southern Arts Federation, "A Survey of the Economic Impact of the Alvin Ailey American Dance Theatre 28-Day Residency in Atlanta Georgia," Mimeographed (Atlanta, Ga.: Southern Arts Federation, 1978); Lawrence S. Davidson and William A. Schaffer, "The Impact of the Barnum Festival," Pamphlet (Bridgeport, Conn.: Barnum Festival, Inc., 1977); William A. Schaffer and Marilu H. McCarty, "The Economic Impact of the Art of the Muppets Exhibit on Atlanta," Mimeographed (Atlanta, Ga.: Georgia Institute of Technology, 1982); Geoffrey Wall and Chris Knapper, "Tutankhamun in Toronto," Mimeographed (Waterloo, Ontario: University of Waterloo, 1981); Peggy Cuciti, *Economic Impact of the Arts in the State of Colorado* (Denver, Colo.: University of Colorado at Denver, 1983); National Endowment for the Arts, *Economic Impact of Arts and Cultural Institutions* (Washington, D.C.: National Endowment for the Arts, 1981); Port Authority of New York and New Jersey and Cultural Assistance Center, *The Arts as an Industry: Their Economic Importance to the New York-New Jersey Metropolitan Region* (New York, N.Y.: Port Authority of New York and New Jersey, 1983); George C. Steinike and Dana N. Stevens, *The Economic Impacts of the Arts in Florida* (Tampa, Fla.: University of South Florida, 1979); Office of Arkansas State Arts and Humanities, "The Arts are for Everyone," Pamphlet (Little Rock, Ark.: Office of Arkansas State Arts and Humanities, 1976); New England Foundation for the Arts, *The Arts and the New England Economy*, 2nd ed. (Cambridge, Mass.: New England Foundation for the Arts, 1981); Marilu McCarty and William A. Schaffer, "The Economic Impact of the Arts on Georgia, 1977-78," Mimeographed (Atlanta, Ga.: Georgia Institute of Technology, 1979); John W. Fuller, "Economic Impact of the Arts in Iowa," Mimeographed (Iowa City, Iowa: University of Iowa, 1982); and Oregon Arts Commission, "Dollars and Sense of the Arts: Summary of an Economic Study," Mimeographed (Salem, Oreg.: Oregon Arts Commission, 1980).

Table 10.
Economic Impacts of Nonarts Pursuits

Reference	Source	Sample Period	Effective Multiplier	Annual Impact in 1983 Prices[a]	
				Direct	Total
Education					
Florida A and M University	Bell and Leeworthy (pp. 93, 109, 112, 119, 121, 124)	1980-1981	1.71	55.0[b]	94.2[b]
Florida State University	Bell and Leeworthy (pp. 19, 47, 53, 55, 76, 78, 88)	1980-1981	1.71	222.6[b]	380.1[b]
Georgia Institute of Technology	Schaffer (p. 140)	1976-1977	1.55	64.4	100.0
Gulf Coast Junior College (FL)	Bell and Leeworthy (pp. 179, 192)	1980-1981	1.64	40.0	65.4
Tallahassee Community College	Bell and Leeworthy (pp. 127, 145)	1980-1981	1.61	33.8	54.2
University of South Florida	University South Florida (pp. 23, 26, 29-30)	1982-1983	1.53	146.1	223.5
Sports					
Atlanta Falcons	Schaffer and Davidson (pp. 5, 13, 15, 18)	1984	2.14	18.0[c]	38.6[c]
FAMU Athletics	Bell and Leeworthy (pp. 112, 119)	1980-1981	2.15	1.5	3.2
FSU Athletics	Bell and Leeworthy (pp. 55, 76)	1980-1981	2.00	7.0	14.0
Montreal Expos	Schaffer (pp. 30, 44)	1969	3.20	23.4	75.2
Olympic Games of Los Angeles	Perelman (p. 122)	1984	3.00	734.6	2,203.9
Pinellas Major League Baseball (FL)	Touche Ross (p. 30)	1984	1.60	26.1[d]	41.7[d]

Table 10.

(continued)

Reference	Source	Sample Period	Effective Multiplier	Annual Impact in 1983 Prices[a]	
				Direct	Total
Beach Use, Ft. DeSoto Park (FL)	Curtis et al. (pp. 43-49)	1979	1.30	6.8	8.9
Recreation					
Boating (FL)	Milon et al. (pp. 23-24)	1980	1.96	909.1	1,786.0
Fishing, Ice (ME)	Reiling et al. (pp. 3, 15)	1979-1980	1.37	18.8	25.7
Fishing, Saltwater (FL)	Bell et al. (pp. 17, 59, 62, 90)	1980-1981	2.70	2,149.5	5,811.9
Fishing and Hunting (CO)	McKean and Nobe (pp. 2, 52-56)	1981	1.91	1,090.7	2,079.5
Recreation (WI)	Wisconsin (pp. 14, 21)	1963	1.60[e]	3,185.3	5,096.5
Tourism (FL)	Florida (p. 11)	1983	1.60[e]	22,820.0	36,511.6
Tourism (MO)	Missouri (p. 3)	1979	1.60[e]	4,535.0	7,256.0
Tourism (SNE)[f]	Rorholm et al. (pp. 1, 77, 99)	1965	2.75	491.8	1,352.4

[a]Entries are expressed in millions of units of the respective domestic currencies.
[b]Includes the athletic program's impact recorded below.
[c]Reflects the local-fan expenditure of $1.4 million (1984 prices) excluded by Schaffer and Davidson.
[d]Reflects the local-fan expenditure of $9.5 million (1984 prices) excluded by Touche Ross.
[e]Multiplier effects are ignored in the original inquiry; the 1.60 value is assumed here.
[f]Abbreviates South New England.

222

Sources: Frederick W. Bell and Vernon R. Leeworthy, "The Economic Impact of Selected Universities and Community Colleges in Northwest Florida," Mimeographed (Tallahassee, Fla.: Florida State University, 1982); William A. Schaffer, "The Financial Impact of a University: A Case Study—The Impact of Georgia Tech on Georgia State Economy," in *Essays in Regional Economic Studies*, Manoranjan Dutta, Jessie C. Hartline, and Peter D. Loeb, eds. (Durham, N.C.: Alcorn Press, 1983); University of South Florida, Office of Institutional Research, "The Economic Impact of the University of South Florida on the Tampa Bay Region," Mimeographed (Tampa, Fla.: University of South Florida, 1984); William A. Schaffer and Lawrence S. Davidson, "Economic Impact of the Falcons on Atlanta: 1984" (Suwanee, Ga.: Atlanta Falcons, 1985); William A. Schaffer, "Economics and Ecstatics: The Impact of Major-League Baseball on Montreal," Mimeographed (Atlanta, Ga.: Georgia Institute of Technology, 1970); Richard B. Perelman, ed., *Olympic Retrospective: The Games of Los Angeles* (Los Angeles, Calif.: Los Angeles Olympic Organizing Committee, 1985); Touche Ross and Company, "Pinellas Sports Authority Major League Baseball Stadium: Economic Study Update," Mimeographed (New York, N.Y.: Touche Ross and Company, 1984); T. D. Curtis, E. W. Shows, and J. G. Spence, "The Economic Importance of the Beaches of Florida to the State's Economy: A Case Study of Ft. DeSoto Park," Mimeographed (Tampa, Fla.: University of South Florida, circa 1980); J. Walter Milon, David Mulkey, Pamela H. Riddle, and Gary H. Wilkowske, "Economic Impact of Marine Recreational Boating on the Florida Economy," Mimeographed (Gainesville, Fla.: University of Florida, 1983); Stephen D. Reiling, Christanna M. Cook, and Janice L. Taylor, "Economic Impact of Ice Fishing in Maine," Mimeographed (Orono, Maine: University of Maine, 1982); Frederick W. Bell, Philip E. Sorensen, and Vernon R. Leeworthy, "The Economic Impact and Valuation of Saltwater Recreational Fisheries in Florida," Mimeographed (Tallahassee, Fla.: Florida State University, 1982); John R. McKean and Kenneth C. Nobe, "Direct and Indirect Economic Effects of Hunting and Fishing in Colorado—1981," Mimeographed (Ft. Collins, Colo.: Colorado State University, 1984); Department of Resource Development, Wisconsin, "The Economic Impact of Recreation," Mimeographed (Madison, Wis.: Department of Resource Development, 1965); Department of Commerce, Division of Tourism, Florida, "Florida Visitor Study, 1983," Pamphlet (Tallahassee, Fla.: Department of Commerce, 1984); Division of Tourism, Missouri, "The Economic Impact of Travel on Missouri Counties, 1979," Mimeographed (Jefferson City, Mo.: Division of Tourism, 1980); and Niels Rorholm, H. C. Lampe, Nelson Marshall, and J. F. Farrell, "Economic Impact of Marine-Oriented Activities: A Study of the Southern New England Marine Region," Mimeographed (Kingston, R.I.: University of Rhode Island, 1967).

Community College attest. But the Met, with its $90.4 million business per annum, operates at the level of universities such as Florida Agricultural and Mechanical University and Georgia Tech. Broadway, showing $792.6 million each year, equals two universities of the Florida State University (FSU) caliber and three of the University of South Florida class. In the two statewide comparisons permitted by Tables 9 and 10, the arts rank behind education both times. Florida arts are responsible for $247.3 million annually, but that level falls well below the $380.1 million provided by FSU alone. Likewise, the $67.0 million of Georgia arts is overshadowed by the $100.0 million of Georgia Tech.

Judged in sports terms, the Boston Symphony is perhaps a USFL version of the Atlanta Falcons, $28.0 million versus $38.6 million yearly. The Met is either two complete squads of Falcons or two full rosters of the major-league baseball club contemplated by Pinellas County. Broadway is virtually a whole professional league: either 20 NFL teams or 19 big-league baseball teams. Similarly, the arts in each of the cities of Baltimore, Denver, and Sarasota are equivalent to a major sports franchise. St. Louis' arts outweight more than two, while Mini Apple's outstrip more than three. By contrast, the arts in those five locales combined translate into only a sixth of the Los Angeles Olympic Games, and even if the arts in all 12 *states* cited were grouped together, they still would rank behind the Games by almost $300 million.

Recreation affords its own instructive comparisons. As an example, the Boston Symphony is economically tantamount to the beaches of three Fort DeSoto Parks. However, because the park encompasses seven miles of shoreline, the symphony also can be seen as the counterpart of a beach that spans more than 20 miles of Florida's Gulf Coast. Arts in the Big Apple environs, with their $5.8 billion contribution, swamp the business stimulus occasioned by sports activists in two enlarged Colorados. Furthermore, since they represent about half the $12.6 billion that Florida paid to its employees in 1983, they can be viewed as generating enough dollars to energize the Sunshine State's government for about six months.

Yet even Big Apple arts have economic limits. They cannot extend beyond the dollar range of saltwater fishing in Florida or beyond the financial bounds of tourism in Missouri, and they almost disappear in the expanse of Florida tourism. These illustrations, like those involving the educational institutions of Florida and Georgia and the Olympic Games of Los Angeles, represent clear reminders that any quantitative comparison says as much about the base as it does about the mate. The price of a sports car looms when set against the price of an orange but fades when parked beside the figure for GNP. Relatives are nothing but

relatives. The arts do not always have large economic impact, and it is wrong to conclude from the tabulations that they do. But it is equally wrong to conclude from the experience of a Talhavancy Theatre Company that they always have negligible impact. They do not. The conclusion that does seem to be warranted by the data is that *on balance, the arts are big business whose economic impact often compares favorably with that of the nonarts.*

Notes

1. William J. Baumol and William G. Bowen, *Performing Arts—The Economic Dilemma* (New York, N.Y.: Twentieth Century Fund, 1966), pp. 381–386.
2. Hans Abbing, "On the Rationale of Public Support to the Arts: Externalities in the Arts Revisited," in *Economic Policy for the Arts,* ed. William S. Hendon et al. (Cambridge, Mass.: Abt Books, 1980), pp. 39–41.
3. Henry Hansmann, "Nonprofit Enterprise in the Performing Arts," *Bell Journal of Economics* 12 (Autumn 1981): 343–345.
4. Baumol and Bowen, *Performing Arts,* pp. 74–84.
5. Ibid., pp. 89–93.
6. Society of West End Theatre, "The West End Theatre Audience," Mimeographed (London: Society of West End Theatre, 1981), pp. 11–12.
7. Ford Foundation, *The Finances of the Performing Arts,* Vol. 2 (New York, N.Y.: Ford Foundation, 1974), pp. 12–18.
8. James H. Gapinski, "Economics, Demographics, and Attendance at the Symphony," *Journal of Cultural Economics* 5 (December 1981): 80, 82.
9. Harold Horowitz, "Study of an Arts Audience/Study of the Arts Public," Mimeographed (Washington, D.C.: National Endowment for the Arts, 1984), pp. 18–21, 29.
10. Jiri Zuzanek and Marlene Lee, "Social Ecology of Art Audiences," *Journal of Cultural Economics* 9 (June 1985): 67–74.
11. Charles W. Cobb and Paul H. Douglas, "A Theory of Production," *American Economic Review,* Supplement 18 (March 1928): 139–165.
12. A Cobb-Douglas could permit a negative marginal product, but it would require the marginal to be negative over the entire practical range of the input. It would not enable the marginal to be positive at some input levels and negative at others.
13. A. N. Halter, H. O. Carter, and J. G. Hocking, "A Note on the Transcendental Production Function," *Journal of Farm Economics* 39 (November 1957): 966–974.
14. U. Reinhardt, "A Production Function for Physician Services," *Review of Economics and Statistics* 54 (February 1972): 55–66.
15. Richard M. Scheffler and John E. Kushman, "A Production Function for Dental Services: Estimation and Economic Implications," *Southern Economic Journal* 44 (July 1977): 25–35.
16. James H. Gapinski, "The Production of Culture," *Review of Economics and Statistics* 62 (November 1980): 578–586.
17. Gapinski, "Economics, Demographics, and Attendance."
18. Baumol and Bowen, *Performing Arts,* pp. 162–167.
19. Unlike Ford's data on theatre, opera, and symphony, those on ballet, although sufficient to permit estimation, are meager nonetheless.

Thus, ballet's characteristics, including the maverick status of staff, may reflect more a limitation of data than a uniqueness of production structure. The issue remains unresolved.

20. Baumol and Bowen, *Performing Arts,* pp. 201–204, 479–481.

21. Steven Globerman and Sam H. Book, "Statistical Cost Functions for Performing Arts Organizations," *Southern Economic Journal* 40 (April 1974): 668–671.

22. Mark Lange, James Bullard, William Luksetich, and Philip Jacobs, "Cost Functions for Symphony Orchestras," *Journal of Cultural Economics* 9 (December 1985): 71–85.

23. James M. Henderson and Richard E. Quandt, *Microeconomic Theory: A Mathematical Approach,* 2nd ed. (New York, N.Y.: McGraw-Hill Book Co., 1971), pp. 71–72, 75–78.

24. Campbell R. McConnell, *Economics: Principles, Problems, and Policies,* 6th ed. (New York, N.Y.: McGraw-Hill Book Co., 1975), pp. 508–510.

25. Harold A. Cohen, "Hospital Cost Curves with Emphasis on Measuring Patient Care Output," in *Empirical Studies in Health Economics,* ed. Herbert E. Klarman (Baltimore, Md.: Johns Hopkins Press, 1970), pp. 286–292.

26. Trevor Gambling and Gordon Andrews, "An Analysis of the Personnel Costs of a Major Theatrical Company: 1968-78," Mimeographed (Birmingham, England: University of Birmingham, 1982).

27. James H. Gapinski, "The Economics of Performing Shakespeare," *American Economic Review* 74 (June 1984): 459–462.

28. Glenn A. Withers, "Unbalanced Growth and the Demand for Performing Arts: An Econometric Analysis," *Southern Economic Journal* 46 (January 1980): 740.

29. Baumol and Bowen, *Performing Arts,* pp. 244, 277–278.

30. Gapinski, "The Economics of Performing Shakespeare," pp. 462–463.

31. Society of West End Theatre, "West End Theatre Data—1982," Mimeographed (London: Society of West End Theatre, 1983), p. 4.

32. Harry H. Kelejian and William J. Lawrence, "Estimating the Demand for Broadway Theater: A Preliminary Inquiry," in *Economic Policy for the Arts,* ed. William S. Hendon et al. (Cambridge, Mass.: Abt Books, 1980), pp. 336–337, 345.

33. James H. Gapinski, "The Lively Arts as Substitutes for the Lively Arts," *American Economic Review* 76 (May 1986): 21–22.

34. Thomas Gale Moore, *The Economics of the American Theater* (Durham, N.C.: Duke University Press, 1968), pp. 172, 175.

35. Steven Globerman, "Price Awareness in the Performing Arts," *Journal of Cultural Economics* 2 (December 1978): 33.

36. Dick Netzer, *The Subsidized Muse* (London: Cambridge University Press, 1978), p. 29.

37. Kelejian and Lawrence, "Estimating the Demand for Broadway Theater," pp. 345–346.

38. Society of West End Theatre, "West End Theatre Data—1982," p. 4; Society of West End Theatre, "Britain at Its Best: Overseas Tourism and the West End Theatre," Mimeographed (London: Society of West End Theatre, 1982), pp. 6–7.

39. Herbert A. Simon, "A Behavioral Model of Rational Choice," *Quarterly Journal of Economics* 69 (February 1955): 99–114; Herbert A. Simon, "Theories of Decision-Making in Economics and Behavioral Science," *American Economic Review* 49 (June 1959): 262–265.

40. Hansmann, "Nonprofit Enterprise," pp. 346–352.

41. James H. Gapinski, "Do the Nonprofit Performing Arts Optimize? The Moral from Shakespeare," *Quarterly Review of Economics and Business* 25 (Summer 1985): 29–34.

42. James H. Gapinski, "What Price Patronage Lost? A View from the Input Side," *Journal of Cultural Economics* 3 (June 1979): 67–70.

43. Susan Kathleen Touchstone, "A Study on the Demand for Four Non-Profit Performing Arts" (Ph.D. dissertation, Florida State University, 1978), pp. 36–39.

44. Gapinski, "The Production of Culture," pp. 582–583.

45. Gapinski, "The Economics of Performing Shakespeare," pp. 463–465.

46. Edwin G. West, "The Economics of Performing Shakespeare: Comment," *American Economic Review* 75 (December 1985): 1206–1209.

47. James H. Gapinski, "The Economics of Performing Shakespeare: Reply," *American Economic Review* 75 (December 1985): 1210–1212.

48. Mathtech, "The Impact of the Broadway Theatre on the Economy of New York City," Mimeographed (Princeton, N.J.: League of New York Theatres and Producers, Inc., 1977), pp. 30, 35, 37, 41–42.

49. Mathtech, Fuller, Touche Ross, Shaffer and Davidson, and others caution that for economic impact, what counts is new spending, spending that would not have occurred in the absence of the enterprise under review. An establishment that draws all of its business away from others does not increase economic activity; it merely redirects activity. Nonetheless, due to the difficulty of determining the amount of new spending embodied in any particular expenditure and consonant with common practice, the ensuing exercise treats all spending as new. Mathtech, "The Impact of the Broadway Theatre," pp. 8–9, 41; John W. Fuller, "Economic Impact of the Arts in Iowa," Mimeographed (Iowa City, Iowa: University of Iowa, 1982), p. 9; Touche Ross and Company, "Pinellas Sports Authority Major League Baseball Stadium: Economic Study Update," Mimeographed (New York, N.Y.: Touche Ross and Company, 1984), p. 30; and William A. Schaffer and Lawrence S. Davidson, *Economic Impact of the Falcons on Atlanta: 1984* (Suwanee, Ga.: Atlanta Falcons, 1985), p. 12.

50. Mathtech, "The Impact of the Broadway Theatre," pp. 3, 35.

51. George C. Steinike and Dana N. Stevens, "The Economic Impacts of the Arts in Florida," Mimeographed (Tampa, Fla.: University of South Florida, 1979), pp. 28, 52–53.

52. Kelejian and Lawrence, "Estimating the Demand for Broadway Theater," p. 335.

53. Peggy Cuciti, *Economic Impact of the Arts in the State of Colorado* (Denver, Colo.: University of Colorado at Denver, 1983), pp. 3–15.

54. R. F. Kahn, "The Relation of Home Investment to Unemployment," *Economic Journal* 41 (June 1931): pp. 173, 182–190.

55. James H. Gapinski, *Macroeconomic Theory: Statics, Dynamics, and Policy* (New York, N.Y.: McGraw-Hill Book Co., 1982), pp. 33, 74.

56. Mathtech, "The Impact of the Broadway Theatre," p. 9.

57. Sam Allis, "Economic Benefits of Arts Spur Many States to Increase Funding," *Wall Street Journal,* September 2, 1980, p. 29.

58. Oregon Arts Commission, "Dollars and Sense of the Arts: Summary of an Economic Study," Mimeographed (Salem, Oreg.: Oregon Arts Commission, 1980), p. 11.

Glossary

This glossary is designed to clarify terms commonly used in studies of the economic impact of the arts. The glossary does not define all economic terms that appear in this book. If readers require such clarification, they should refer to basic economics texts.

Amenities—Attractive features of a place—physical, historical, cultural, and social—that contribute to a community's overall quality of life. Quality of life includes elements such as health, safety, education, housing, and transportation, which together determine whether a particular community is a generally desirable place to live and work. From Robert H. McNulty, Dorothy R. Jacobson, and R. Leo Penne, *The Economics of Amenity: Community Futures and Quality of Life* (Washington, D.C.: Partners for Livable Places, 1985), p. 30.

Cost-Benefit Analysis—A systematic quantitative review of a project to determine whether its costs outweigh its benefits. Key to the effort is the imputation of a monetary value to effects that often are not commonly thought of as having monetary value and the consideration of these values in decision making. For example, a city reviewing the desirability of continued support for a city art museum might conduct a cost-benefit analysis. In the analysis, the ability of the museum to serve as an amenity and tourist attraction is given monetary value and considered as much a monetary asset as the museum's income from memberships, admission, and grants.

Cultural Tourism—The use of arts-centered activities as a basis for or partner in the short-term attraction of persons to an area.

Direct Expenditures—Expenditures by arts institutions and related households in their transactions with local vendors. For example, the fee a ballet company pays to a public relations firm is a direct expenditure, as is the money the administrator of a local arts council pays for his or her groceries.

Economic Impact of the Arts—The sum of the direct, indirect, and induced expenditures related to the arts activity or activities under study. Ideally, the economic impact is based on a defensible multiplier that is rooted in a model and developed using appropriate scientific research.

Indirect Expenditures—The multiplier effects of direct expenditures. For example, if the music director of a symphony orchestra purchases music in a music store and the store manager later pays part of the heating bill for the store with part of the dollar expended by the music director, part of the money expended for fuel is an indirect expenditure related to the arts.

Induced Effects—Economic effects that are related to the presence of an arts activity but that are not directly attributable to that activity. For example, a person traveling to an arts activity may purchase food and gasoline. In addition, that person may hire a babysitter and pay

for parking. These effects, although attributable to the arts activity, are often difficult to measure and allocate specifically to the arts activity itself. For example, if a person travels to a state and participates in a summer music festival but also visits state parks and purchases Christmas gifts in area stores, the part of that spending directly attributable to the arts activity is difficult to measure and must be estimated with a defensible method.

Macroeconomics—The study of the economy as a whole, with special emphasis on national wealth, income, employment, and capital and how they can be manipulated to achieve national economic policy objectives.

Microeconomics—The study of part of the economy, such as the economic behavior of consumers and well-defined collectivities such as a firm, a market, or an industry.

Multiplier—The increase in a community's total income per dollar of direct expenditure. The multiplier is the measure of dollar flow related to a specific activity in an economy. It is the measure of the number of times a dollar will "turn over" in a defined geographic area before it leaves the economy or is transformed into savings. The multiplier is generally higher in a large metropolitan area because many goods and services can be purchased in that area before the dollar leaves it. In a small town that has a simple, undiversified economy, the multiplier can be expected to be lower.

An example of a multiplier is the purchase of paint for the set of an opera company. If an opera company spends 20 dollars for a gallon of paint at a local paint store, part of the money the store receives goes to pay personnel, part to pay for rent and overhead, and part to pay for the wholesale cost of the product itself. Personnel from the store use their paychecks to purchase food, gas, and other items. Part of those paychecks originate from the opera company's paint purchase. If the paint is manufactured in the town, the wholesale price of the paint goes directly to the paint manufacturing company, where it also pays for overhead, personnel, and raw materials. If there is no paint manufacturing company in the town, all of the wholesale price of paint leaves the area immediately. The result is a lower multiplier because a good portion of the funds leaves the area rapidly, thus reducing the ability of the original dollars to be spent over and over again.

Ideally, a multiplier is determined through extensive research that results in the construction of a model from which the multiplier for a specific activity in a certain area can be determined. These models are called "input-output" models. Because of the complexity and cost of developing such models, input-output models based on arts spending in a particular area are rarely developed. Instead, researchers use extant models from related endeavors as a basis for arts multipliers. To apply a multiplier correctly, then, one must keep in mind that a multiplier based on a model developed for one area and activity cannot necessarily be applied to another.

If arts multipliers are not developed from arts-based, input-output models, researchers should state explicitly the input-output model on which they are basing their multiplier. The multiplier should be based on an activity and area that are defensible as related to the arts. There is no nationwide arts-spending multiplier that is applicable to all localities.

Bibliography

Books and Reports

American Council for the Arts. *The Arts and Tourism: A Profitable Partnership*. New York, N.Y.: American Council for the Arts, 1981.

Baumol, William J., and Bowen, William G. *Performing Arts: The Economic Dilemma*. Cambridge, Mass.: MIT Press, 1967.

Blaug, Mark. *The Economics of the Arts*. London: Westview Press, 1976.

Canada Council. *An Economic Impact Assessment of the Canadian Fine Arts: An Arts Research Monograph*. Ottawa: The Canada Council, 1984.

_____. *A "Short-Hand" Technique for Estimating the Economic Impact of the Performing Arts*. Ottawa: The Canada Council, 1982.

Clark, George. "Footlight Districts." In *The City as a Stage*, edited by George Clark. Washington, D.C.: Partners for Livable Places, 1983.

Cultural Assistance Center. *America's Stake in New York City Arts and Culture*. New York, N.Y.: Cultural Assistance Center, 1979.

_____. *The Financial Condition of New York City Arts Organizations*. New York, N.Y.: Cultural Assistance Center, n.d.

_____. *Growth in New York City Arts and Culture: Who Pays?* New York, N.Y.: Cultural Assistance Center, 1979.

Feld, Alan L.; O'Hare, Michael; and Schuster, J. Mark Davidson. *Patrons Despite Themselves: Taxpayers and Arts Policy*. New York, N.Y.: New York University Press, 1983.

Fuller, John; Kralik, Scott; Nichols, Steve; Peckham, Dean; and Schwab, James. *Economic Impact of the Arts: Methods of Analysis*. Technical Report 145. Iowa City, Iowa: Institute of Urban and Regional Research, University of Iowa, 1982.

Greytak, David, and Blackley, Dixie. *Multiplier Analysis: Arts and Cultural Institutions*. Unpublished monograph. Syracuse, N.Y.: The Maxwell School, Syracuse University, 1980.

Hendon, William S., and Shanahan, James L., eds. *Economics of Cultural Decisions*. Cambridge, Mass.: Abt Books, 1983.

Hendon, William S.; Shanahan, James L.; and McDonald, Alice J., eds. *Economic Policy for the Arts*. Cambridge, Mass.: Abt Books, 1980.

Miernyk, William. *The Elements of Input-Output Analysis*. New York, N.Y.: Random House, 1965.

Moore, Thomas. *The Economics of the American Theater.* Durham, N.C.: Duke University Press, 1968.

National Endowment for the Arts. *Conditions and Needs of the Professional American Theatre.* Research Division Report Number 11. Washington, D.C.: National Endowment for the Arts, 1981.

_____. *Economic Aspects of the Performing Arts: A Portrait in Figures.* Washington, D.C.: National Endowment for the Arts, 1971.

_____. *Research Division Report Number 6, Economic Impact of Arts and Cultural Institutions: A Model for Assessment and a Case Study in Baltimore.* Washington, D.C.: National Endowment for the Arts, 1980.

Netzer, Dick. *The Subsidized Muse: Public Support for the Arts in the United States.* New York, N.Y.: Cambridge University Press, 1978.

Peacock, A., and Weir, R. *The Composer and the Market-Place: An Economics of the Arts.* London: Faber, 1977.

Perloff, Harvey S. *The Arts in the Economic Life of the City.* New York, N.Y.: American Council for the Arts, 1979.

Poggi, Jack. *Theatre in America. The Impact of Economic Forces 1870-1967.* Ithaca, N.Y.: Cornell University Press, 1968.

Rockefeller Panel. *The Performing Arts: Problems and Prospects.* New York, N.Y.: McGraw-Hill, 1965.

Schwarz, Samuel. "Growth of the Earnings Gap: Some Preliminary Evidence." In *Economic Research in the Performing Arts,* edited by William S. Hendon et al. Akron, Ohio: Association for Cultural Economics, 1983.

Scitovsky, Tibor. *The Joyless Economy: An Inquiry into Human Satisfaction and Consumer Dissatisfaction.* London: Oxford University Press, 1976.

Throsby, David, and Withers, Glenn. *The Economics of the Performing Arts.* New York, N.Y.: St. Martin's Press, 1979.

Violette, Caroline, and Taqqu, Rachelle, eds. *Issues in Supporting the Arts: An Anthology Based on the Economic Impact of the Arts Conference.* Ithaca, N.Y.: Graduate School of Business and Public Administration, Cornell University, 1982.

Wall, Geoffrey, and Knapper, Chris. *Tutankhamun in Toronto.* Waterloo, Ontario, Canada: Department of Geography, University of Waterloo, 1981.

Weisbrod, Burton A. The Supply of the Performing Arts. In *The Economics of the Arts,* edited by Mark Blaug. Boulder, Colo.: Westview Press, 1977.

Yankelovich, Skelly and White, Inc. *A Study of Out-of-Town Visitors to the Vatican Exhibit at the Metropolitan Museum of Art.* New York, N.Y.: Philip Morris USA, 1983.

Articles

Abrams, B., and Schmitz, M. "The 'Crowding Out' Effect of Governmental Transfer on Private Charitable Contributions." *Public Choice* 33 (1978): 29–39.

Austen-Smith, D. "Skilled Consumption and the Political Economy of the Performing Arts." Ph.D. dissertation, Cambridge University, 1978.

Azarchi, Lynne. "Effects Resulting from the 1980 Metropolitan Opera Season Postponement." Mimeographed. New York, N.Y.: Lincoln Center for the Performing Arts, 1980.

Baumol, H., and Baumol, W. "On Finances of the Performing Arts During Stagflation: Some Recent Data." *Journal of Cultural Economics* 4 (December 1980): 1–14.

Baumol, William J., and Bowen, William G. "On the Performing Arts: The Anatomy of Their Economic Problems." *American Economic Review* 55 (May 1965): 8–14.

Belk, Russell W., and Andreason, Alan. "The Effect of Family Life Cycle on Arts Patronage." *Journal of Cultural Economics* 6 (December 1982): 25–36.

Blaug, Mark. "Justification for Subsidies to the Arts: A Reply to F. F. Ridley." *Journal of Cultural Economics* 7 (June 1983): 19–22.

_____. "Rationalizing Social Expenditure: The Arts." In *Public Expenditure,* edited by Michael Posner. New York, N.Y.: Cambridge University Press, 1977.

Boulding, Kenneth I. "Note on Goods, Services and Cultural Economics." *Journal of Cultural Economics* I (June 1977): 1–11.

Cwi, David. "Economic Studies with Impact." *Museum News* (May/June 1981).

_____. "Issues in Developing a Model to Assess the Community-Wide Economic Effects of Cultural Institutions." Mimeographed. Baltimore, Md.: Johns Hopkins University, 1977.

_____. "Perspectives on the Economic Role of the Arts and the Impact of Arts Impact Studies." Mimeographed. Ithaca, N.Y.: Conference on the Economic Impact of the Arts, Cornell University Graduate School of Business and Public Administration, 1981.

_____. "Public Support for the Arts: Three Arguments Examined." *Journal of Behavioral Economics* 3 (December 1979): 39–68.

_____. *The Role of the Arts in Urban Economic Development.* Washington, D.C.: Department of Commerce, Economic Development Administration, 1980.

_____. "Subscribe Now! But What About Tomorrow?" *Symphony Magazine* (December 1983).

Gapinski, James H. "What Price Patronage Lost? A View from the Input Side." *Journal of Cultural Economics* 3 (June 1979): 62–72.

Girard, Augustin. "A Commentary: Policy and the Arts: The Forgotten Cultural Industries." *Journal of Cultural Economics* 1 (June 1981): 61–67.

Globerman, Steven. "Price Awareness in the Performing Arts." *Journal of Cultural Economics* 2 (December 1978): 27–42.

Greytak, David, and Blackley, Dixie. "Multiplier Analysis: Arts and Cultural Institutions." Unpublished monograph. Syracuse, N.Y.: The Maxwell School, Syracuse University, 1980.

Haworth, John. "The Arts and New York City's Economy." Mimeographed. New York, N.Y.: 1979.

Lawrence, William J. "Economic Impacts of 'Leisure-Time' Activities: Modeling the Cultural, Arts, Sports, and Tourist Industries in New York City." Mimeographed. New York, N.Y.: Sociometrics, n.d.

Peacock, Alan T. "Public Patronage and Music: An Economist's View." *Three Banks Review* 77 (March 1968): 18–36.

_____. "Welfare Economics and Public Subsidies to the Arts." *The Manchester School* 37 (December 1969): 323–335.

Peacock, Alan T., and Godfrey, Christine. "The Economics of Museums and Galleries." *Lloyds Bank Review* 3 (January 1974): 17–28.

Schwarz, Samuel. "A New Look at the Earnings Gap in the Arts." *Journal of Cultural Economics* 6 (December 1982): 1–10.

Scitovsky, Tibor. "Can Changing Consumer's Tastes Save Resources?" *Journal of Cultural Economics* 6 (December 1982): 1–10.

_____. "What's Wrong with the Arts Is What's Wrong with Society." *American Economic Review* 62 (May 1972): 62–69.

Seaman, Bruce A. "Local Subsidization of Culture: A Public Choice Model Based on Household Utility Maximization." *Journal of Behavioral Economics* 8 (Summer 1979): 93–132.

Sexton, Donald E. "Patterns of Cultural Consumption Behavior." In *Symbolic Consumer Behavior,* edited by Elizabeth C. Hirschman and Morris B. Holbrook. Ann Arbor, Mich.: Association for Consumer Research, 1980.

Sexton, Donald E., and Britney, Kathryn. "A Behavioral Segmentation of the Arts Market." In *Advances in Consumer Research*, edited by Jerry C. Olsen. Ann Arbor, Mich.: Association for Consumer Research, 1980.

Shanahan, J. L. "The Consumption of Music: Integrating Aesthetics and Economics." *Journal of Cultural Economics* 2 (December 1978): 13–26.

Singer, Leslie P. "Microeconomics of the Art Market." *Journal of Cultural Economics* 2 (June 1978): 21–39.

Thompson, Wilbur R. "Internal and External Factors in the Development of Urban Economies." In *Issues in Urban Economics*, edited by Harvey S. Perloff and Lowdon Wingo, Jr. Baltimore, Md.: Johns Hopkins University Press, 1968.

Throsby, David, "Social and Economic Benefits from Regional Investments in Arts Facilities: Theory and Application." *Journal of Cultural Economics* 6 (June 1982): 1–14.

Wiener, Louise W. *Perspectives on the Economic Development Potential of Cultural Resources*. Washington, D.C.: White House Conference on Balanced National Growth and Economic Development, 1978.

State Studies

Arkansas Arts Council. "The Arts Are Big Business." Mimeographed. Little Rock, Ark.: Department of Natural and Cultural Heritage, 1979.

Arts Advocates of North Carolina. *The Arts Business in North Carolina*. Pamphlet. Raleigh, N.C.: Arts Advocates of North Carolina, 1985.

Becker Research Corporation. *A Study of the Economics of Non-Profit Arts and Humanities Organizations in the Commonwealth of Massachusetts*. Boston, Mass.: Massachusetts Council on the Arts and Humanities, 1973.

Bureau of Business and Economic Research, Arizona State University, College of Business Administration. *The Arts in Arizona: A Study of Economic Impact*. Tempe, Ariz.: Arizona State University, 1981.

Center for Applied Urban Research, University of Nebraska-Omaha. *Economic Impact of Non-Profit Arts Organizations in Nebraska: 1975-76*. Omaha, Nebr.: Nebraska Arts Council, 1978.

Center for Arts Administration, Graduate School of Business, University of Wisconsin-Madison. *The Economic Impact of the Arts in Wisconsin*. Madison, Wis.: Center for Arts Administration, 1976.

Colorado Council on the Arts and Humanities. *Economic Impact of the Arts Update*. Denver, Colo.: Colorado Council on the Arts and Humanities, 1985.

Cuciti, Peggy. *Economic Impact of the Arts in the State of Colorado*. Denver, Colo.: Center for Public-Private Sector Cooperation, 1983.

Cunningham, M. L.; Jahr, Dale; and Johnson, Jerry. *Economic Survey of Non-Profit Arts Organizations in South Dakota.* Vermillion, S.D.: Business Research Bureau, University of South Dakota, 1981.

Cwi, David. *The Arts in New Jersey: Status, Impact, Needs.* Trenton, N.J.: New Jersey State Council on the Arts, 1982.

Delaware State Arts Council. *Delaware State Arts Council Economic Impact Survey, 1979-1980 and Projected Economic Impact, 1981-1982.* Dover, Del.: Department of State, Division of Historical and Cultural Affairs, 1981.

Frost, Murray. *Analysis of Economic and Activity Data Reported by Nebraska Non-Profit Arts Organizations, 1983.* Omaha, Nebr.: Center for Applied Urban Research, 1984.

Frost, Murray, and Peterson, Garneth O. *The Economic Impact of Non-Profit Organizations in Nebraska, 1976-77.* Omaha, Nebr.: Nebraska Arts Council, 1978.

Fuller, John. *Economic Impact of the Arts in Iowa.* Des Moines, Iowa: Iowa Arts Council, 1985.

_____. *Economic Impact of the Arts in Iowa.* Iowa City, Iowa: Institute of Urban and Regional Research, 1982.

Gisler, John, and Billings, Marjorie. *Cultural Activities in Utah: Economic and Social Aspects.* Salt Lake City, Utah: Bureau of Community Development of the Office of University Relations, University of Utah, 1974.

Governor's Commission on the Arts. *Minnesota: State of the Arts.* St. Paul, Minn.: Governor's Commission on the Arts, 1984.

Governor's Task Force on the Arts and Humanities. *The Arts: A Priority for Investment.* Boston, Mass.: Governor's Task Force on the Arts and Humanities, 1973.

Hersgaard, Doris, and Midgarden, Bette. *The Economic Impact of the Arts in North Dakota.* Fargo, N.D.: Statistical Associates, 1985.

Hillendahl, Wesley H.; Sunderland, Barbara and Associates; and Hartwell, Patricia. *The Economic Impact of Hawaii's Non-Profit Arts and Cultural Organizations 1982.* Honolulu, Hawaii: Arts Council of Hawaii, 1982.

Howard Schrag and the Professional Research Group. *The Arts and the Public Dollar in Idaho.* Boise, Idaho: Idaho Commission on the Arts, 1978.

Illinois Arts Alliance. *The Arts Industry and the Illinois Economy 1983.* Chicago, Ill.: Illinois Arts Alliance, 1983.

Indiana Arts Commission. *Indiana's Arts Economy.* Pamphlet. Indianapolis, Ind.: Indiana Arts Commission, 1985.

Kentucky Citizens for the Arts. *Kentucky's Arts: Economy the Bottom Line*. Frankfort, Ky.: Kentucky Citizens for the Arts, 1983.

Lawton, Eileen K. "The Arts in New Jersey—Current Conditions and Resources." Mimeographed. Trenton, N.J.: New Jersey State Council on the Arts, 1981.

McCarty, Marilu, and Schaffer, William A. *The Economic Impact of the Arts in Georgia, 1977-78*. Atlanta, Ga.: Georgia Institute of Technology, 1978.

Mississippi Research and Development Center and the Mississippi Arts Commission. *Economic Impacts of the Arts and Cultural Institutions in Mississippi*. Jackson, Miss.: Mississippi Arts Commission, 1983.

Missouri Arts Council. "18 Million People Attend Missouri Arts Events." Press Release. Missouri Arts Council: St. Louis, Mo.: 1984.

Montana Arts Council. *Montana Cultural Survey 1982*. Missoula, Mont.: Montana Arts Council, 1984.

National Research Center of the Arts. *The Non-Profit Arts Industry in California*. Sacramento, Calif.: California Arts Council, 1975.

_____. *A Second Look: The Non-Profit Arts and Cultural Industry of New York State 1975-76*. New York, N.Y.: New York Foundation for the Arts, 1978.

Nevada State Council on the Arts. *The Economics of Selected Non-Profit Arts Organizations in Nevada: A Survey of 31 Organizations for the Period 1981-1984*. Reno, Nev.: Nevada State Council on the Arts, 1983.

New England Foundation for the Arts. *The Arts and the New England Economy*. Cambridge, Mass.: New England Foundation for the Arts, 1980.

_____. *The Arts and the New England Economy*. 2nd ed. Cambridge, Mass., 1981.

New Hampshire Commission on the Arts. *The Arts and the New Hampshire Economy*. Concord, N.H.: New Hampshire Commission on the Arts, 1978.

Ohio Citizens Committee for the Arts. *The Arts: An Investment in Ohio*. Canton, Ohio: Ohio Citizens Committee for the Arts, n.d.

_____. *The Arts: Ohio's Competitive Advantage*. Canton, Ohio: Ohio Citizens Committee for the Arts, 1985.

_____. "The Citizen's Workbook on the Arts." Mimeographed. Canton, Ohio: Ohio Citizens Committee for the Arts, 1979.

Oklahoma Advocates for the Arts. *Arts Mean Business*. Oklahoma City, Okla.: Oklahoma Advocates for the Arts, 1980.

Oregon Arts Commission. *Dollars and Sense of the Arts: Summary of an Economic Impact Study.* Salem, Oreg.: Oregon Arts Commission, 1981.

_____. *Report on the Arts.* Salem, Oreg.: Oregon Arts Commission, 1982.

_____. *Report on the Arts.* Salem, Oreg.: Oregon Arts Commission, 1980.

_____. *Report on the Arts.* Salem, Oreg.: Oregon Arts Commission, 1978.

Peat, Marwick, Mitchell and Company. *Report on the Economic Impact of the Arts in Texas.* Houston, Tex.: Texas Commission on the Arts, 1984.

Research Associates. *Resource Directory and Economic Impact of the Arts in Louisiana.* Baton Rouge, La.: Research Associates, 1980.

State Arts Council of Oklahoma. *1985 Economic Impact of the Arts in Oklahoma.* Oklahoma City, Okla.: State Arts Council of Oklahoma, 1985.

_____. *1982 Economic Impact of the Arts in Oklahoma.* Oklahoma City, Okla.: State Arts Council of Oklahoma, 1982.

_____. *1980 Economic Impact of the Arts in Oklahoma.* Oklahoma City, Okla.: State Arts Council of Oklahoma, 1980.

Steinike, George, and Stevens, Dana. *The Economic Impact of the Fine Arts in Florida.* Tampa, Fla.: Fine Arts Council of Florida, 1979.

Sullivan, John J., and Wassall, Gregory H. *The Impact of the Arts on Connecticut's Economy.* Hartford, Conn.: Connecticut Commission on the Arts, 1977.

Thompson and Associates, Center for Policy Studies. *The Economic Impact of the 1979/80 California Arts Council Budget.* Sacramento, Calif.: California Arts Council, 1979.

Touche Ross. *Michigan: State of the Arts, An Economic Impact Study Summary of Findings.* Detroit, Mich.: Touche Ross, 1985.

University of Arkansas at Little Rock, Division of Business Studies, Center for Research and Public Policy. *A Survey of the Arts in Arkansas.* Little Rock, Ark.: Report Division of Business Studies, University of Arkansas at Little Rock, 1984.

Washington State Arts Commission. *The Economics Factor: The Arts Mean Business.* Olympia, Wash.: Washington State Arts Commission, 1984.

City, Metro Area, and Facility Studies

Anchorage Arts Council. *The Art of the City Comparative Economic Study.* Pamphlet. Anchorage, Alaska: Anchorage Arts Council, 1985.

Art and Education Council of Greater St. Louis. *The Economics of the St. Louis Metropolitan Area's Arts and Cultural Organizations.* St. Louis, Mo.: Art and Education Council of Greater St. Louis, 1975.

Arts Alliance of Jackson/Hinds County, Economic Analysis Division of the Mississippi Research and Development Center. *The Economic Impact of the Arts on the Jackson/Hinds County Economy.* Jackson, Miss.: Arts Alliance of Jackson/Hinds County, 1984.

Arts Committee of the Spokane Area Chamber of Commerce. *Economic Impact of the Major Non-Profit Cultural Organizations of Spokane County.* Spokane, Wash.: Spokane Area Chamber of Commerce, n.d.

Arts Council. *Impact of Arts and Cultural Organizations of the Economy and Education in Winston-Salem/Forsyth County.* Winston-Salem, N.C.: Arts Council, 1984.

Arts for Greater Rochester and the Center for Government Research. "Economic Impact of the Arts Study/Monroe County." Unpublished Paper, 1985.

Baird, Nini. The Arts in Vancouver: *A Multi-Million Dollar Industry.* Vancouver: Community Arts Council of Vancouver, 1976.

Birmingham Area Chamber of Commerce. *Economic Impact of the Major Cultural Institutions on the Birmingham Area.* Birmingham, Ala.: Birmingham Area Chamber of Commerce, 1983.

Brown, Harris, Stevens. "Updated Report on the Influence and Effect of the Lincoln Center Complex on Manhattan Real Property Values." Mimeographed. New York, N.Y.: Lincoln Center for the Performing Arts, 1978.

Bureau for Economic and Business Research, College of Charleston. *Charleston Area Arts Activities/Needs and Economic Impact.* Charleston, S.C.: Bureau of Economic Research, College of Charleston, 1984.

Chicago Council on Fine Arts. *A Survey of Arts and Cultural Activities in Chicago.* Chicago, Ill.: Chicago Council on Fine Arts, 1977.

Citizens Union of the City of New York. *Economic Implications of the Arts in New York City Subcommittee Draft Report.* New York, N.Y.: Citizens Union of the City of New York, 1981.

Community Foundation of Greater Washington. *A Cultural Assessment.* Washington, D.C.: Community Foundation of Greater Washington, 1982.

Cultural Resources Council. *The Arts Industry: A Profile of the Economic Impact of the Arts on Syracuse and Onondaga County.* Syracuse, N.Y.: Cultural Resources Council, 1982.

Cultural Resources Council of Syracuse and Onondaga County. *What Industry in Syracuse and Onondaga County Generates $33,000,000 a Year, Requires a Workforce of Nearly 10,000 and Supplies Products to 1,800,000 Consumers?* Pamphlet. Syracuse, N.Y.: Cultural Resources Council of Syracuse and Onondaga County, 1982.

Cwi, David, and Moore, Susanne. *The Economic and Social Impact of the Proposed Long Island Performing Arts Center.* New York, N.Y.: New York State Urban Development Corporation, 1981.

241

Dade County Council of Arts and Sciences. *The Economic Impact of Cultural Activity in Dade County.* n.p.: Dade County Council of Arts and Sciences, 1982.

DeKorte, J. M. *Economic Impact of the Arts in Toledo.* Toledo, Ohio: Arts Commission of Greater Toledo, 1979.

Division of Business and Economics, Indiana University, Purdue University at Fort Wayne. *The Economics Impact of Selected Cultural Institutions and the Arts in the Fort Wayne Community.* Fort Wayne, Ind.: Division of Business and Economics, 1984.

_____. *The Economics Impact of Selected Cultural Institutions and the Arts in the Fort Wayne Community.* Fort Wayne, Ind.: Division of Business and Economics, 1977.

Doherty, Anne, and Wermiel, Sara. *The Contribution of Boston Theatre District Audiences to Boston's Economy, 1979-80.* Boston, Mass.: Boston Redevelopment Authority, 1981.

Drevs, Robert. *Investment in Tomorrow: Economic Impact of the Arts in Michiana.* South Bend, Ind.: Michiana Arts and Sciences Council, 1980.

Greater Columbus Arts Council. *The Arts in Columbus: Impact and Diversity.* Columbus, Ohio: Greater Columbus Arts Council, 1980.

Greater Hartford Arts Council. *A Survey of the Arts in Greater Hartford.* Hartford, Conn.: Greater Hartford Arts Council, 1979.

Greater Philadelphia Cultural Alliance. *An Introduction to the Economics of Philadelphia's Cultural Organizations.* Philadelphia, Pa.: Greater Philadelphia Cultural Alliance, 1975.

Greenleaf, Robert W. *The Economic Impact of the Arts in Indianapolis.* Indianapolis, Ind.: Metropolitan Arts Council of Indianapolis, 1977.

Grimes, A. Ray. *The Economic Impact of the Arts on the Oklahoma City Economy: 1983 Update.* Oklahoma City, Okla.: Arts Council of Oklahoma City, 1984.

Hammer, Siler, George Associates. *Economic Impact of Selected Arts Organizations on the Dallas Economy.* Dallas, Tex.: City of Dallas, 1977.

Hart, Krivatsy, Stubbee. *Lincoln Square Community Action Planning Program.* New York, N.Y.: Lincoln Square Community Council and New York City Department of City Planning, 1971.

Houston Chamber of Commerce. *State of the Arts: The Houston Spirit.* Houston, Tex.: Houston Chamber of Commerce, 1985.

Jedel, Peter. *Economic Impact of the Arts.* Tulsa, Okla., 1982.

Kansas City Arts Council. Economic Impact of the Performing Arts on Kansas City. Kansas City, Mo.: Hallmark Educational Foundation, 1980.

Kellog School of Management, Northwestern University. *The Economic Impact of the Arts in Evanston.* Evanston, Ill.: Evanston Arts Council, 1985.

Leavitt, Michael, and Helmuth, John. *Economic Impact of the Rochester Philharmonic Orchestra on the Local Economy.* Rochester, N.Y.: College of Business, Rochester Institute of Technology, 1984.

Mathtech. *The Impact of the Broadway Theatre on the Economy of New York City.* New York, N.Y.: League of New York Theatres and Producers, 1977.

Mayor's Committee on Cultural Policy. *Report of the Mayor's Committee on Cultural Policy.* New York, N.Y., 1974.

Metropolitan Arts Commission. *The Arts Mean Business.* Portland, Oreg.: Metropolitan Arts Commission, 1984.

Metropolitan Arts Council. *The Economic Impact of the Arts on Indianapolis.* Indianapolis, Ind.: Metropolitan Arts Council, n.d.

Metropolitan Richmond Chamber of Commerce. *Economic Impact of the Arts in the Metropolitan Richmond Area.* Richmond, Va.: Metropolitan Richmond Chamber of Commerce, 1982.

Michiana Arts and Sciences Council. *Investment in Tomorrow: Economic Impact of the Arts in Michiana.* South Bend, Ind.: Michiana Arts and Sciences Council, 1980.

Minneapolis Arts Commission. *The Role of the Arts in Urban Economic Development.* Minneapolis, Minn.: Minneapolis Arts Commission, 1978.

Mount Vernon College, Market Research Group. *Final Report: An Economic Analysis of the Impact of the Torpedo Factory on Lower King Street.* Alexandria, Va., 1978.

Nassau County Office of Cultural Development. *Economic Impact of the Arts on Nassau County, New York.* Nassau County, N.Y.: Nassau County Office of Cultural Development, 1983.

National Endowment for the Arts. *Economic Impacts of Arts and Cultural Institutions: A Model for Assessment and a Case Study in Baltimore.* Washington, D.C.: National Endowment for the Arts, 1977.

_____. *Economic Impacts of Arts and Cultural Institutions: Case Studies in Columbus; Minneapolis/St. Paul; St. Louis; Salt Lake City; San Antonio; Springfield.* Washington, D.C.: National Endowment for the Arts, 1981.

_____. *The Economic Impact of Eight Cultural Institutions on the Economy of the St. Louis SMSA.* Washington, D.C.: National Endowment for the Arts, 1980.

_____. *The Economic Impact of Five Cultural Institutions on the Economy of the San Antonio SMSA.* Washington, D.C.: National Endowment for the Arts, 1980.

243

_____. *The Economic Impact of Six Cultural Institutions on the Economy of the Columbus SMSA*. Washington, D.C.: National Endowment for the Arts, 1980.

_____. *The Economic Impact of Ten Cultural Institutions on the Economy of the Minneapolis/St. Paul SMSA*. Vols. I and II. Washington, D.C.: National Endowment for the Arts, 1980.

_____. *The Economic Impact of Ten Cultural Institutions on the Economy of the Salt Lake SMSA*. Washington, D.C.: National Endowment for the Arts, 1980.

_____. *The Economic Impact of Ten Cultural Institutions on the Economy of the Springfield, Illinois SMSA*. Washington, D.C.: National Endowment for the Arts, 1980.

_____. *Technical Supplement to the Economic Impact of Eight Cultural Institutions on the Economy of the St. Louis SMSA*. Vols. I and II. Washington, D.C.: National Endowment for the Arts, 1980.

_____. *Technical Supplement to the Economic Impact of Five Cultural Institutions on the Economy of the San Antonio SMSA*. Vols. I and II. Washington, D.C.: National Endowment for the Arts, 1980.

_____. *Technical Supplement to the Economic Impact of Six Cultural Institutions on the Economy of the Columbus SMSA*. Vols. I and II. Washington, D.C.: National Endowment for the Arts, 1980.

_____. *Technical Supplement to the Economic Impact of Ten Cultural Institutions on the Economy of the Minneapolis/St. Paul SMSA*. Vols. I and II. Washington, D.C.: National Endowment for the Arts, 1980.

_____. *Technical Supplement to the Economic Impact of Ten Cultural Institutions on the Economy of the Salt Lake SMSA*. Vols. I and II. Washington, D.C.: National Endowment for the Arts, 1980.

_____. *Technical Supplement to the Economic Impact of Ten Cultural Institutions on the Economy of the Springfield, Illinois SMSA*. Vols. I and II. Washington, D.C.: National Endowment for the Arts, 1980.

New York League of Theater Owners and Producers. *The Impact of the Broadway Theater on the Economy of New York City*. New York, N.Y.: New York League of Theater Owners and Producers, 1983.

Office of Cultural Affairs, Clarke County Board of Commissioners. *The Arts in Clarke County, Georgia: Section IV, Economic Impact*. n.p.: Office of Cultural Affairs, Clarke County Board of Commissioners, 1980.

Port Authority of New York and New Jersey and the Cultural Assistance Center. *The Arts as an Industry: Their Economic Importance to the New York-New Jersey Metropolitan Region*. New York, N.Y.: The Port Authority of New York and New Jersey and the Cultural Assistance Center, 1983.

Public Information Office, Lincoln Center for the Performing Arts. "The Economic Impact of Lincoln Center." Slide Show. New York, N.Y.: Lincoln Center for the Performing Arts, 1982.

Richman, Roger. *The Arts in Tidewater.* Norfolk, Va.: Metropolitan Arts Congress of Tidewater, 1977.

Roe, David. *Study of the Impact of the Arts on the Economy of Greenville County, South Carolina.* Greenville, S.C.: Department of Economics and Business, Furman University, 1979.

Sierra Arts Foundation. *A Marketing and Economic Study of Selected Arts Organizations in the Reno-Sparks Area.* Reno, Nev.: Sierra Arts Foundation, 1981.

Southern Arts Federation. *A Survey of the Economic Impact of the Alvin Ailey American Dance Company Long Term Residency in Atlanta, Georgia.* Atlanta, Ga.: Southern Arts Federation, 1978.

University of Southern California, Graduate School of Business. *The Economic Impact of Cultural Activities.* Sun Valley, Idaho: Sun Valley Center for the Arts and Humanities, 1984.

Urwick, Currie and Partners. "An Assessment of the Impact of Selected Large Performing Companies Upon the Canadian Economy." Mimeographed. Ottawa: Canada Council Information Services, 1974.

Washington Regional Arts Project. *The Arts in Metropolitan Washington: Some Preliminary Data on Economics, Financing and Organization.* Washington, D.C.: Washington Center for Metropolitan Studies, 1975.

Winston-Salem, North Carolina. *Winston-Salem: Arts in Action.* Winston-Salem, N.C.: Winston-Salem Arts Council, n.d.

Worchester Cultural Commission. *1981 Economic Impact: A Study of the Impact of Cultural Activity on the Economy of Worchester, Massachusetts.* Worchester, Mass.: Worchester Cultural Commission, 1982.

International Studies

Arts Council of Great Britain. *Survey of Visual Artists—Their Incomes and Expenditures and Attitudes to Arts Council Support.* Research Report No. 4. London: Arts Council of Great Britain, 1974.

Backerman, S. *Arts Means Business.* Vancouver: Social Planning Department, City of Vancouver, 1983.

Book, Sam. "Economic Aspects of the Arts in Ontario." n.p.: Ontario Arts Council, 1973.

Hillman-Chartrand, Harry. *An Economic Impact Assessment of the Canadian Fine Arts.* Akron, Ohio: Third International Conference on Cultural Economics and Planning, 1984.

_____. *Ontario and the Arts: The Investment, The Dollars, The Jobs and The Votes*. Toronto: Toronto Arts Council Public Forum, 1984.

Urwick, Currie and Partners. *An Assessment of the Impact of Selected Large Performing Companies Upon the Canadian Economy*. Ottawa: Canada Council, 1974.

About the Authors

David Cwi directs the Cultural Policy Institute, a not-for-profit research and planning organization. He has been the special advisor on the arts for the U.S. Conference of Mayors and principal investigator for numerous studies of the arts. His work has been supported by national governments and public and private agencies such as the government of Canada, the Theatre Development Fund, the city of Chicago, the state of New Jersey, DANCE USA, the Mid-Atlantic States Arts Consortium, the League of Chicago Theatres, the National Assembly of State Legislatures, and the National Endowment for the Arts. As a senior staff member at Johns Hopkins University, he was instrumental in the development of the Metropolitan Planning and Research Center.

Sonja K. Foss is assistant professor of speech at the University of Oregon. She earned a Ph.D. in communication studies from Northwestern University, and she is the co-editor of _Women's Studies in Communication,_ the journal of the Organization for Research on Women and Communication. She has published in the areas of rhetorical theory; rhetorical criticism, particularly the criticism of visual images; and gender communication. She is the co-author of _Contemporary Perspectives on Rhetoric_ (1985).

James H. Gapinski is professor of economics at Florida State University. He also has served the United States Department of Commerce's Office of Policy Development and Coordination and has been a Brookings Economic Policy Fellow. His publications include several in the area of arts and economics, and he has served as a referee for many major economics journals. He earned a Ph.D. in economics at the State University of New York at Buffalo.

William S. Hendon is professor of economics and urban studies at the University of Akron. He is editor of the _Journal of Cultural Economics_ and the primary founder of the Association for Cultural Economics. He is the author and editor of numerous works in the field of cultural economics.

Harry Hillman-Chartrand holds a Master of Arts degree in economics from Carleton University in Ottawa. For 10 years, he operated his own consulting firm, Futures, Socio-Economic Planning Consultants, working in the fields of intergovernmental finance and cultural economics. Since 1981, he has served as director of research for the Canada Council. He is the author of many studies and reports on the role of the arts in the economy.

Dick Netzer is senior fellow of the Urban Research Center and professor of economics and public administration at the Graduate School of Public Administration at New York University. He was the founding director of the center and is a former dean and department chair at NYU. His research career has focused on public finance, urban economics and, in recent years, economics and financing of the arts. His work in this area includes _The Subsidized Muse: Public Support of the Arts in the United States_ (1978), studies of data needs in the arts, and papers on the economics and financing of dance.

R. Leo Penne is the principal author of _The Economics of Amenity_ (1985) and the supervising editor of _The Return of the Livable City: Learning from America's Best_ (1986). He has held senior policy positions in both the federal government and the private sector. Currently, he is the director of the State of Nevada office in Washington, D.C.

Anthony J. Radich is senior project manager for the Arts, Tourism and Cultural Resources Project of the National Conference of State Legis-

latures and the former chair of the Denver Commission on Cultural Affairs. He holds a doctorate in public administration from the University of Colorado at Denver, and his research concerns public policy and state legislatures as they relate to the arts.

Bruce A. Seaman completed his doctoral work at the University of Chicago and is associate professor of economics and graduate programs coordinator for economics at Georgia State University. He has been staff economist and consultant to the Atlanta office of the Federal Trade Commission. In addition to the economics of the arts, his research includes work in public finance and industrial organization and antitrust. He is a founding member of the National Association of Forensic Economists.

James L. Shanahan is director of the Center for Urban Studies and professor of urban studies at the University of Akron. He earned a Ph.D. in economics at Wayne State University. His previous writings on cultural economics include "Cultural Development and Economic Development: How They Come Together" in *Economic Support for the Arts* (1982) and "Arts and Urban Development" in *Economic Policy for the Arts* (1980). He is co-founder of the International Association of Cultural Economics and served as associate editor of the *Journal of Cultural Economics*. He has written extensively about urban policy and local economic development issues.

Subject Index

Advertising 22, 37
Advocacy 78, 123, 128
 Identification strategies as advocacy 90-102
Amenities 9, 129, 133-141, 144, 145, 155, 156, 205, 229
Arts
 And capital 8-11, 15, 37
 And employment 13-15, 37, 128, 129, 144, 151, 155, 216
 And health 30-31
 And industry 28-30, 139, 141, 143-145
 And government 5-19
 Architect state 17
 Engineer state 18
 Patron state 17
 And human development 140, 142-143
 And technology 11
 As public goods 6, 68-69
 As research and development 38
 Audience for 20, 21, 187-189, 190, 192, 196, 199
 Definition of 138
 Demand for 200-205, 212
 Facilities for 8, 9, 146-149, 155, 156
 In neighborhood development 140
 Production function and structure in 193-200
 Willingness to pay for 69-70, 107, 162-176, 206-207
Arts impact studies
 And policymaking 46, 57, 61-64, 101, 106-107, 113, 114, 115-116, 118,
 122, 124-125, 135, 154-155, 160, 161, 183-184
 Cost of 80, 82, 84, 106
 Criticisms of 45-72, 78, 101-102, 123-125, 161
 Data collection in 80, 82-83, 84, 85, 86, 119-122
 Data extrapolation in 81, 83, 86, 120-122, 123
 Definitions of *the arts* in 116-118
 Effectiveness of 86-88
 Objectives of 80, 82, 88-90, 114-116
 Types of information presented in 80-86, 118-119
 Use for
 In philanthropic sector 26-31
 In private sector 19
 In public sector 32-37
Business location 9, 60-61, 95, 111, 129, 131, 134, 135, 136, 140, 145
Case studies 81-84
City image 151, 152-153, 156
Clawson-Knetsch demand curve 165-170
Cobb-Douglas function 193, 195, 199
Copyright 8, 10, 11, 12, 37
Corporate support 23, 28
Cost/benefit 45, 47, 62-68, 70, 107-109, 160, 184, 210, 211, 229
Cultural economics 27, 28, 160, 183
Cultural planning 146-153
Cultural tourism 34-35, 111-112, 147, 149, 150-152, 186-187, 205, 217,
 218, 224, 229
Design, economic aspects of 25-26, 37
Developmental services 132-133, 135 (also see amenities)

Name Index

Index of Studies Cited